THE CERAMIC
DESIGN BOOK

THE CERAMIC DESIGN BOOK

A Gallery of Contemporary Work

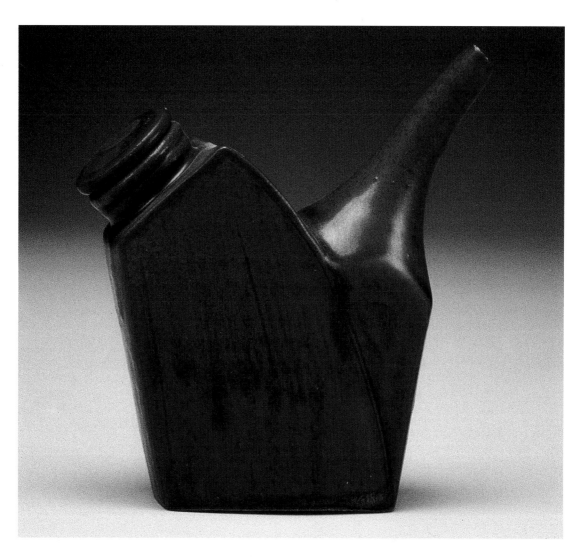

Introduction by
VAL M. CUSHING

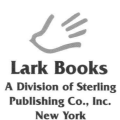

Lark Books
A Division of Sterling
Publishing Co., Inc.
New York

Editor: Chris Rich

Art director: Kathleen J. Holmes

Editorial assistants: Nancy Orban and Heather Smith

Production assistant: Hannes Charen

Library of Congress Cataloging-in-Publication Data

The ceramic design book : a gallery of contemporary work /
 introduction by Val M. Cushing ; [editor, Chris Rich]. — 1st ed.
 p. cm.
 Includes index.
 ISBN 1-57990-058-5 (hard)
 1. Pottery—20th century. 2. Porcelain—20th century.
 3. Ceramic sculpture—20th century I. Cushing, Val M.
 II. Rich, Chris, 1949- .
 NK3930.C48 1998 98-7319
 738'.09'049—DC21 CIP

10 9 8 7 6 5 4 3 2

Published by Lark Books, a division of
Sterling Publishing Co., Inc.
387 Park Avenue South, New York, N.Y. 10016

Distributed in Canada by Sterling Publishing,
c/o Canadian Manda Group, One Atlantic Ave., Suite 105 Toronto, Ontario,
Canada M6K 3E7
Distributed in Australia by Capricorn Link (Australia) Pty Ltd., P.O. Box 6651,
Baulkham Hills, Business Centre
NSW 2153, Australia

If you have questions or comments about this book, please contact:
Lark Books
50 College St.
Asheville, NC 28801
(828) 253-0467

Printed in Hong Kong
ISBN 1-57990-176-x

Title page: **Ellen Shankin,**
Soy Bottle (see page 56)

Opposite page: **Christine
Federighi,** *Low Spiral*

1997, 72" x 8" x 10" (183 x
20 x 25 cm). Coiled in one
piece, smoothed, and carved;
fired in electric kiln, cone
05-04; painted oil patina
surface. Photo by Fareed Al Mashat

*The clay figure form has been
constant to my work for several
years. It has served as a vehicle
for carving and layering painted
narrative patterns. In many
ways, it relates to a potter deco-
rating and designing images on
a pot. I think of the Native
American potters of Acoma
Pueblo or the Hopi potters in
their wrapping of symbolic and
narrative forms around tradi-
tional shapes. Native American
art and tribal art of all cultures
has always held my interest. I
appreciate these artists' skills
with material, their connection
to nature and the spiritual, their
sense of design and narrative.*

TABLE OF CONTENTS

Details from photos on pages 25, 60, 69, 13, 137, and 149

PREFACE

For the people at Lark, *The Ceramic Design Book* is more than a collection of fine contemporary claywork. We offer this photographic gallery for your pleasure of course, but for us, it's also a capstone to our series of instructional ceramics books, a commitment to continuing that series, and a gesture of respect and gratitude to the hundreds of ceramic artists who have helped make it possible.

When Lark first decided to publish ceramics titles, we had little or no idea what to expect. We knew that accessible books on clay (informative, inspirational, beautiful, and fun) were few and far between. We knew that we had the expertise to produce good books, and we knew that we loved clay—its look, its feel, and its power to transform. With one exception, however (our art director, who was a potter in a previous lifetime), we weren't on a first-name basis with many ceramic artists.

We needn't have worried. Within weeks of beginning the first book in the series, we were inundated by slides of truly stunning ceramic art. Technical articles and advice, personal encouragement and support, proposals for future books, and notes of thanks came pouring in from around the world—and have continued to pour in ever since. For the past several years, famous ceramists, struggling studio artists, devoted teachers, and eager students alike have voluntarily guided, taught, coddled, cajoled, and rewarded us at every step. (They've even told us their first names.) Without these people, many of whom you'll meet as you browse through *The Ceramic Design Book*, Lark's ceramic series wouldn't exist.

From the thousands of slides submitted for this book, we've selected a wide range of work, from functional pottery to sculpture, and from architectural installations to vessels. Many of the pieces were made by well-established ceramic artists. Others are works by relative newcomers. They all, however, serve as testimony to the skills, creativity, struggles, and successes that ceramic artists share. We hope that we'll be able to offer similar testimonies in future years—updated pictorial guides to contemporary ceramics from around the world.

For the sake of design, we've separated these photos into very loose, technique-based categories. Don't take these divisions too seriously! Many of the pieces shown could easily be fit into two or more categories. Approach each piece, instead, in its own right, and view it from your own perspective. Renowned ceramist and professor, Val M. Cushing, who kindly consented to write the introduction that follows, finishes his essay with a sentence we'd like to appropriate here. "What most of us will experience through our work," he explains of today's ceramists, "is a deep sense of personal fulfillment and pleasure from whatever meaning and beauty it communicates." We hope that *The Ceramic Design Book* offers you a similar sense of personal fulfillment and pleasure.

Chris Rich, Editor
Kathy Holmes, Art Director

CONTEMPORARY CERAMICS

Artists new to the field of ceramics face some problems. Much of the work they see and admire seems so accessible and so relatively easy to do. There are, after all, excellent teachers, excellent schools with first-rate facilities, and libraries filled with informative books. People know how to make a Robert Arneson "head" or a Pete Voulkos platter, a Richard Devore vessel or a Clary Illian pot. There appear to be quick routes to success. Occasionally, some of our prestigious galleries do discover a young artist who has found an idea " ... based on some obscure source and covered with great skills," as Bill Daley once so perceptively said. Indeed, these artists may have an instant, if short-lived, fame. Our market place and the art world it represents reward newness over consistency and quirkiness over familiarity. Some artists become millionaires almost overnight, but are these the role models we need?

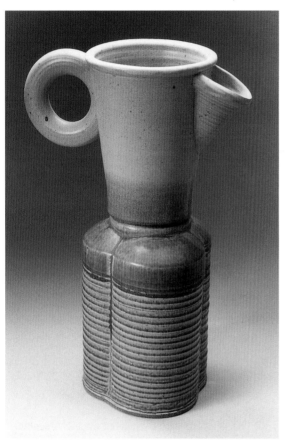

Val Cushing, *Pitcher*
1996, height: 22" (56 cm)

We generate confusion because we encourage the belief that success in ceramics is measured by acceptance in the right galleries and coverage in the popular media. "The medium is the message," as Marshall McLuhan said so long ago. Perhaps, in our instant culture, appropriation art is what we deserve, but the best art, in my view, isn't made that way. Short cuts, copying, and imitation will not work in the long run. Sometimes, achievement can come quickly, but lasting meaning, real depth, and maturity do not. Identifying your personal artistic voice takes time, and learning how to give it expression takes even longer. The very best of our most talented ceramists have resisted the traps described. As a result, some of the work we see today is among the best work ever done.

In our burgeoning field of ceramic art, there is much confusion and much success—much good art and an ocean of bad art. The situation is the same in all the arts. The confusion arises from unclear or nonexistent standards, which hardly encourage the constructive criticism so badly needed today. No one seems able to say or to know what art is—or isn't! Where does this leave the artist? "There really is no such thing as art; there are only artists," said Ernst Gombrich. It's not my objective to discuss this complex subject, but rather to show how some aspects of these problems affect the field of ceramic art.

Something began to happen at the beginning of the twentieth century—something that accounts for much of the success and some of the confusion we now experience. Nearly every professional who works in ceramics today was educated, either entirely or in part, in a school of art or some kind of university art program. This has been in direct contrast to the preceding 10,000 years of ceramic history. In the past, one learned the craft of ceramics as an apprentice working with a master potter. Artistic considerations, if any, were handed down from master to pupil, and thus traditions were born. Contemporary ceramists, on the other hand, usually have an education and philosophical background in art, which they combine with training in the skills, techniques, materials, and processes of the craft of ceramics.

The implications of today's system of art-school education leaves us with a "good news/bad news" situation. The good news is that the system helps open up each individual to the potential and possibilities that talent and curiosity can discover. Nothing is taken for granted, and no one is tied to any particular way of working. Innovation and new ways of thinking prosper. The bad news is that skills and techniques tend to be de-emphasized, and much of the strength and refinement of traditional ways gets lost. The natural outcome of going to art school and expecting to come out as an artist is that one's concerns tend to focus exclusively on aesthetics and making art. The problem is that we may have gone too far in this direction, forgetting in the process how crucial it is to have superb skills and expert knowledge of materials and processes. The freedom that an art education gives means we have more choices about how and what we make. That same freedom also makes life more confusing; many people working in ceramics today are lost and unsure about what they are making—and what to call it.

Most of ceramic art falls into one of four categories: pottery, vessels, sculpture, and architectural ceramics. "Pottery"—clay objects made to be functional in the utilitarian sense—is used for pouring, storing, serving, cooking, and other household purposes. Pottery is about clay objects that have uses in daily life; use is essential to its meaning. The best pottery, however, may also exist as an art object, with all the spiritual and emotional meaning contained therein.

"Vessel" has come to mean something different than pottery. Although vessels have the general look of pottery, their use is irrelevant. A vessel's meaning therefore lies in the area of visual or spiritual fulfillment. Only in this sense can a vessel be called functional. A vessel is a clay object that appears to be part sculpture and part pottery—what Ted Randall used to call a "sculpot"! Part of the justification or validity of vessels comes from their metaphorical or symbolic power, which suggests revitalized or more emphatic meanings for the pottery forms they represent.

"Ceramic sculpture" simply means works of sculpture made with ceramic materials and processes. In earlier times, the word "sculpture" was not preceded by naming the medium from which it was made. Today, it is common to speak of sculpture as "glass sculpture," "wood sculpture," "fiber sculpture," and so on. Ceramic sculpture is the one category within ceramics that is most likely to be considered "art" and that is least likely to be confused with or dismissed as craft or called decorative.

The category of "architectural ceramics" includes a myriad of clay objects that have many uses, from bricks to tiles, and from free-standing screens to wall installations and fireplace frontals. All comprise clay objects that have diverse uses. Many objects in this category are industrially produced and somewhat out of the scope of this discussion.

Let's return to pottery. Some potters still seem a bit confused about their place in the art world. In this regard, the potter is lucky and should be free from worry because pottery will never be accepted as a valid part of the contemporary western art world. The art of the potter is very real, of course, and will always be understood and even celebrated by those who feel that the useful and the beautiful can have one voice. The potter can avoid confusion by accepting that his or her artistic satisfaction will come from personal pride and fulfillment and not from external recognition. The useful pot is a bridge between the maker and the user. It creates a special and intimate kind of connection.

Trying to figure out what to make can be very confusing. With hard work and patience, a potter can acquire the skills and know-how to work in any way, at any temperature, and by any firing method. (The information available can be overwhelming.) Certain styles of work sweep the country, in constantly changing fashion cycles; it's easy to feel left out. What counts, however, is to find those qualities of work that are most appropriate to one's own philosophical point of view. The potter must maintain integrity and develop a personal voice. Pottery has the great advantage of communication and accessibility; the content and purpose—if not the particular choice of shape, color and texture—are always understood.

The main confusion for vessel makers is the ambiguous nature of their work. A vessel can look like pottery, but it really isn't pottery. Or, it can look like sculpture, but may not be perceived as sculpture. The vessel maker intends his or her work to function as art, but the work is likely to be rejected from the art world because it may look like pottery—and pottery is not in that world. A vessel may be considered to be sculpture, in the sense that all three-dimensional objects are viewed as sculpture. As long as the vessel has the look of pottery, however, it probably won't be judged as sculpture outside the

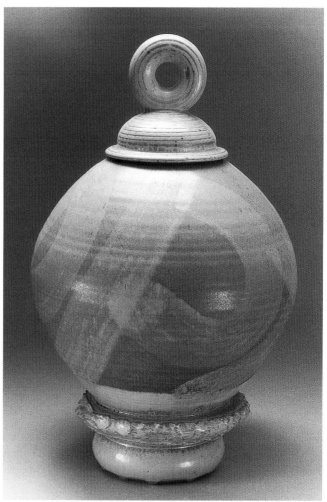

Val Cushing, *Covered Jar*
1996, height: 24" (61 cm)

ceramic world. As Saul Bellow wrote, "A great deal of intelligence can be invested in ignorance when the need for illusion runs deep." The potential audience for vessels can be narrowed down to informed people who not only can afford the higher prices of vessels but who also understand and appreciate the

visual statement and the ritual and spiritual content of the vessel.

Another problem I see in the vessel world (one shared by all of ceramics), is an overemphasis on skills and techniques. In many cases, the only content of work in this category is skill and craftsmanship. These tour-de-force pieces are often empty of meaning and seem to have been made for the purpose of producing beautiful slides; they exist only in the two-dimensional world. In spite of all this, vessel-makers in contemporary ceramics are the ones who have often led the way to new ideas and to much of the originality we associate with American ceramics. The vessel has captured the interest of galleries and the attention of the media. If one were to view ceramics only through magazines, books, catalogues, and juried exhibitions, the vessel would appear to be the most significant statement of contemporary ceramics.

The best vessel work stands the test of all good art, particularly in terms of the imaginative use of materials and processes and the integration of the craft of ceramics with aesthetic content. The break with tradition and a new sense of freedom about clay objects seems to have flourished with the vessel. But the worst of this work is shallow, insignificant, pretentious, and unclear about what it really is.

"Ceramic sculpture" is free of the dreaded association with "use" from which pottery and vessels may suffer in terms of acceptance by the art world. Clay has been an ideal medium for sculpture, and throughout the history of art, has been used for certain kinds of sculpture. With the popularity of cast metal sculpture, however, clay gradually became only a means to an end and almost disappeared with the onset of modernist art. One reason for ceramic sculpture falling behind is that many sculptural artists do not have the skills, techniques, and knowledge of the whole process of ceramics. In addition, the ceramic sculpting process does not lend itself readily to the monumental scale that has become more and more popular in sculpted work.

This situation started to change with the emergence of a group of artists such as Peter Voulkos, who had the knowledge, the skills, and the creative ideas to make significant ceramic sculpture. Artists all over the world now produce lively and challenging sculpture in clay. Many use clay with other materials in multimedia works, while others incorporate clay as part of installation and performance art. Ceramics has found a legitimate place in the larger world of contemporary sculpture. Here, too, however, are problems and confusion. A great many of the artists doing clay sculpture were initially trained as potters, and although they have the essential skills and techniques required to do sculpture, they are missing an education in sculpture and lack the ideas and the aesthetic to produce valid work. The result has been that much of today's ceramic sculpture will never make it in the larger world of sculpture. Sculptural ideas and concepts should be developed through materials and processes that are the most suitable. When ceramic sculptors try to follow the concepts and trends of contemporary sculpture, they're often taken in directions incompatible with the limitations of their medium. Much of this work falls into limbo; it falls neither into the pottery category nor the vessel category and is unacceptable as sculpture. Nevertheless, the work of some artists has made ceramic sculpture an exciting and dynamic leading edge in both the ceramic and the sculpture fields.

In some ways, "architectural ceramics" is the most interesting and certainly the most diverse of the categories under discussion—too vast in scope to cover in detail here. In a way, this area is an extension of functional ceramics. Most of the work, like pottery, has a purpose, but its uses are different. New ceramic materials and processes suggest new forms—more in the realm of industrial ceramics. Some works in architectural ceramics benefit from the ideas, designs, and technology that result from the collaboration among artists, designers, and engineers.

Contemporary ceramics is something of a phenomenon. Never before have so many people throughout the world made things in clay. What I hope for is a de-emphasis on short routes to success and less concern about whether or not what we make belongs in the art world. Outstanding talent will always be found and rewarded. What most of us will experience through our work is a deep sense of personal fulfillment and pleasure from whatever meaning and beauty it communicates.

Val M. Cushing
Alfred, New York

FROM THE POTTER'S WHEEL

Mastering the art of throwing clay on a spinning potter's wheel—centering the clay, opening it outward, and pulling it upward to create walls—is in part a matter of acquiring technical expertise, but the best throwers bring more to their clay and wheels than years of practice and superb skills. To their wheels and clay, fine throwers bring respect as well as knowledge, receptivity as well as vision, and humility as well as clear intent. Precisely because they treat their clay and wheels not as subjects to be dominated but as partners in an act of creation, their work rarely looks—or is—contrived.

In this section, you'll find wheel-thrown work ranging from beautiful functional ware to stunning vessels and sculpture. We've included simple but exquisitely shaped bowls, vases, and platters; works thrown in sections and then joined; and altered forms—thrown clay pieces that have been paddled, pushed, cut, carved, or joined to other clay forms. We hope that these exceptional pieces will give you a glimpse of the infinite number of variations possible when excellent potters, malleable clay, and spinning wheels come together.

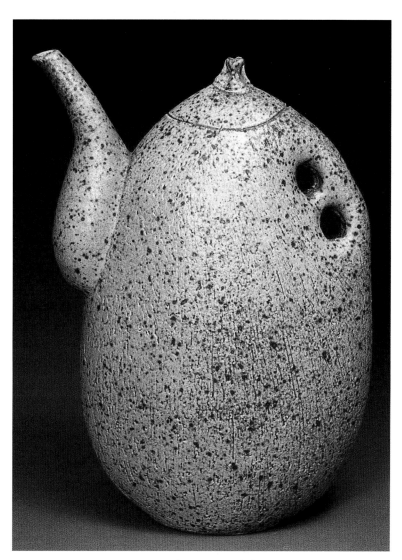

Hsin-Chuen Lin, *Untitled,*

1996, 9½" x 7" x 4" (24 x 18 x 10 cm). Wheel thrown and altered; sprayed glaze; reduction fired, cone 10

There are many influences on my work, but the most important one would be my Chinese cultural background. Mainly, the idea of making this piece was from Shang and Zhou bronzes in the early age of Chinese history. I like to translate the objects of several thousand years ago into modern works by using different media and firing. The process of making pots—tearing, punching, squeezing, decorating and finally, firing—is the most enjoyable thing.

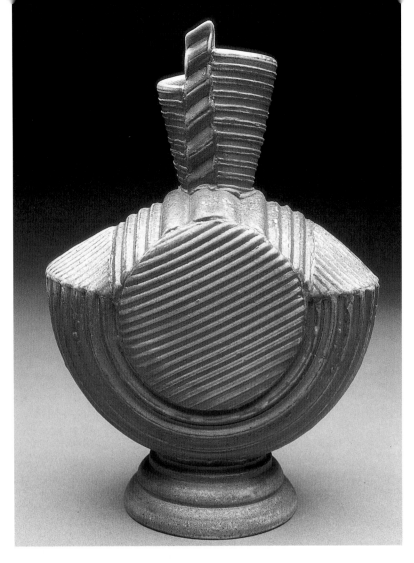

Left: Neil Patterson, *Bottle Form*

1997, 8" x 6" x 5" (20 x 15 x 13 cm). Wheel-thrown white stoneware, textured and cut-apart components; slip, light salt glaze; wood fired, cone 11. Photo by artist

Below: Courtney Moore, *Split Bowl*

1996, diameter: 15" (38 cm). Wheel-thrown and altered stoneware; slip and oxides; reduction fired, cone 9

I have been working on developing a cracked pattern for several years now. During this period, it occurred to me to coax the form itself into maintaining an aesthetic pattern of cracks while still maintaining its complete form. The dry piece is wet and squeezed in areas to develop body cracks, which then are further accentuated by the firing. This piece was one of the more successful.

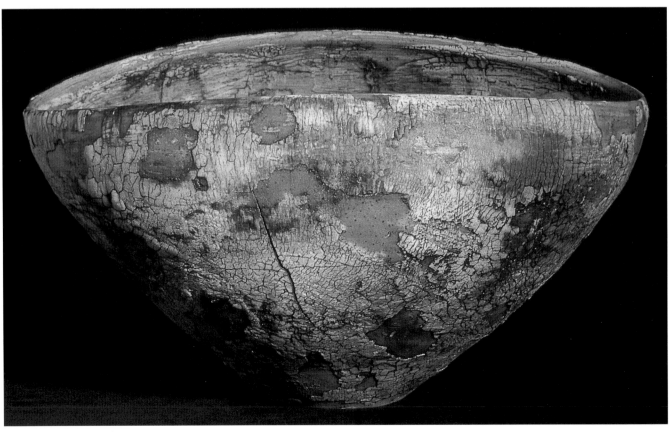

Right: Kenny Kicklighter, *"Signature" series*

1997, 10" x 11" x 11" (25 x 28 x 28 cm). Wheel thrown; glazed; raku fired. Photo by Macario

Clay is my window that allows me to see the creativity that is within me. I'll start with an idea and make changes along the way as new possibilities occur. The end result is a captured moment of spontaneous creativity, with clay being the catalyst. Each piece represents its own moment and therefore is one-of-a-kind. As I work with the raw clay or the firing, a part of my "manao" (spiritual being) goes into every piece. I feel the presence of life in the clay as it becomes an extension of myself.

Below: Sam Clarkson, *Faceted Platter*

1997, 23" x 23" x 5" (58 x 58 x 13 cm). Wheel thrown, cut with kiln element, rethrown; slips, glaze; wood fired, cone 11; refired with enamels, cone 019. Photo by Tracy Hicks

I turn to pots out of my own isolation and my desire to grow and change. Through pottery, I discover people and societies, past and present, known and unknown. Pots often take after their makers.

Through my work, I discover myself. It's easier to see the strengths and flaws in my pottery than in my life, but the two are inseparable. I believe that by working to improve my pots and myself over time, my best work will begin to seem as natural as fire, clay, air, and water.

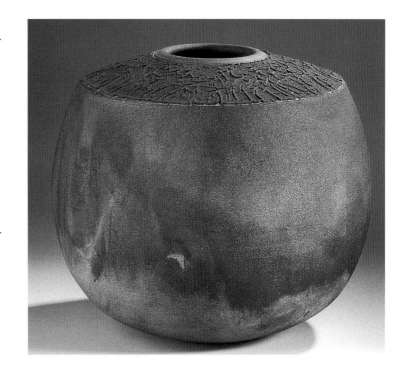

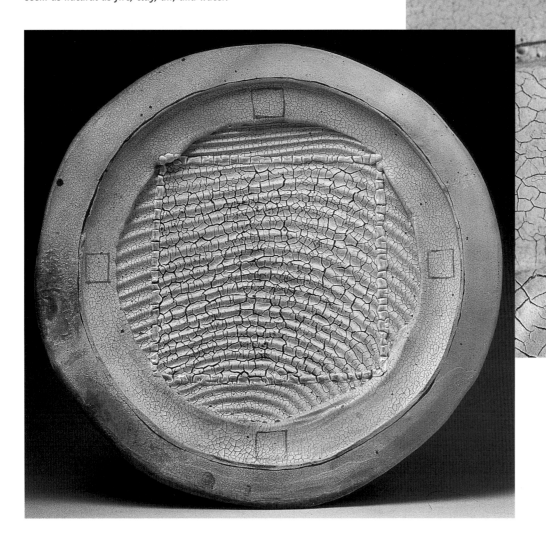

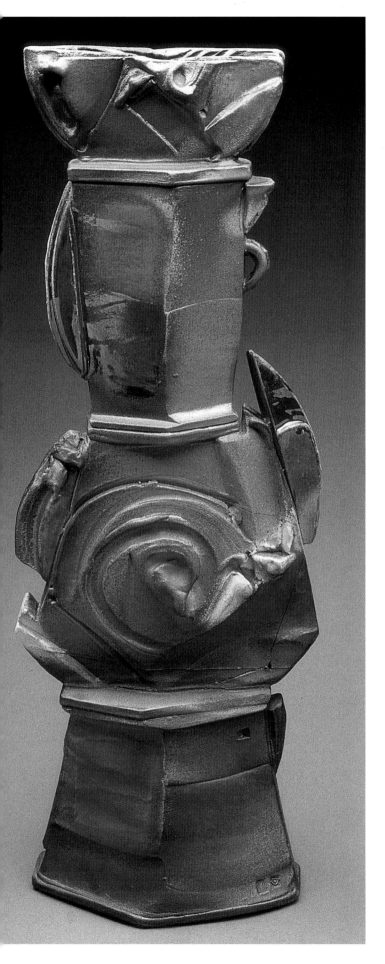

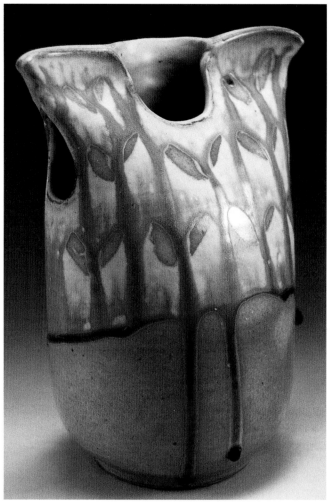

Above: **Kate Shakeshaft, *Mantle of Dignity***

1996, 9½" x 7" x 4½" (24 x 18 x 11 cm). Wheel thrown, squashed oval while wet, corners pressed together to seal; when leather hard, arm and neck holes cut, bottom trimmed; inner yellow glaze poured, then waxed; outer shino glaze dipped; decorative marks brushed with wax resist, top dipped down into ash glaze that beads and runs at high kiln temperatures; reduction fired in gas kiln, cone 10

These "shirt" pots are empty, but the form implies heavy weight inside, like a leather bottle full of liquid. I like the way gravity pulls the ash glaze drips to reinforce ideas about weight. This piece implies a dignified presence—hence the title.

Left: **Brad Schwieger, *Tower***

1997, 38" x 14" x 8" (97 x 36 x 20 cm). Wheel-thrown and altered stoneware; multiple slips and glazes; soda fired in reduction, cone 9

My work is a fusion of intent and improvisation. Form comes first and has always been the most essential element in my work. The altering process I use consists of faceting, stretching, and cutting up sections of the form and reassembling them. These techniques temper the symmetry of the wheel-thrown process. The tension between the expected symmetry and the actual asymmetry is a visual statement that I continue to concentrate on in my most recent work.

Right: **Robert Bowman,** *Rocked Covered Jar*

1996, 10" x 5¾" x 5¾" (25 x 14.5 x 14.5 cm). Wheel-thrown stoneware, with hand-carved textures; reduction fired, cone 10.
Photo by Peter Lee

Whether I'm making a small functional bowl or a large decorative urn, my concerns are the same: strong form and a certain visual density. I'm most satisfied with the work when it combines seemingly contradictory qualities: richness and simplicity, humor and gravity, sensuality and discipline.

Bottom left: **John Tilton,** *Porcelain Hourglass Vase*

1997, 11" x 5½" x 5½" (28 x 14 x 14 cm). Wheel thrown in one piece, force-dried with hair dryer and butane torch during forming; layered matt crystalline glazes, reapplied between multiple reduction firings, cone 10. Photo by artist

I strive for the kind of perfection that makes my pots seem born, not made or contrived—for an organic quality that comes from attunement rather than merely expertise.

Bottom right: **Adriana Pazmany Thomas,** *Untitled*

1996, 6½" x 5¼" x 5¼" (16.5 x 13 x 13 cm). Wheel-thrown and chiseled porcelain vase; crystalline glaze; fired in electric kiln, cone 10 (soaked for 3 hours); chiseled and then bottom ground. Photo by Steve Gyurina

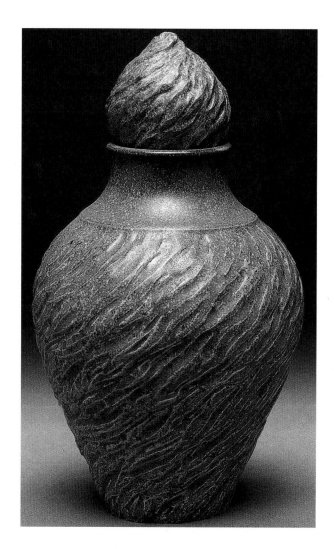

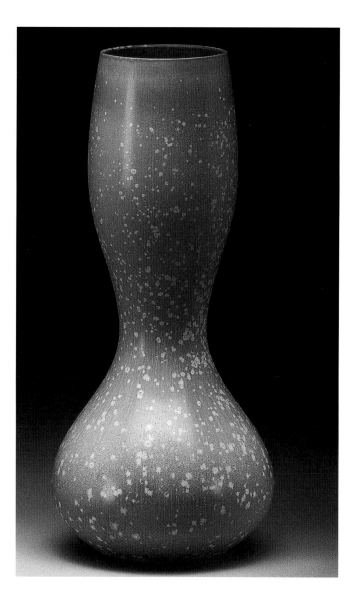

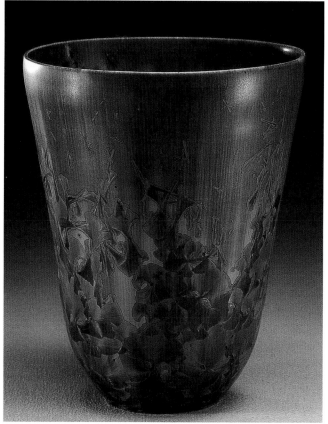

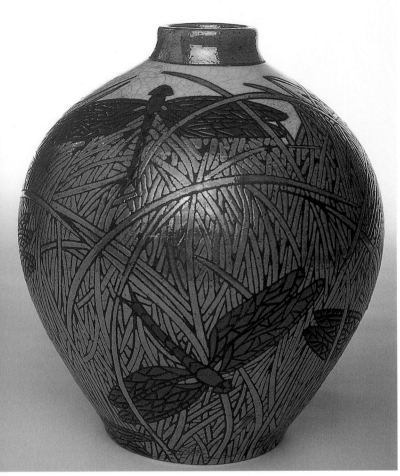

Left: **Laurie Sylwester, *Dragonflies on the Tuolumne River***

1996, 10" x 9" x 9" (25 x 23 x 23 cm). Wheel thrown; masking tape resist, low-fire commercial glazes; raku fired, cone 06, reduced in pine needles. Photo by Ed Doell

Bottom left: **Stephen C. Martin, *Ramone's World***

1997, height: 13" (33 cm). Wheel thrown; burnished; bisque fired, cone 018; pit fired with Keawe wood and driftwood; a dash of copper carbonate thrown in the pot at peak temperature. Photo by Macario

Bottom right: **Karl McDade, *Beaked Oinochoa***

1997, height: 22" (56 cm). Wheel thrown, with slip-cast elements; saggar fired, cone 10-13, with sawdust, cow dung, copper, Portland cement, salt, and other materials. Photo by Chris Autio

This series uses ancient Greek forms combined with cast contemporary industrial objects. Their character is a result of the various events to which each piece has been exposed, including throwing, building, firing, and sandblasting. Each of these events is performed forcefully, with the intent that the pieces that survive will take on the character of ancient objects.

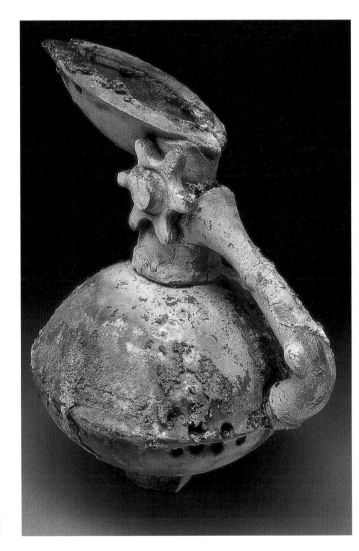

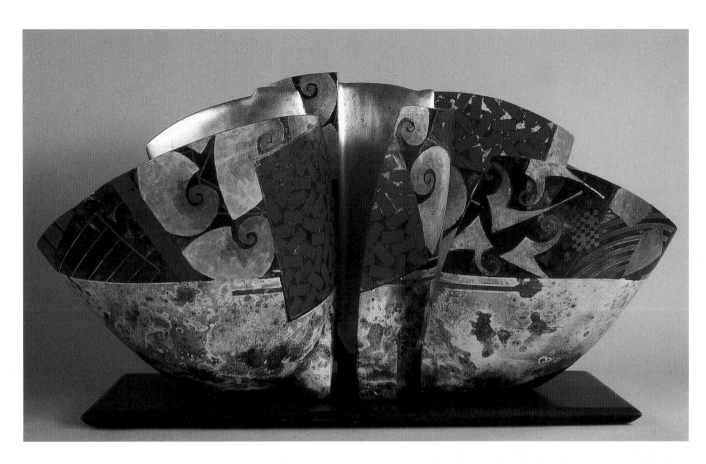

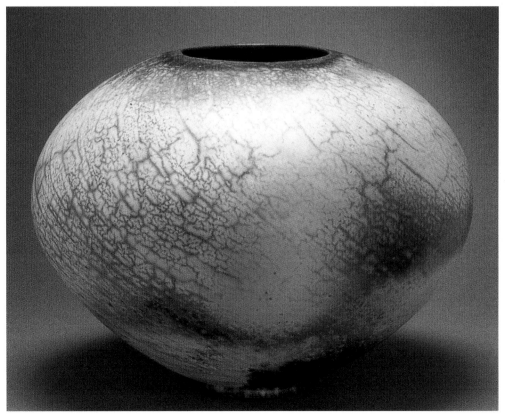

Above: **Bennett Bean, Vessel: "Triptych" series**

1997, 15½" x 29" x 15" (39 x 74 x 38 cm). Wheel-thrown and altered earthenware; tape resist, glazed, painted, gold-leafed interior; bisqued and pit fired

Right: **Jim and Susan Whalen, *Number 31***

1996, 11" x 14" x 14" (28 x 36 x 36 cm). Wheel thrown; burnished; covered with resist slip; sawdust fired

We are drawn to the primitive, mysterious act of creativity— and wish to strip away all the trappings of the modern world and return to the basic elements of fire, earth, water, and air. Our pots are unglazed; their beauty lies in our lack of control of the dark and dramatic markings the fire creates.

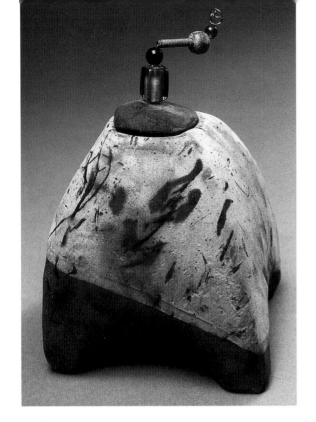

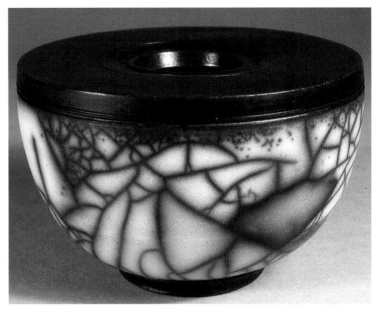

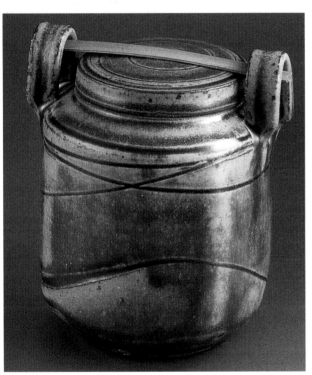

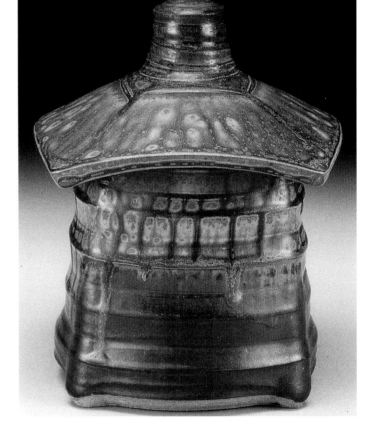

Top left: **Patricia L. Hankins, *Flames—a Box for Secrets***

1996, 4" x 2" x 2" (10 x 5 x 5 cm). Wheel thrown as small closed form, altered into box shape; legs cut into base, small lid cut into top; box dipped into alkaline glaze; raku fired

Bottom left: **Ronald Larsen, *Tea Caddy***

1994, 5" x 4½" x 3¾" (13 x 11 x 9.5 cm). Wheel-thrown and altered stoneware; ash-like copper green glaze; reduction fired, cone 10. Photo by North-South Photography

I make pots for use rather than contemplation—pots meant to serve and give pleasure in the intimate rituals of everyday life.

Top right: **Michael Sheba, *"Sipapu" Vessel***

1997, 3" x 4½" x 4½" (8 x 11 x 11 cm). Wheel thrown and burnished; special slip applied and peeled off vessel after firing to reveal shadow crackle imprint on the surface of the burnished clay; raku fired, with post-firing reduction, cone 06. Photo by artist

Bottom right: **Ellen Shankin, *Pagoda Jar***

1997, height: 9" (25 cm). Wheel-thrown, squared, and rippled stoneware; fake ash glaze; fired to cone 9. Photo by Tim Barnwell

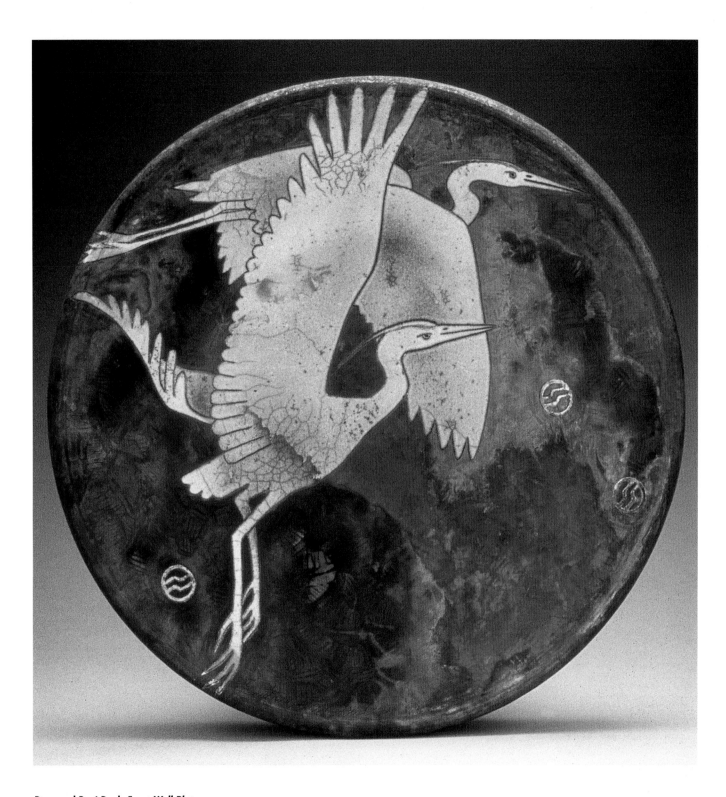

Dave and Boni Deal, *Egret Wall Plate*

1996, 23" x 23" x 4" (58 x 58 x 10 cm). Wheel thrown; drawn with pencil in the clay, brush-textured matt stain, sprayed copper and clear crackle glazes, brushed and sprayed oxide colorants; raku fired to 1850°F (1010°C). Photo by Bill Bachhuber

This piece was influenced by our Pacific Northwest home environment and enhanced by flame play on the stained surface during the reduction process. Our technique goes like this: We design together, Dave throws, Boni draws, both stain and glaze, and Dave raku fires.

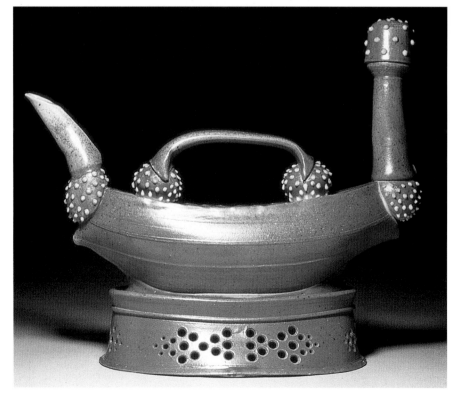

Above: **Robert Bede Clarke,** *Eyelash of Morning (After Vallejo)*

1997, 7" x 17" x 17" (18 x 43 x 43 cm). Wheel-thrown white earthenware; mason stains mixed with white slip applied to greenware, dark stain ribbed into lines after bisque firing, light coat of frit used to develop a sheen, terra sigillata on body of pot; oxidation bisque fired; glaze fired in electric kiln, cone 03

This work is inspired by poets and poetry I've been reading. I'm especially fond of the poets who seem to be in touch with the conditions of ecstatic life—the Spanish language poets Vallejo and Machado; the Sufi poets Kabir, Rumi, and Mirabi; and Rilke and Dante. Rather than trying to illustrate the poems, I simply try to respond authentically to the way in which they move me.

Left: **Skeff Thomas,** *Iron Teapot*

1997, 12" x 14" x 6" (30.5 x 36 x 15 cm). Wheel thrown and altered; wood and soda fired, cone 10

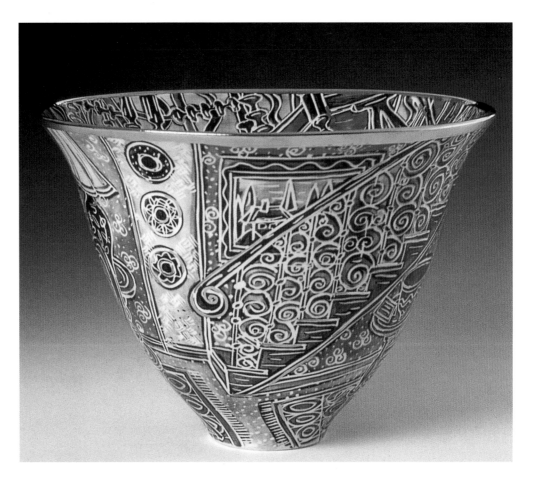

Right: **Ljubov Seidl, *Upstairs, Downstairs***

1997, height: approx. 9½" (24 cm). Wheel-thrown porcelaneous stoneware; underglazes, sgraffito, clear glaze, gold trims and outlines; fired to 1200°C (2192°F)

Below: **Michael Vatalaro, *Reconstructed Vessel***

1997, 8" x 24" x 24" (20 x 61 x 61 cm). Wheel-thrown and altered stoneware forms, cut and assembled when leather hard; bisque fired; sprayed glaze; reduction fired in gas kiln, cone 10

My work is generated from the act of throwing and then directed by my interest in the situation or state of mind I am in at the time. This work is about a reconstruction of self and self-image—a restructuring of "center."

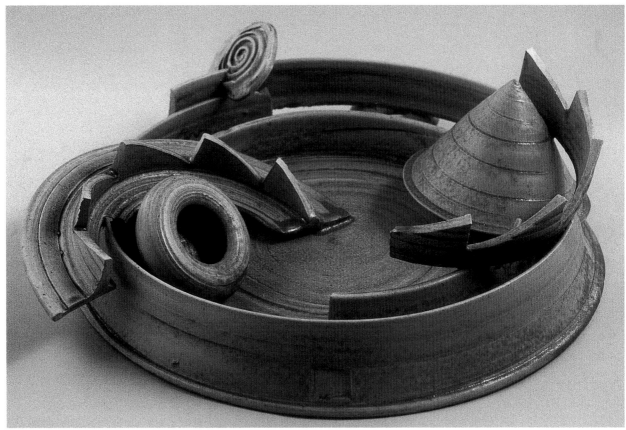

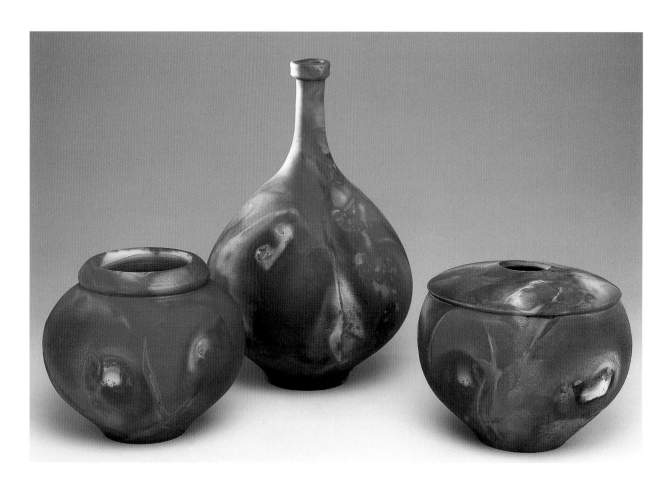

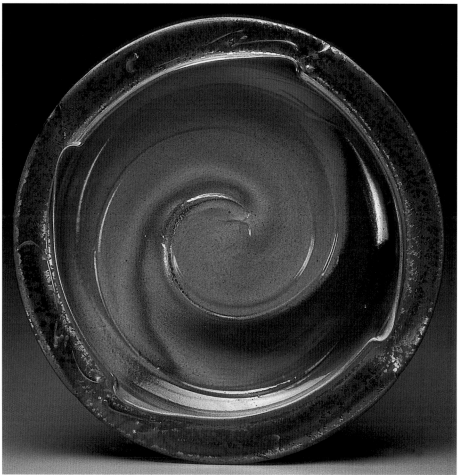

Above: **Billie Powell,** *Smoke Fired Pots*

1996, bottle height: 11¾" (30 cm). Wheel thrown; bisque fired; sawdust fired in pit kiln to approximately 1000°C (1832°F). Photo by Uffe Schulze, Concept Photographics

Left: **Steven Hill,** *Platter*

1997, 3" x 20" x 20" (8 x 51 x 51 cm). Wheel thrown and altered; brushed slip spiral, multiple sprayed glazes; once-fired stoneware (reduction), gas kiln, cone 10. Photo by Al Surratt

This has been a time of tremendous growth for me, having drawn inspiration from a recent trip to Italy. It wasn't the majolica pottery that Italy is famous for, but the colors and textures of Tuscany that spoke to me. The weatherworn painted wood and stucco surfaces, which highlight architectural form by stripping away surface embellishment, have found their way into my pottery.

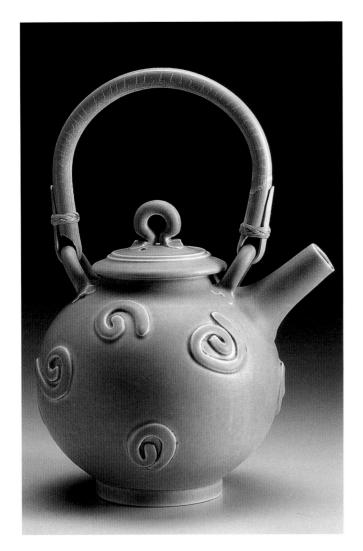

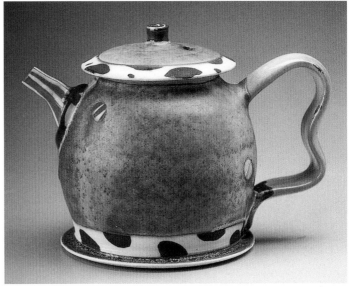

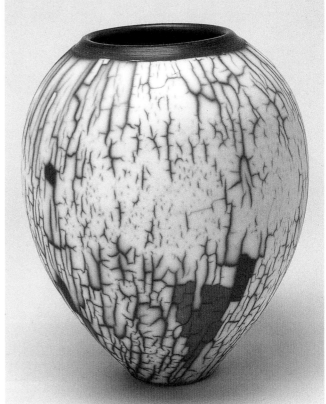

Above: **Bonnie K. Morgan,** *Teapot*

1997, 12" x 7" x 7" (30.5 x 18 x 18 cm). Wheel-thrown porcelain, with extruded clay coils; paddled surface, sprayed glaze; fired in electric kiln, cone 5. Photo by Robert Jaffe

I like form: simple and strong.

Top right: **Lynn Smiser Bowers,** *Tiny Teapot with Orange Spout*

1997, 5" x 7" x 4" (13 x 18 x 10 cm). Wheel-thrown porcelain clay body, spout, and lid; handle pulled, altered, and attached; oxide stains and reduction glazes; resist methods: wax, latex, and paper stencils; reduction fired in brick gas kiln, cone 10. Photo by E. G. Schempf

Bottom right: **Eileen Wong,** *Untitled*

1997, height: 7½" (19 cm). Wheel-thrown porcelain; terra sigillata on rim; bisque fired; dipped in "fall-away" slip; raku fired, cone 06; reduced in newspaper, submerged in water after firing. Photo by Douglas Prince

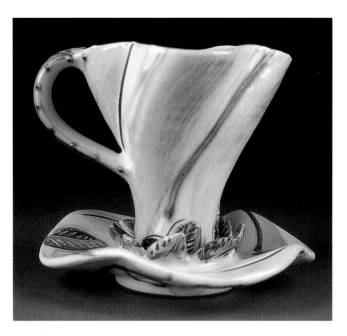

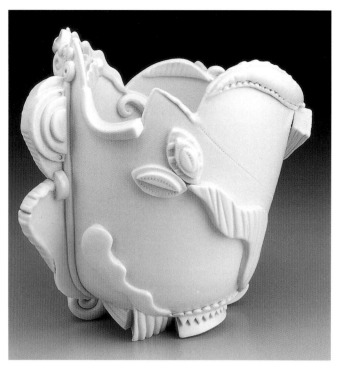

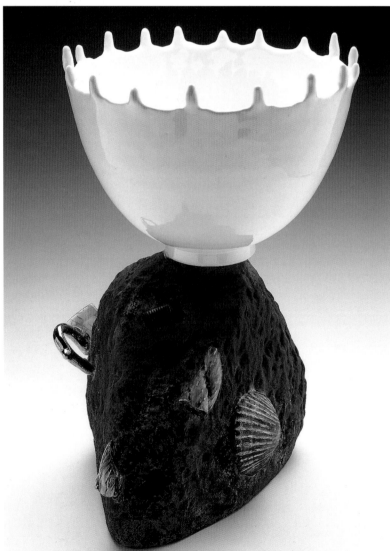

Above: **Barbara Chadwick, *Adagio***

1997, 9" x 7" x 6" (23 x 18 x 15 cm). Wheel-thrown and altered porcelain; clear satin matt glaze; fired in electric kiln, cone 8. Photo by Greg Kolanowski

Top left: **Lori Mills, *Cup and Saucer***

1996, 6½" x 6" x 6" (16.5 x 15 x 15 cm). Wheel-thrown terra-cotta, altered by paddling; colored slips, clear glaze; oxidation fired, cone 05-04

My work is a joining together of childhood recollections of backyard garden environments with the visual and physical language of pottery. The work is inspired by my memories of discovery, the generosity of nature's spirit, and the youthful emotions of wonder and delight.

Left: **Keiko Fukazawa, *Gift from the Sea III***

1996, 11" x 9" x 9" (28 x 23 x 23 cm). Stack-thrown earthenware bowl with turned bottom and handbuilt base; bowl set upside down to create dripped slip effect, then joined to base; base textured with rock and slipcast objects; bisque fired, cone 08; glaze fired, cone 06; luster fired, cone 018. Photo by Anthony Cuñha

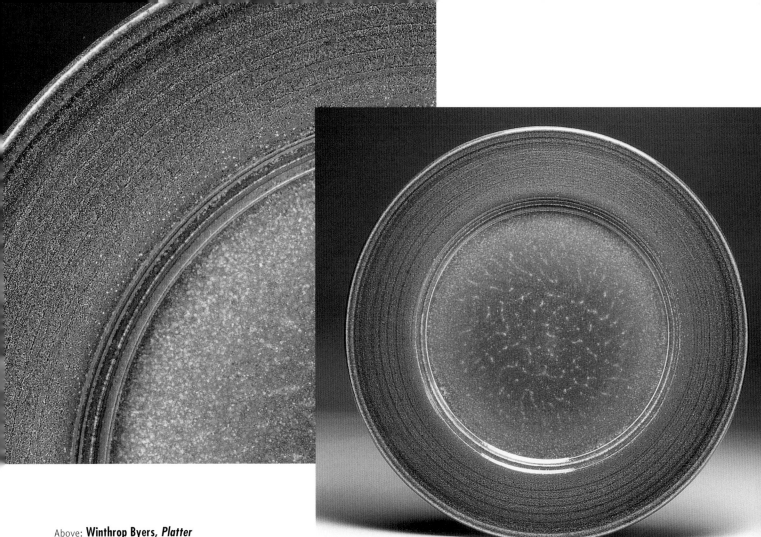

Above: Winthrop Byers, *Platter*

1996, diameter: 17" (43 cm). Wheel-thrown and trimmed stoneware; bisque fired; sprayed glazes on back and rim, center scraped and sponged clean, center glaze sprayed, crawl lines hand-rubbed; oxidation fired in gas kiln, cone 08; reduction fired, cone 11. Photo by Sandra Byers

Right: Ginny Marsh, *Garden Basin*

1995, diameter: 18" (46 cm). Wheel-thrown uncentered clay; trimmed; rim stained, interior glazed; reduction fired in gas kiln, cone 9. Photo by artist

We Americans have long been ambivalent about our surroundings. Though the ancient metaphor of the garden accompanied immigrants from the Old World to the New, we still struggle to know whether we view it as a pristine source or terrifying wilderness. We do not know whether to conquer it or leave it alone, and we are confused about the boundaries between pollution and tending, or neglect and control. While for the most part, technology and the pastoral ideal have been for us a recurrent metaphor of contradiction, it seems to me that these clay pots we make one at a time may be tokens of a possibility of reconciliation.

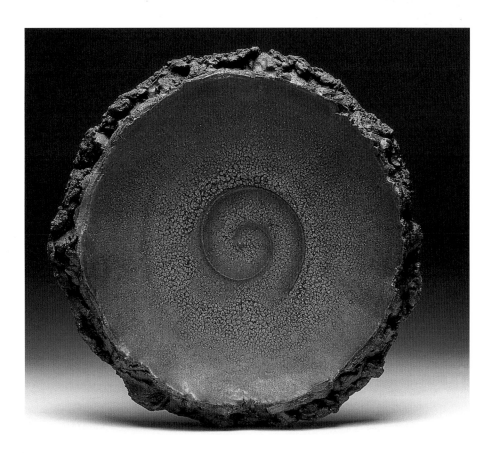

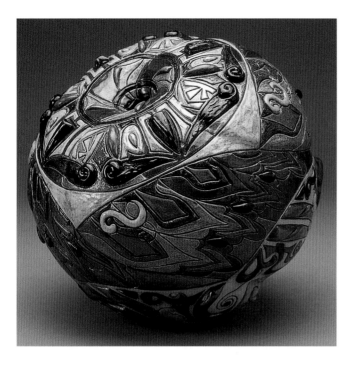

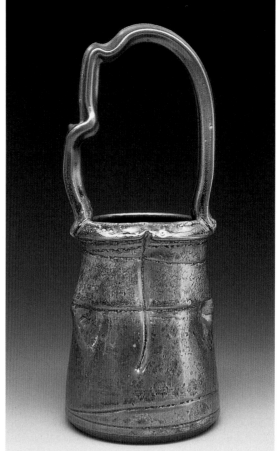

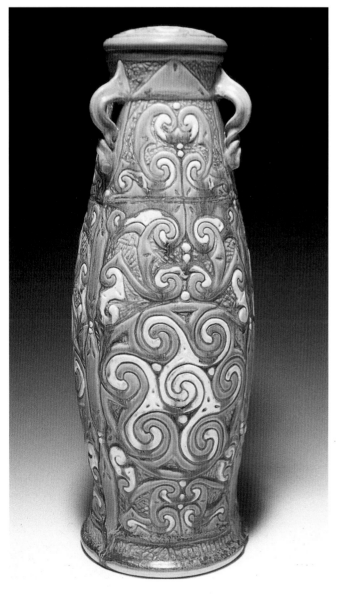

Above: **Brian McCarthy, *Basket***

1997, 10" x 4" x 4" (25 x 10 x 10 cm). Wheel thrown, with pulled handle; shino glaze; reduction fired, gas kiln, cone 10. Photo by Neil Pickett

Top left: **Kristen A. Kieffer, *Altered Mandala Pot (Calligraphic Karma)***

1997, diameter: 10" (25 cm). Wheel thrown in multiple sections, upside down—top shoulder to wheel head and top (or bottom of pot) closed off; turned right side up when leather hard, trimmed, and altered; incised and raised patterns, brushed vitreous slips and flashing slip; reduction fired, cone 10, in soda vapor and rock-salt atmosphere

The mandala pots I make incorporate my love for symbolism, pattern, and spiritual tradition. The radial motif of each pot is not simply decoration. It is an important part of the whole—a skin of concentric configuration synthesized with the form, a patterned layer stretching and softening each shape within the mandala, creating illusion and variation from different viewing angles. The pattern shapes I use with the mandalas are primarily my own developed and evolved symbology, with influences from a variety of rituals, religions, and nationalities.

Left: **Lisa Ernst Harpole, *Heaven and Earth***

1997, height: 16½" (42 cm). Wheel-thrown porcelain; deeply carved Celtic meanders, from ninth/tenth/eleventh century stone carving and from *The Pictish School Book of Kells* (sixth, seventh, eighth centuries); reduction fired, cone 10. Photo by artist

We are beings with inner and outer selves, woven into one whole essential fabric. When I carve a large urn with these ancient images, it expresses tangibly that unseen aspect of our human selves. It is my intention to stimulate the process by which we sense our connection to the whole.

Above: **Hiroshi Nakayama, *Ceremonial Vessel***

1996, 3½" x 12" x 12" (9 x 30.5 x 30.5 cm).
High-fire stoneware, wheel thrown in two
pieces, altered, and carved; wood-ash base
glazes; multiple reduction firings, cone 10

*The special color and texture come from the
glazes that I developed. The glaze has the
appearance and feel of polished stone. The
specks of colors—grey, gold, rust, and
cream—develop during the firing. The surface
is so integrated with the clay form that they
appear to be made out of one solid material.*

Right: **Judy Glasser, *Ceramic Lamp***

1996, diameter: 14" (36 cm). Wheel-
thrown and assembled forms; scraped and
burnished surface, stained with oxides;
reduction fired, cone 9. Photo by George Erml

*Achieving gracefulness is what motivates me
and directs the style of my work. I develop
techniques to fit how I like to work. I enjoy
working with the clay in the prefired stages,
not at the glazing end. I work on the form
and design as thoroughly as possible before
the bisque and then apply a light, quick
wash of stains and slips before the second
firing. I also want the glazed surface to sink
into the clay rather than sit on it. This gives
the feeling of the beautiful leather-hard
stage of the clay.*

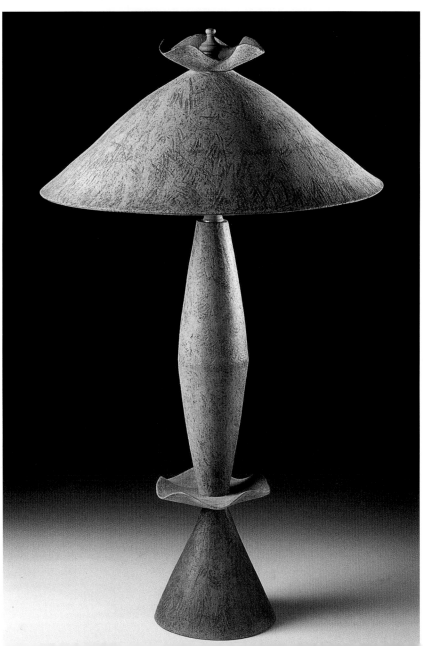

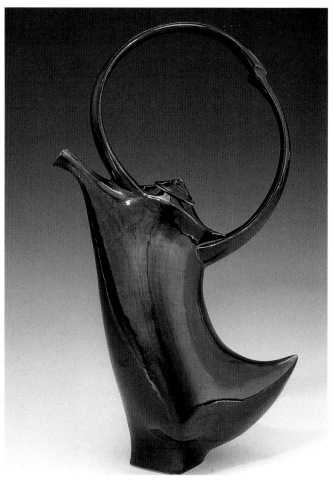

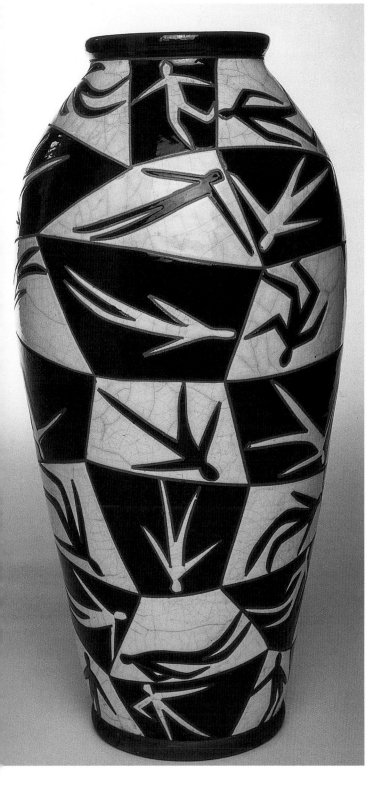

Above: **Susan Filley**, *As A Bird: "Dancing Teapot" series*

1996, 12" x 8" x 5" (30.5 x 20 x 13 cm). Wheel-thrown porcelain; cylinder, lid, shoulder, and spout thrown separately; cylinder altered and attached to slab base, other parts attached; sculpted with Surform tool, smoothed, and two-part pulled handle attached; sprayed, layered glazes; fired in gas kiln, cone 10, light reduction. Photo by artist

In my work, I create a playful sense of elegance that is both distinctive and very personal. My "Dancing Teapots" are very animated thrown and altered porcelain forms. They draw the viewer in with their attitudinal stance, yet they still remain teapots. The intrinsic beauty of porcelain works well with my affinity toward elegant design. Together, they are used to create a sense of delight and intimacy in my work.

Left: **Laurie Sylwester**, *Falling Man*

1996, 19" x 9" x 9" (48 x 23 x 23 cm). Wheel thrown; masking-tape resist, low-fire commercial glazes; raku fired, cone 06, reduced in pine needles. Photo by Ed Doell

The image—falling man—first reminded me of some 1950s curtains of oak leaves. The people images are in various stages of floating, like leaves drifting in the fall. A lot of the images are the way I remember flying in my dreams—passive and peaceful. The name is sort of a joke, which I expanded on during a slide lecture, just for laughs. The complete title of this piece is Falling Man, Ascending Woman. *You decide.*

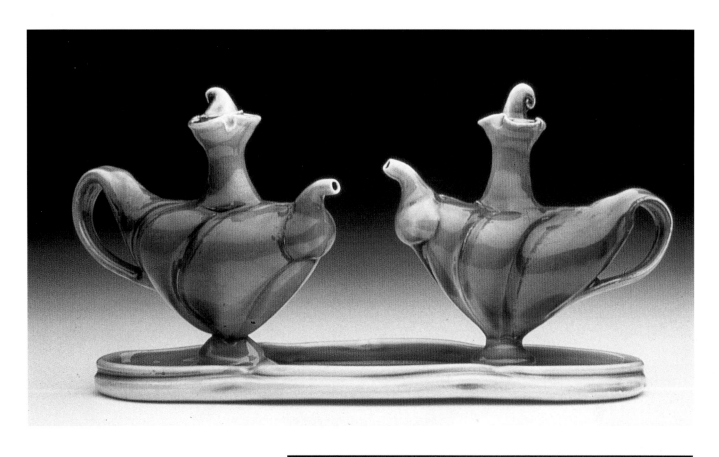

Above: **Leah Leitson,** *Dark Green Lobed*
Cruets & Tray

1996, each: 6" x 5" x 3½" (15 x 13 x 9 cm).
Wheel-thrown and altered porcelain; salt
fired, cone 10

Functional handmade pottery as art transcends
the purely utilitarian, and is a form of art that is
integrated into our daily lives. My forms are pre-
dominantly inspired by the eighteenth- and nine-
teenth-century decorative arts, particularly utili-
tarian silver tableware and Sevres porcelain. I am
further inspired by plant forms. My intent is to
integrate the two so that they become one.

Right: **Robert Moore,** *Tureen*

1997, 18" x 16" x 14" (46 x 41 x 36 cm).
Wheel thrown, altered, and assembled; copper
bearing glaze; salt-fired stoneware, cone 10.
Photo by Boomer

Ceramics to me is a game without rules. It is an
endless journey of building and playing.

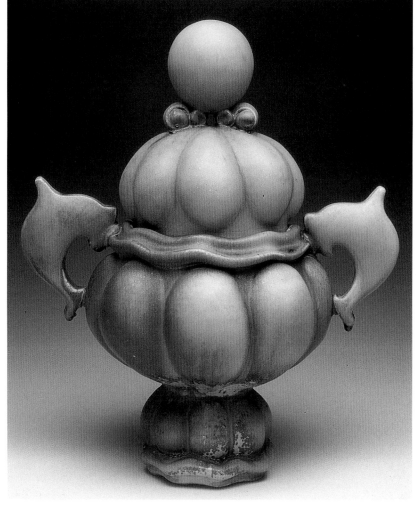

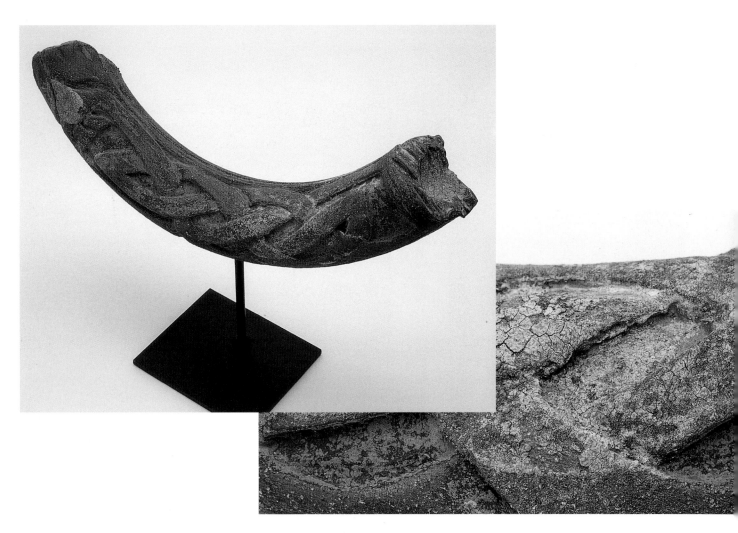

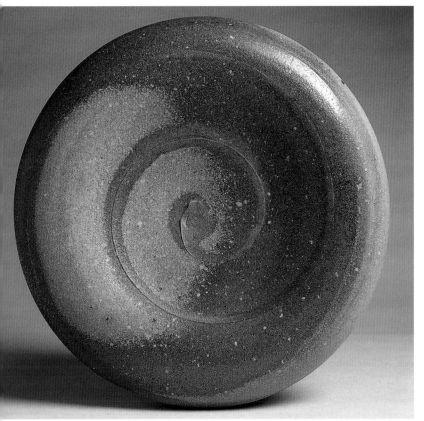

Above: **Stephen O'Leary, *Quarter Shard***

1997, length: 15" (38 cm). Wheel thrown, cut, hand carved; copper and manganese dry glaze; reduction fired, cone 6. Photo by Terence Bogue

My work is reflective not only of my own Irish heritage, but also of that of the Western Districts of Victoria, Australia. The broken "shards" bear relevance to today's need to investigate our past and display it with iconographic symbolism.

Left: **Robert Sanderson, *Pillow Dish***

1996, diameter: 13" (33 cm). Wheel thrown; white slip applied immediately after throwing and wiped off to leave spiral shape; wood fired in a "Bourry Box" type kiln, cone 11 flat after 24-hour firing. Photo by John McKenzie

In my work, I now seek to take advantage of the intrinsic qualities achievable in my wood-fired kiln. The contrast of "light" and "dark" may be translated into exposed/protected, oxidized/reduced, in a way that helps to describe the form and in doing so, captures the softness of the freshly thrown piece.

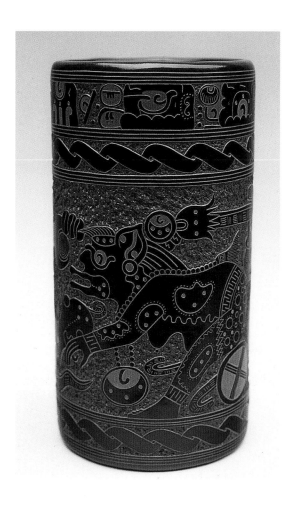

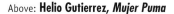

Above: **Helio Gutierrez, *Mujer Puma***

1997, height: 8½" (22 cm). Wheel thrown in one piece; incised, carved, and textured; oxide applied to greenware, then burnished; once-fired in wood kiln, cone 08

I look to break through my Mayan traditional pre-Colombian style in search of a style I can call my own. My imagery comes from my culture and nature.

Right: **Lisa Tevia-Clark, *Mnemosyne's Vessel***

1997, 23" x 8" x 6" (58 x 20 x 15 cm). Wheel-thrown porcelain, with attached wheel-thrown arch and ornaments; impressed relief decoration, sprigged medallions, ash glaze, incidental high-fire copper luster; reduction fired, cone 10-11. Photo by James Tevia-Clark

I love the spring of circular motion and energy, the synthesis of clay, alchemy, fire, and my being which brings a pot to life. In my work, I explore relationships between mind and material, intent and occurrence, spirit and hands.

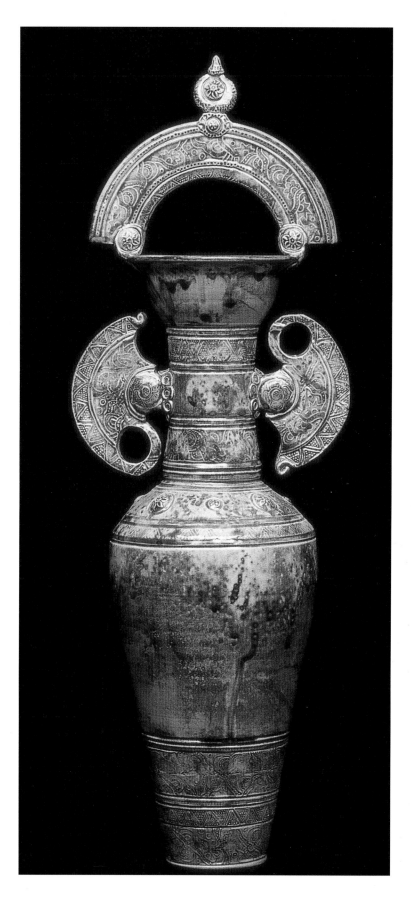

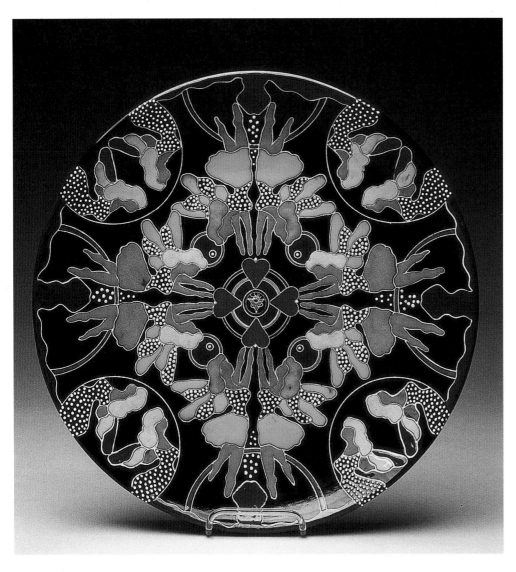

Left: **Linda Arndt, _Kaleidoscope for David_**

1997, diameter: 25" (63.5 cm). Wheel thrown, slipped, carved when leather hard; underglazes, glazes, and engobes; multiple firings in electric kiln, cone 010-04. Photo by Serina Landis

Below: **Donna Anderegg, _Sugar Jars_**

1997, height of each: 6" (15 cm). Wheel thrown; slips applied when bone dry; salt fired, cone 9-10. Photo by artist

I was initially drawn to traditional Japanese and Korean pottery and studied with a Japanese family of potters for several months after acquiring my B.F.A degree. While the rigid schedule and the technical training were extremely valuable, I found that mere production without creative input was not very gratifying. I strive to make work that is personal, visually pleasing, warm, and a bit playful. It is a challenge to create work that incorporates elements of function, form, and decoration. To end up with a piece that I or someone else will truly enjoy using is very satisfying.

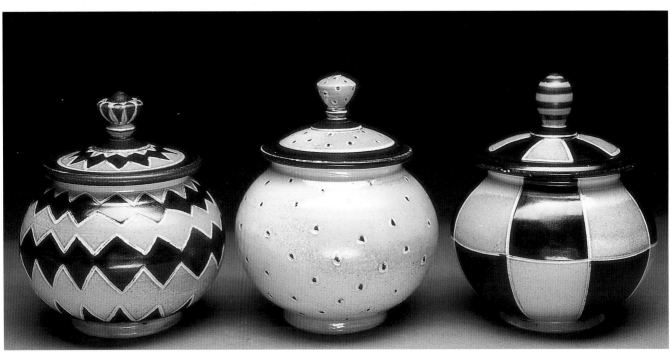

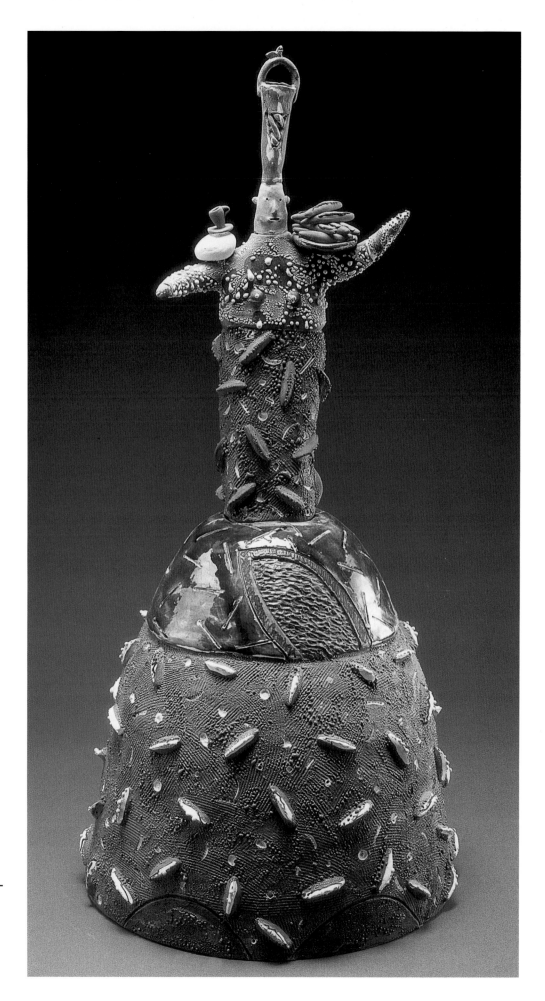

Don McCance, *Sterility Figure*
1997, height: 27" (66 cm).
Red earthenware; wheel-
thrown bottom and hand-
built figure; texture glaze,
sprigging, engobes; fired in
electric kiln, cone 04-06

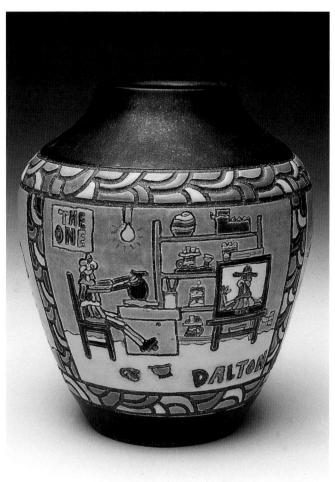

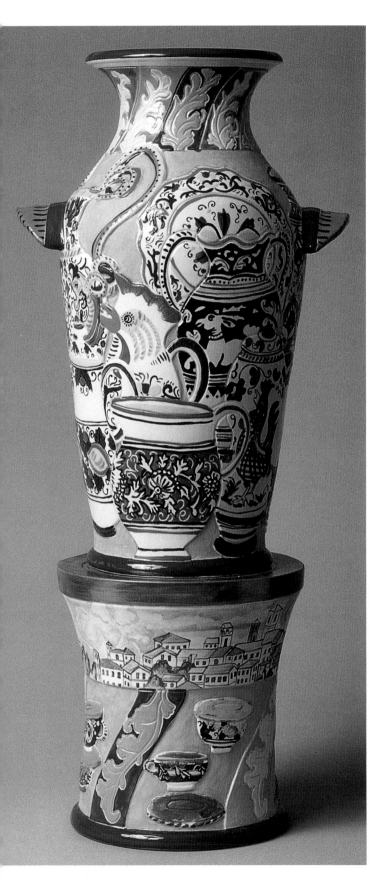

Above: **Norris Dalton, *Pictorial Vase: Late Night***

1997, 7¼" x 6¼" x 7⅛" (18.5 x 16 x 18 cm). Wheel-thrown mid-range stoneware; sgraffito, brushed glazes with stains; oxidation fired, cone 5. Photo by Dan Wickliff

I've drawn in this style for many years, mostly in sketchbooks and on various types of papers. The drawings were done in quiet solitary moments and were a source of intense enjoyment. During most of that period, I did intricate, handbuilt pots in porcelain, fired in cone 10 reduction. Then, several years ago, I returned to the potter's wheel and shortly thereafter became involved with cone 5 glazes and stains. I became fascinated with the idea of finally doing the drawings on the wheel-thrown pots, utilizing the bright colors of the cone 5 range. That fascination has continued to this day.

Left: **Karen Koblitz, *Santa Caterina of Deruta***

1997, 24¾" x 8½" x 8½" (63 x 22 x 22 cm). Wheel thrown and carved; underglaze, glaze, and luster; bisque fired, cone 04; glaze fired, cone 06; luster fired, cone 017. Photo by Susan Einstein

This piece pays homage to the city of Deruta, Italy, which has had a continuous ceramics tradition since the Renaissance and where I have designed functional pottery since 1990. St. Catherine was selected as the patron saint of the workers of Deruta because she was martyred on the wheel and potters use a wheel to throw on.

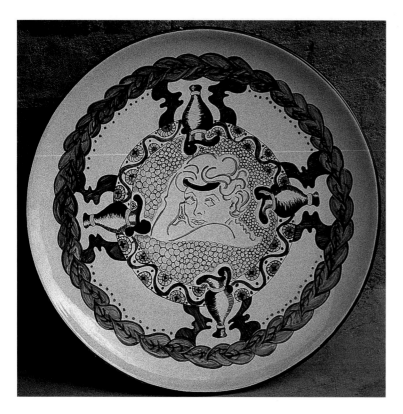

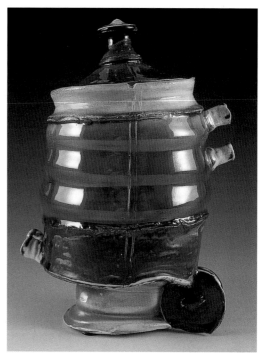

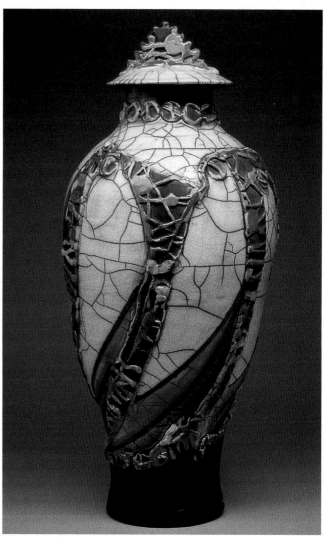

Above: **Rebecca L. Fraser, *Vite Clàssico (Made in Italy)***

1996, diameter: 20¾" (53 cm). Wheel-thrown red earthenware; hand-brushed Maioliche glazes; bisque fired at 990°C (1814°F); glaze fired at 920°C (1688°F)

My work, in which free-flowing forms compete with classical motifs, is anthropomorphic and whimsical. The inspiration for this piece, which I made in Deruta, Italy, was drawn from my residency at the seventeenth-century ceramic factory, Grazia Maioliche Artistiche. The classic designs I observed there, prescribed over the centuries, mixed with my immersion in the joy and spontaneity of contemporary Italian life.

Top right: **John Britt, *Little Green Jar***

1997, 9" x 7" x 6" (23 x 18 x 15 cm). Wheel thrown, altered, cut, and assembled; slip, ash glaze, and green glaze; soda fired, cone 10. Photo by artist

I work as William Burroughs did with the "cut up" method, trying to break through the tyranny of linear thought to find the meaning of meaninglessness.

Right: **Barbara Newell, *Jar with Lid***

1997, 20½" x 9½" x 9½" (52 x 24 x 24 cm). White stoneware; wheel thrown in sections, assembled; clay slab impressed with carved woodblock and cut into various shapes to fit vessel; low-fire polychrome glazes and underglazes, white crackle; bisque fired, cone 06; reduction glaze/raku fired, cone 06

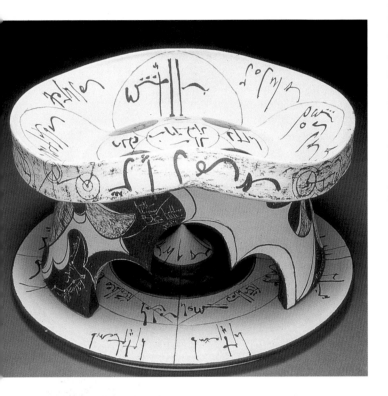

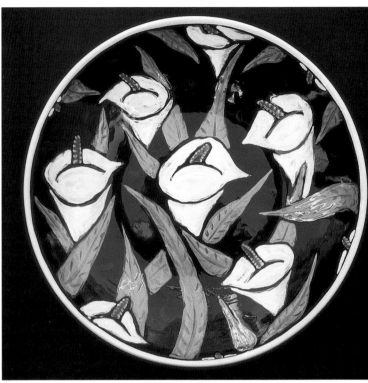

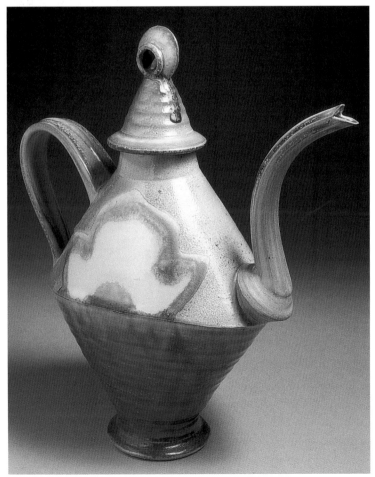

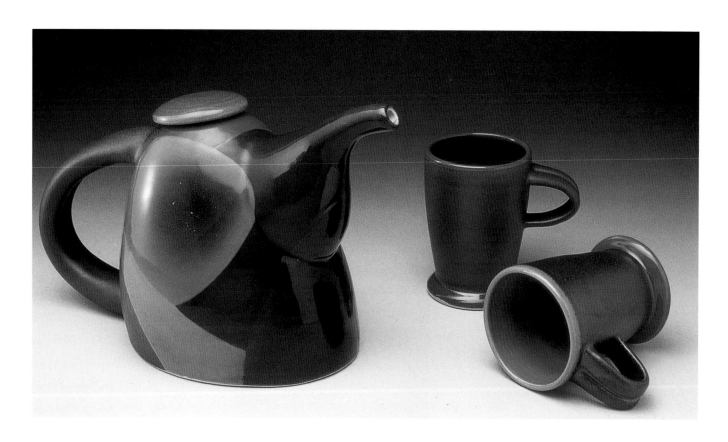

Above: **Chris Simoncelli,** *Teapot & Cups*

1995, teapot: 7" x 10" x 6" (18 x 25 x 15 cm). Wheel-thrown and assembled parts; painted glaze; oxidation fired in electric kiln, cone 6. Photo by Bart Kasten

My pots serve people's daily needs, both artistic and utilitarian. Aesthetically, my repertoire of forms is influenced by the directness of contemporary design, and the presence and strength of Minoan, Greek, and Chinese pottery. The shapes painted on the surfaces are derived from the same repertoire.

Right: **Stephen Fabrico,** *Spiral Bowl*

1997, 5" x 16" x 16" (13 x 41 x 41 cm). Wheel-thrown porcelain; bowl thrown in two stages, first to round shape and then, after setting up, rethrown and refined; carved, sprayed glazes, sandblasted after glaze firing; reduction fired in gas kiln, cone 10. Photo by Ralph Gabriner

This current body of work involves carving the surfaces when the clay is leather hard. This is my favorite part of working with clay. I love it when it's wet; after that, it turns into work.

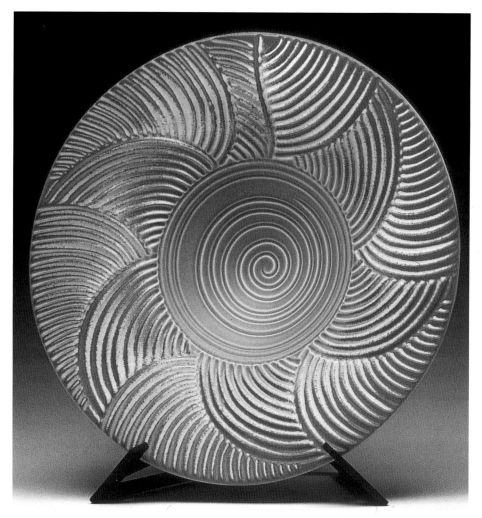

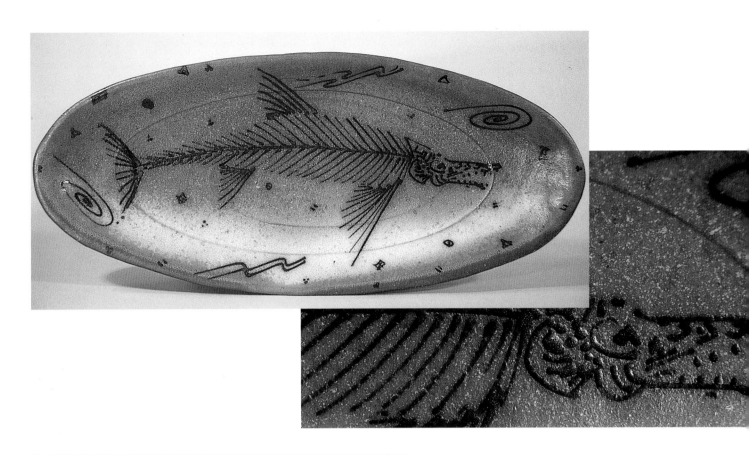

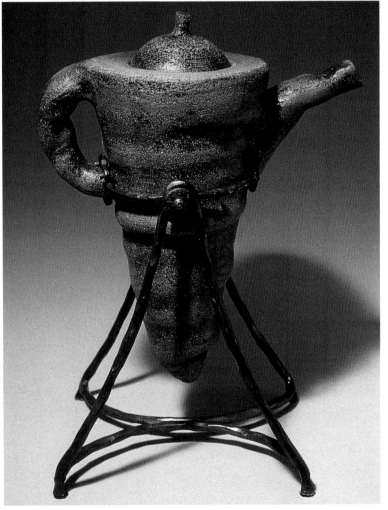

Above: Roger Jamison, *Night Fish Platter*

1997, 8" x 22" x 2½" (20 x 56 x 6 cm). Wheel-thrown, altered, and assembled stoneware; kaolin slip, trailed glaze; wood fired, salt glazed, cone 9

Left: Pascale Girardin, *Teapot*

1996, height: 12" (30.5 cm). Wheel-thrown red earthenware; vitreous engobe; once-fired in electric kiln, cone 02. Base by blacksmith Kelly Backs; photo by Paul Litherland

I like functional pieces that have a sculptural aspect. I enjoy taking traditional pieces such as teapots and lamp bases and taking them out of their usual context. I exaggerate proportions, shapes, sizes—everything and anything! I like things that move and sway. Overall, I like to have fun with clay, but to keep it useful!

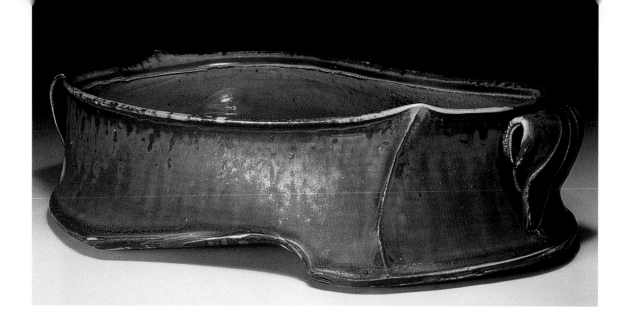

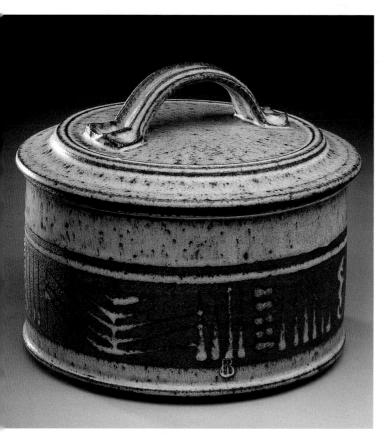

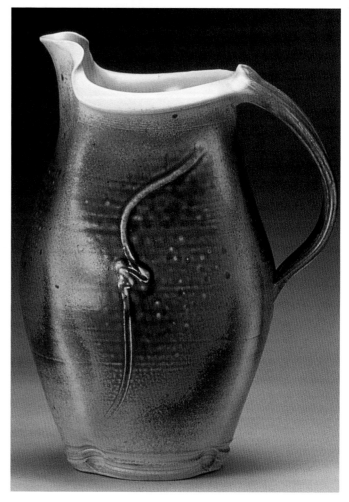

Top: **Andy Shaw, *Serving Dish***

1997, 3½" x 8" x 12" (9 x 20 x 30.5 cm). Stoneware; wheel thrown in two parts: a twice-faceted cylinder without a bottom, altered into kidney-bean shape after clay has set up; and a wheel-thrown bottom portion stretched into a slab and added; black metallic glaze and sprayed slip on exterior, sprayed glaze on interior; soda fired, cone 10-12

Bottom left: **Bruce C. Bangert, *Casserole***

1996, height: 7" (18 cm). Wheel-thrown body, pulled handle; trailed glaze, wax resist; reduction fired in gas kiln, cone 10

Above: **Charles Tefft, *Pitcher***

1997, 10¼" x 5¼" x 4¾" (26 x 13 x 12 cm). Wheel-thrown white stoneware, altered while wet on the wheel by squaring with wooden tool; pulled spout and handle; trailed porcelain slip down sides, sprayed spodumene and ash glazes on exterior; reduction fired in gas kiln, cone 10. Photo by Fabio Camara

With the use of altering, I have tried to create as much movement and tension in each piece as possible. I continue the process by spraying ash glazes on the pots; these take on lives of their own in the kiln, sometimes pooling and sometimes running.

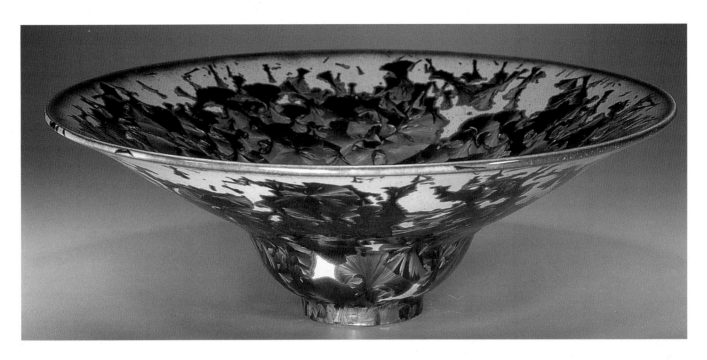

Above: Adriana Pazmany Thomas, *Untitled*

1996, 4½" x 13¼" x 13¼" (11 x 34 x 34 cm). Wheel-thrown porcelain; crystalline glazed; oxidation fired in electric kiln, cone 10, soaked for three hours; chiseled and then bottom ground. Photo by Steve Gyurina

I have been working with crystalline glazes for ten years. The crystals form when the glaze, supersaturated in various oxides, is fired to a high temperature and held there for several hours. Because of the extreme fluidity of the glaze, each pot must be fired on a pedestal and saucer to catch the excess glaze as it runs down the sides. After firing, the pedestal is chipped off with a chisel and the foot of the pot ground down to smoothness. Despite the exactness of the firing process, there is always a wonderful unexpectedness to the finished pot, each pot achieving a crystal pattern that cannot be duplicated.

Right: Anne Fallis Elliott, *Tall Ash Teapot*

1996, 7" x 12½" x 3" (18 x 32 x 8 cm). Wheel thrown, altered, and assembled, with pulled handle; ash glaze; fired in electric kiln, cone 6. Photo by Kevin Noble

Pots have become a major part of my life. I collect pots, show pots, write about pots, and often stay connected with friends because of pots, and best of all, I make pots. The shapes I use have been evolving over years and years. I'm more interested than ever in how they change. Pots have also become a major source of livelihood for me. I feel very lucky that this is the case.

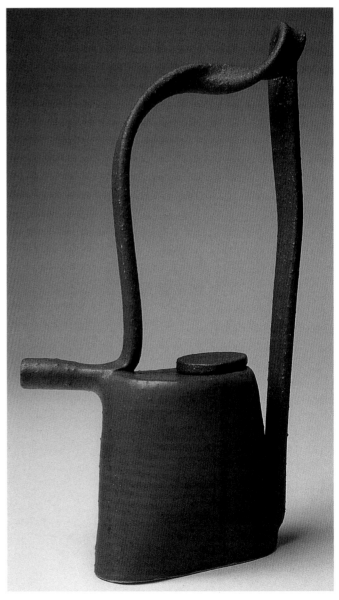

Right: Posey Bacopoulos, *Square Teapot*

1997, 7" x 8" x 4" (18 x 20 x 10 cm).
Terra-cotta; wheel-thrown body pad-
dled square, collar and lid thrown
separately, collar attached; majolica
and stains; fired in electric kiln, cone
04. Photo by D. James Dee

**Below: John W. Hopkins, *T—Rowing the
Great Wave***

1996, 32" x 32" x 6" (81 x 81 x 15
cm). Wheel-thrown earthenware,
sandblasted; bisque fired, cone 06;
underglaze; fired, cone 05; clear
glaze; fired, cone 04; image taped,
surface sandblasted, china paints;
fired, cone 019; re-taped, sandblast-
ed, more china paints; fired, cone
020; all firings in electric kiln. Photo
by artist

*My latest series of wall plates has
evolved around Japanese imagery—
mostly Koi. I was invited to do a teapot
show during this series and decided not
to do a traditional teapot. I have
always admired the Great Wave of
Hokusai and wanted to use this image
someday. After studying the print, I
decided to change the boat to a teapot,
put oars in it, and bring it off the plate,
making it three dimensional.*

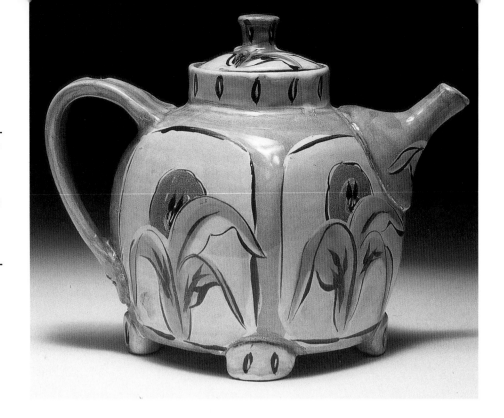

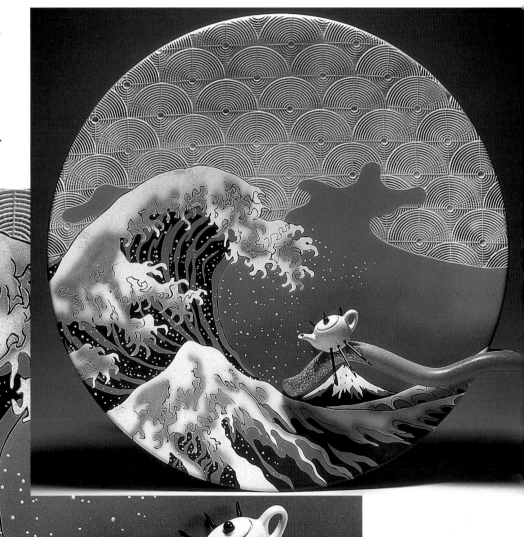

41

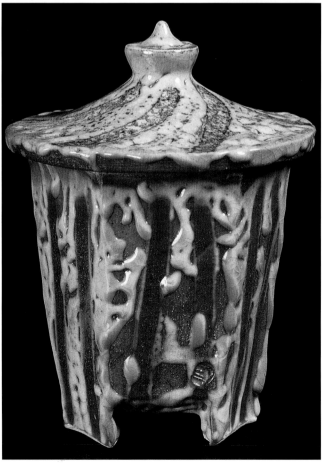

Above: **Mary Maxwell,** *Composition with White Squares*

1997, diameter: 15" (38 cm). Wheel-thrown white clay (wall hanging); torn masking-tape resist, airbrushed with underglazes and defined with underglaze pencils; fired in electric kiln from luster to cone 6; some of the squares and small pieces were made from torn clay and attached with epoxy

Up to this time, my entire life has been devoted to the search for and pursuit of the perfect pot. The remainder of this life will continue to allow me to do this, and only I will know when it happens.

Left: **Joseph Bruhin,** *Faceted Covered Jar*

1996, 7" x 5" x 5" (18 x 13 x 13 cm). Wheel thrown and faceted; shino glaze, finger wiped; wood fired, cone 10-12

I'm looking for the "Ju-Ju." I think you can find that with wood firing.

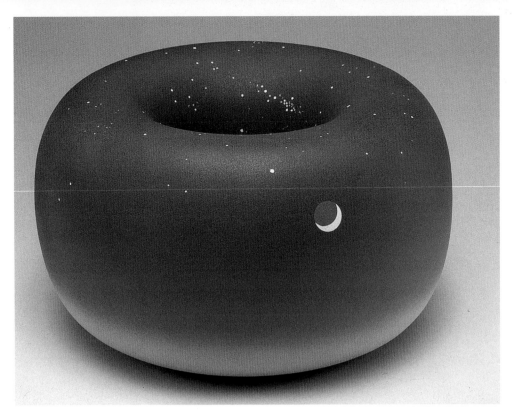

Above: **Don Jones, *Crescent Moon with Black Hole***

1997, 6½" x 12" x 12" (16.5 x 30.5 x 30.5 cm). White earthenware, wheel thrown in one piece; underglazes, clear overglaze; once-fired, cone 05. Photo by Damian Andrus

My work is inspired by the sky. My goal is to create a surrealistic object that has both a pure form and the illusion of an additional three-dimensional space.

Right: **Elaine F. Alt, *Princess Rachel***

1996, 14" x 14" x 8½" (36 x 36 x 22 cm). Wheel-thrown lid, body, and base; pulled and attached handle and spout; bisque fired, cone 06; velvet glazes over tape and wax resist, dots of glossy glaze; glaze fired, cone 01; dots of luster on glossy glaze dots; luster fired, cone 018. Photo by Tommy Olof Elder

I want my decorated vessels to convey the tension between whimsy and seriousness, between careful control and irreverence. I've learned from quilters and other folk artists how to integrate complex patterns and colors into a whole. I admire the way Venetian glassmakers blended elegance, delicacy, and humor into a single piece.

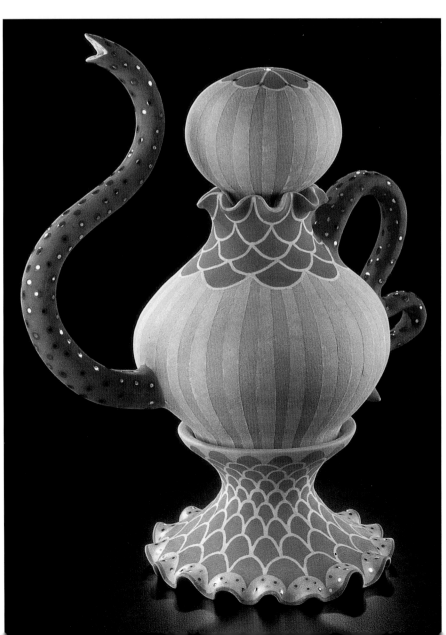

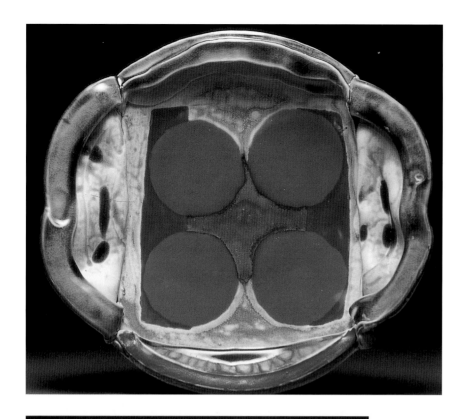

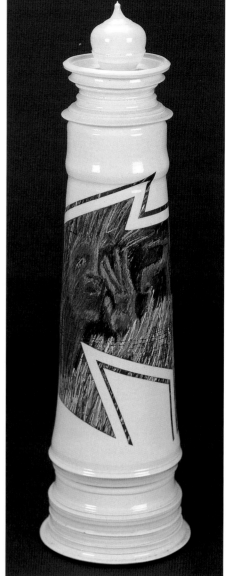

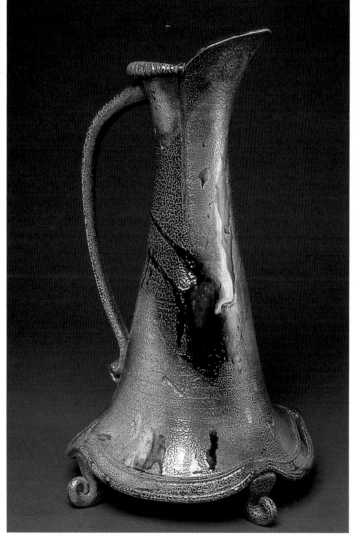

Above: **Marianne Weinberg-Benson,** *King: "Honey I Can't Hear You the Water is Running"*

1996, 29" x 10" x 10" (74 x 25 x 25 cm). Part of chess set entitled "Games People Play." Wheel-thrown porcelain, assembled while wet; sandblasted clear glaze with multiple layers of pastel drawing and fixative; oxidation fired in gas kiln, cone 10. Photo by Ron Lee

Top left: **Frank Martin,** *Plate*

1997, 11" x 13" x 2½" (28 x 33 x 6 cm). Wheel thrown, cut, and altered; brushed glaze; oxidation fired (mid-range porcelain), cone 4,5,6 range

As a functional potter and keeper of a tradition, it is my aim to achieve harmony between disparate parts that are suggestive of my natural environment. It is within function that the challenge lies, where objects are made by hand and satisfy personal needs.

Left: **Roy Hanscom,** *Pitcher*

1997, 26" x 12" x 12" (66 x 30.5 x 30.5 cm). Wheel thrown; colored slips; salt fired, cone 10

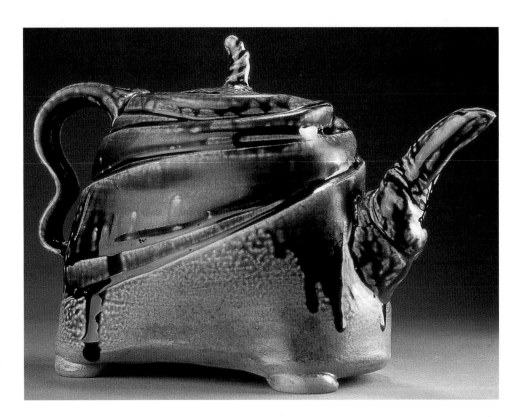

Cheri Glaser, *Square Teapot*

1996, 6" x 4½" x 7" (15 x 11 x 18 cm). Wheel-thrown and altered body, bottom thrown separately, spout pulled and twisted on a dowel, handle pulled off the pot; poured and sprayed fake ash glaze; wood fired, cone 9-10, with salt added at cone 8. Photo by Joe Harrison

Having been a production potter for more than two decades, I built a wood kiln to try for some new inspiration. It worked. I now make only one-of-a-kind pieces that have much more character and life to them. The wood kiln has changed my entire approach to clay. It is an ever-evolving journey of discovery and reward (with the occasional setbacks).

Paul Rozman, *Platter*

1997, diameter: 13¾" (35 cm). Wheel-thrown white stoneware; washes of stain on titanium matt glaze; oxidation fired, cone 6. Photo by artist

I don't consciously set out to make art. My aim is to make living a work of art, by transforming the ordinary into the extraordinary. The interactive nature of pottery through our daily actions of drinking and eating offers an opportunity to have meaningful aesthetic experiences. One way to achieve this is when pots delight us, humor us, exalt us. Ideas of utility expressed through these qualities are essential to me because they invite an emotional connection and gracefully become transformed by ordinary actions. The mark of great art, after all, is its overwhelming capacity to transform us, not inform us. Expressed this way, utility has purpose for me and meaning for others.

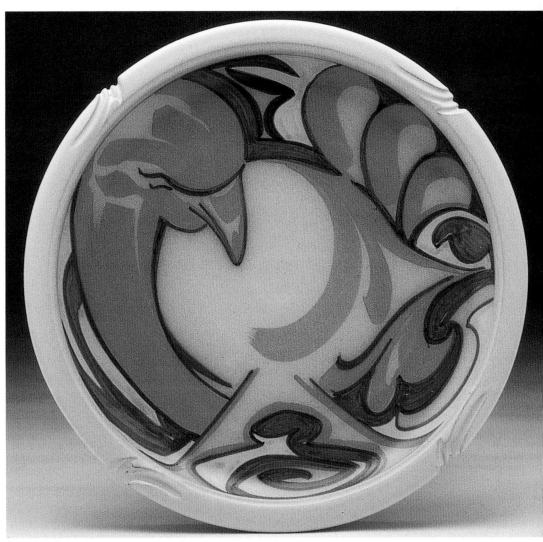

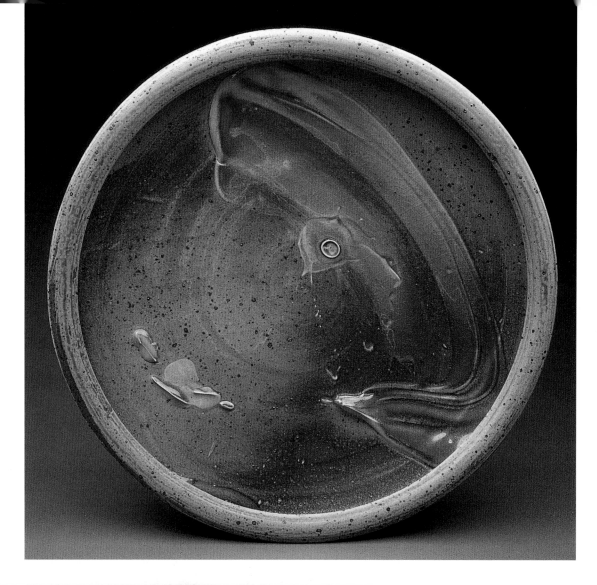

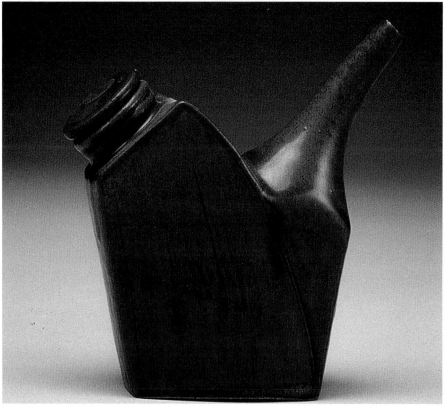

Above: **Amy L. Smith**, *Untitled*

1997, diameter: 16½" (42 cm). Wheel thrown; porcelain slip on stoneware platter; reduction fired, cone 10

I enjoy combining elements such as the practiced and the spontaneous, the predictable and the unpredictable, or elements as simple as matt glazes and glossy glazes. I believe combinations like these make my work lively.

Left: **Ellen Shankin**, *Soy Bottle*

1997, 4" x 3" x 1½" (10 x 8 x 4 cm). Wheel-thrown, altered, paddled, and shaved stoneware; fired to cone 9.
Photo by Tim Barnwell

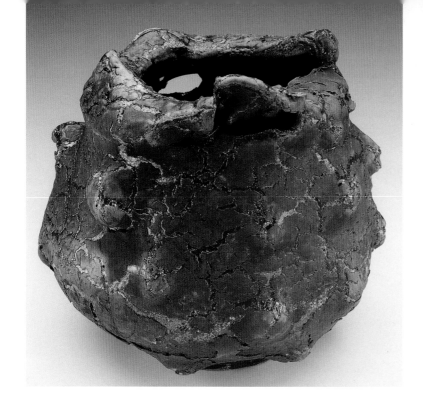

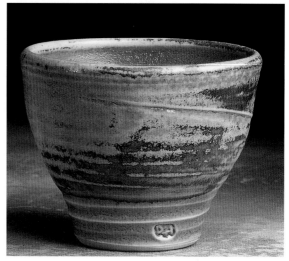

Above: **Kevin A. Myers,** *Untitled*

1997, 10" x 8" x 8" (25 x 20 x 20 cm).
Thrown off center, cut, torn and pinched;
low fire-glaze, brushed raku glaze with high
percentage of copper carbonate and rutile
(glaze on top separates to reveal red glaze
underneath); raku fired, cone 08. Photo by
Anthony Cuñha

Top right: **Dale Huffman,** *Teabowl*

1996, 4 x 5 x 5 (10 x 13 x 13 cm). Wheel-
thrown and altered porcelain; shino glaze;
reduction fired, cone 9. Photo by Michael Ray

Right: **Shari Sikora,** *Mustard Tea-Pot*

1997, 9½" x 5½" x 5½" (24 x 14 x 14 cm).
Wheel-thrown pieces; textured with wooden
tools; copper glaze, reduced and smoked;
raku fired. Photo by John Carlano

*To me, clay is a way of expression and thera-
py—I love throwing separate pieces and
putting them together, giving them life and
character.*

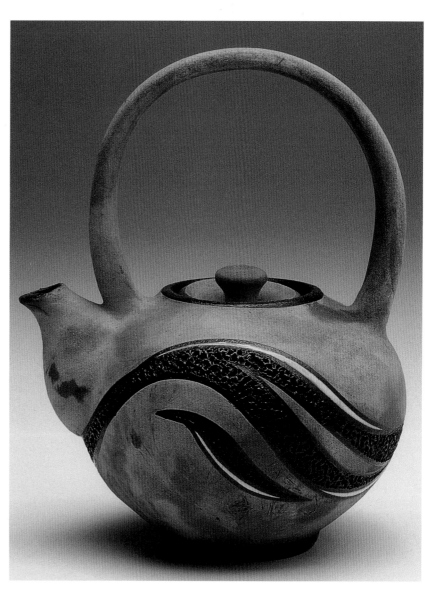

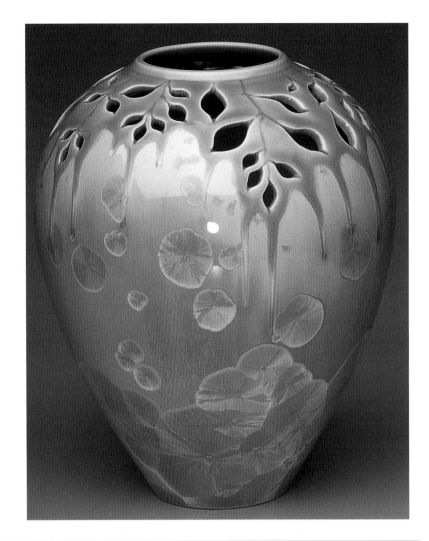

Top: **Ronalee Herrmann and Alfred Stolken, *Untitled***

1997, 9" x 7" x 7" (23 x 18 x 18 cm). Wheel-thrown and carved porcelain; crystalline glazed; fired in electric kiln, cone 10-12 (depending on specific glazes, oxidation and occasionally reduction). Photo by Alfred Stolken

Being inspired by nature, we interpret natural form through crystalline-glazed porcelain. We focus on the delicate and fragile, choosing porcelain for its fine grain, translucency, and strength. Our goal is to create beauty in form, surface, and decoration.

Left: **Lorene Nickel, *Shallow Bowl***

1997, diameter: 10" (25 cm). Wheel-thrown and altered stoneware; overglaze applications of enamel and gold; reduction fired, cone 6; then enamel and luster firings

I work primarily with thrown stoneware and porcelain forms, often altered and transformed into assembled sculptural vessels. Other simpler pieces are designed to show off the qualities of layered, textured glazes.

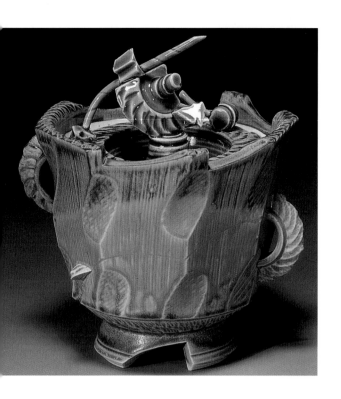

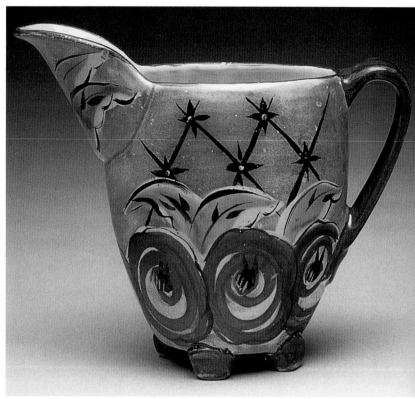

Above: **John W. Hopkins, *Jar with Lid Sculpture***

1997, 7" x 6" x 6" (18 x 15 x 15 cm).
Wheel thrown, rasped with Surform tool,
rim and foot sliced; wheel-thrown, cut,
and reassembled handle; chattered sur-
face, overlapped and wiped glaze; reduc-
tion fired, cone 10. Photo by artist

*Sculpture has always been my main focus.
I have been trained as a potter and always
kept my pottery separate from my sculp-
ture. With this latest series of pots, I have
started to bring my sculpture knowledge
together with my ceramic pottery form
knowledge. I am excited about finally com-
bining my two interests.*

Top right: **Posey Bacopoulos, *Beaked Pitcher***

1996, 7" x 7½" x 3" (18 x 19 x 8 cm).
Terra-cotta; wheel-thrown body paddled
into oval; feet, spout, and handle
attached; majolica and stains; fired in
electric kiln, cone 04. Photo by D. James Dee

Right: **Peter S. MacDougall, *Bamako Platter***

1997, height: 3" (8 cm). Wheel-thrown
white stoneware, with painted porcelain
slip in center; celadon glaze with black
stain, sgraffito, trailed green glaze slip;
oxidation fired, cone 9. Photo by Robert Nicoll

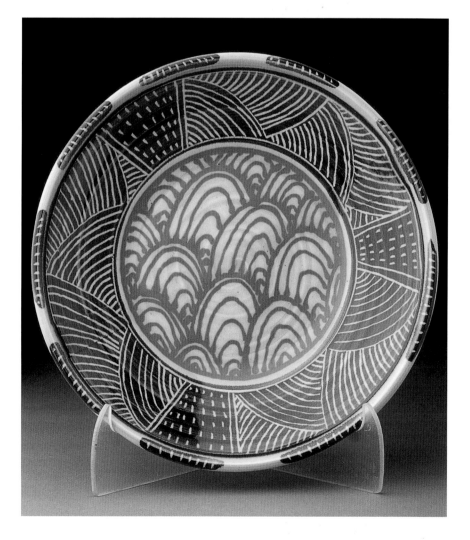

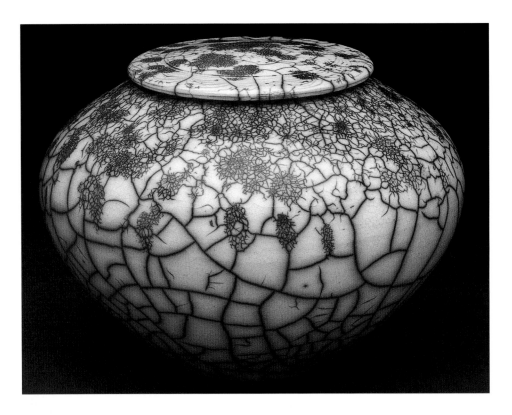

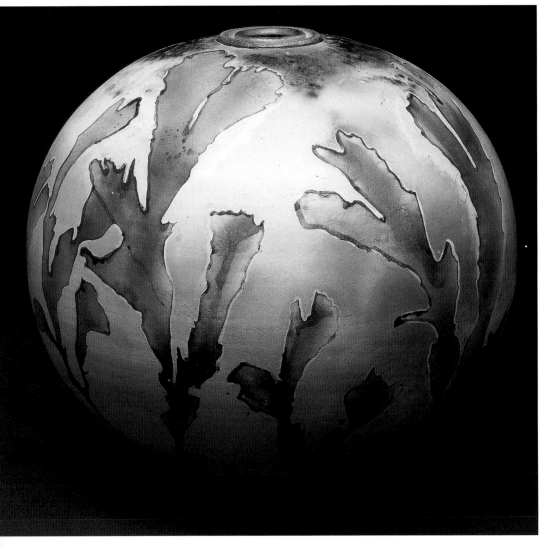

Top: **Carl Baker, *Crackle Jar***

1996, height: 5" (13 cm). Wheel-thrown white stoneware pieces; clear raku crackle glaze, crackle patterns altered by spraying pieces with water before smoking; raku fired, cone 07.
Photo by George Post Photo

I enjoy working with altered crackle, as it gives me a good balance of freedom and control. The randomness of crackle presents the challenge; my controls are timing, spraying, and blowing. The result is always a compromise.

Left: **Aase Haūgaard, *Seaweed 2***

1997, 12½" x 12½" x 12½" (32 x 32 x 32 cm). Wheel thrown; airbrushed terra sigillata over waxed background; saggar salt fired, 1100°C (2012°F), cooled for two days.

The seaweed inspires me when I go bathing every day. I am interested in different firing methods. I am working with low and high salt-fired ceramics.

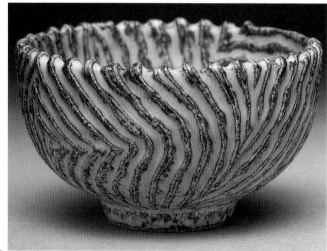

Above: Chris Staley, _Covered Jar_

1996, height: 6" (15 cm). Wheel-thrown and altered stoneware, with added clay to create edges; wax resist, thin black slip; residual salt fired, cone 9

Top right: Robert Bowman, _Grained Bowl_

1997, 2½" x 4½" x 4½" (6 x 11 x 11 cm). Wheel-thrown stoneware, with hand-carved textures; reduction fired, cone 10. Photo by Peter Lee

Whether I'm making a small functional bowl or a large decorative urn, my concerns are the same: strong form and a certain visual density. I'm most satisfied with the work when it combines seemingly contradictory qualities: richness and simplicity, humor and gravity, sensuality and discipline.

Right: Brad Tucker, _Platter_

1996, diameter: 21" (53 cm). Wheel-thrown stoneware; ash glazed, design carved in base glaze, additional glaze trailed on top; reduction fired, cone 10. Photo by Bob Barrett

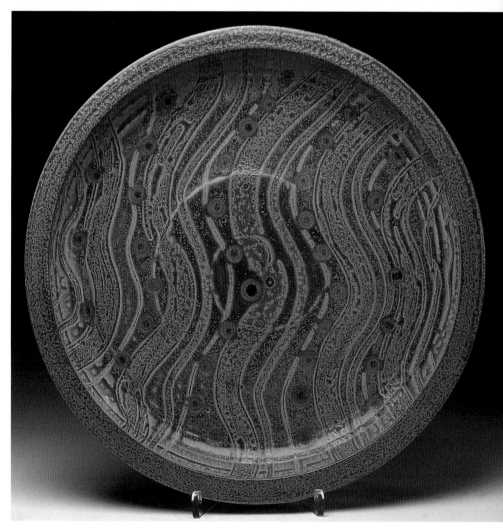

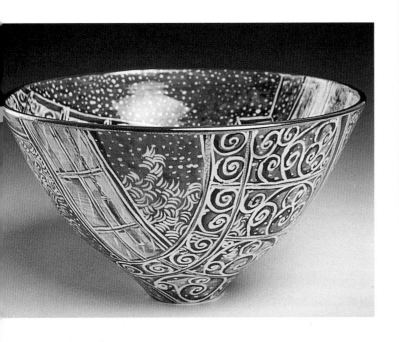

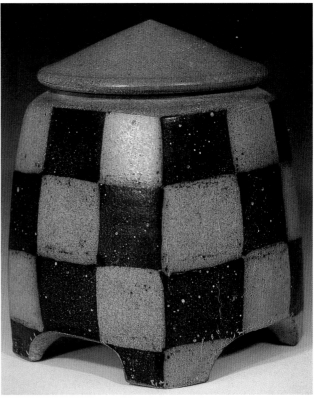

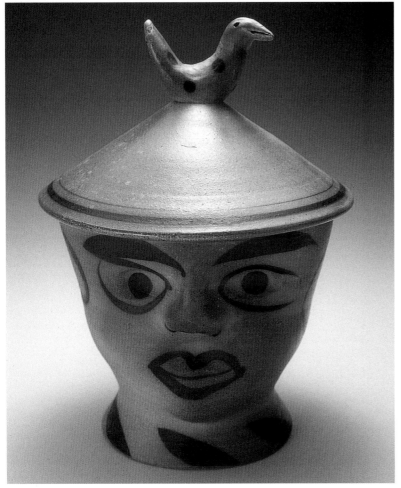

Above: **Roger Jamison,** *Checkered Jar*

1997, 9" x 7" x 7" (23 x 18 x 18 cm). Wheel-thrown and altered stoneware; kaolin slip, black stain; wood fired, salt glazed, cone 9

Top left: **Ljubov Seidl,** *Laced Stairs*

1997, diameter: 9¾" (25 cm). Wheel-thrown porcelaneous stoneware; underglazes, glazes, sgraffito, clear glaze, gold trims and some gold outlines; fired to 1200°C (2192°F).

My inspiration for work and decoration comes from the nature and achievements of man in past time, and from my attraction to old myths and the environment.

Bottom left: **Fred Johnston,** *Head Jar*

1996, 13" x 10" x 10" (33 x 25 x 25 cm). Wheel thrown and pinched; white slip, with block decoration; soda fired stoneware (oxidation), cone 10

I am fascinated by facial expressions and body language—how we communicate without the use of words. The Head Jar *gives me a great opportunity to explore this idea.*

HANDBUILT CERAMICS

Handbuilding—the art of shaping clay without a potter's wheel—includes a variety of different shaping techniques. Potters create an amazing array of forms by working with slabs of moist or stiff clay, "pinching" one or more lumps of clay; "coiling" ropes of clay by simultaneously wrapping and stacking them; and working with extrusions (lengths of clay squeezed from extruders—mechanisms that operate much like the tools used to decorate cakes with icing).

While handbuilding may seem laborious when compared with wheel-throwing, a tremendously rich diversity of forms and expressions is made possible by handbuilding's inherent flexibility: sculpted tiles, ritual vessels, functional ware such as plates and boxes, sculptural forms, wall hangings, teapots, and more. As you'll no doubt notice, many forms are created by combining different handbuilding techniques. A coiled vase, for example, might include extruded handles; a pinched sculpture might have a slab-built base.

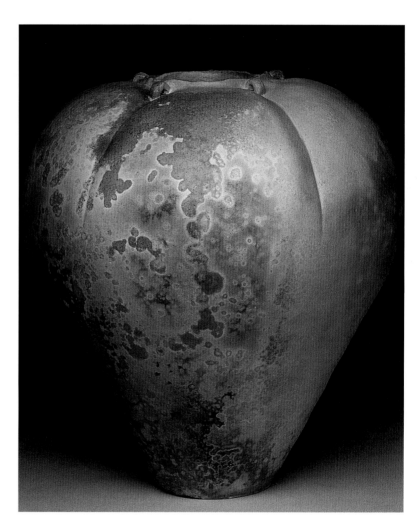

Jan Presley, *Melon Pot*

1996, 17" x 13" x 13" (43 x 33 x 33 cm). Coiled; sprayed and lightly burnished terra sigillata containing copper and stains; salt sprinkled over piece (made to adhere with wax) before raku firing; bisque fired, cone 06; then fired 50 minutes singly in a raku fiber kiln, removed when cool enough to handle, no reduction

My pots are handbuilt in simple classical shapes and are fired to reproduce the hues and intensities of nature. The combination of color and form evokes a feeling of calmness and serenity.

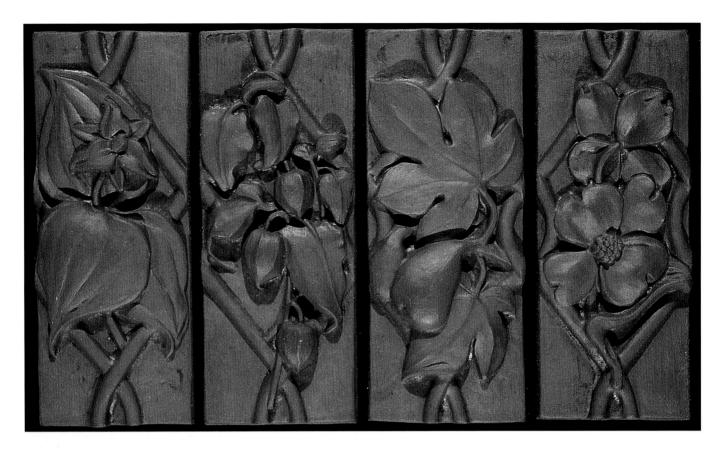

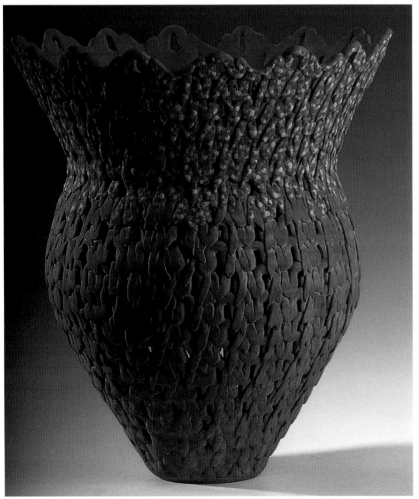

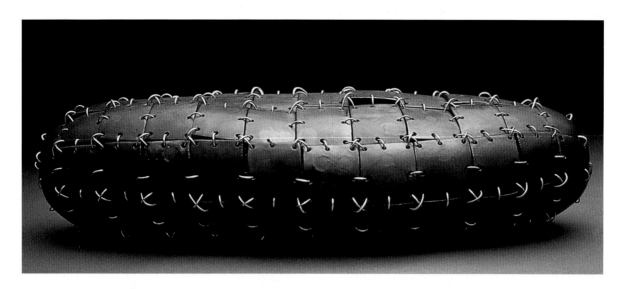

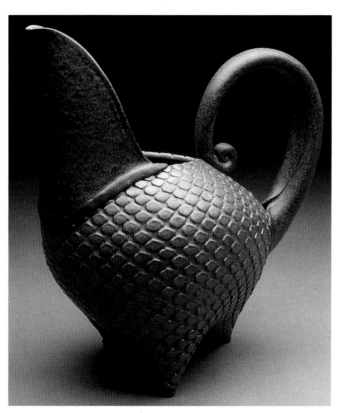

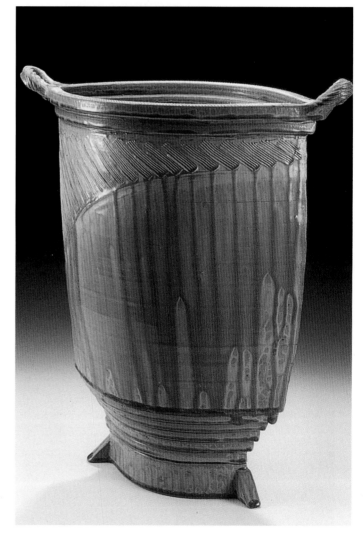

Top: **Vincent Burke,** *Flex*

1997, 6" x 10" x 22" (15 x 25 x 56 cm). Slab-built form; soda fired, cone 10; fired in electric kiln, cone 04; stitched together with steel

Center left: **Sandi Pierantozzi,** *Proud Bird Pitcher*

1997, 8" x 7" x 6" (20 x 18 x 15 cm). Earthenware; handbuilt with slabs; low-fire glaze; fired in electric kiln, cone 05

I love to make pots and hope that the pots I make are filled with good spirit and that this feeling is carried over to the user. I am first inspired by a certain texture, and I go on from there. All my pots are formed with textured slabs, which are made into cylinders and pushed out.

Above: **Jim Parmentier,** *Coil Vessel*

1997, 22" x 13" x 7" (56 x 33 x 18 cm). Coil built with extruded coils of different sizes; altered with Surform tool, smoothed; white slip, fake ash glaze; fired in gas kiln, cone 10. Photo by Ralph Gabriner

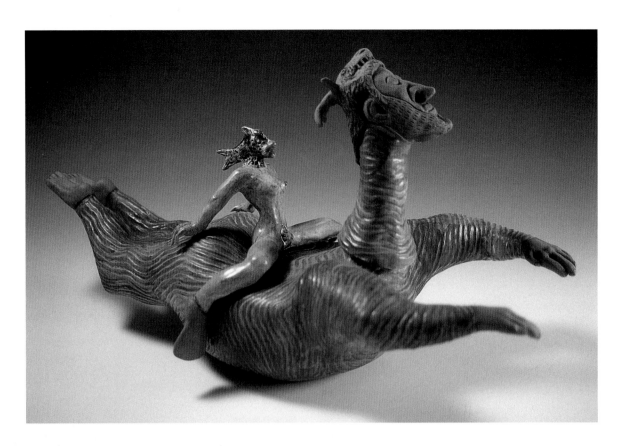

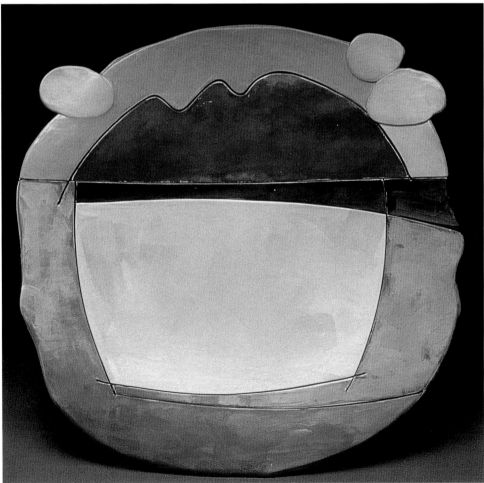

Above: **Carol Gentithes, *Marriage***

1996, 10" x 9" x 20" (25 x 23 x 51 cm). Earthenware; hand-built with coils, carved with dental tool when leather hard; white slip; multiple firings in electric kiln, cone 05. Photo by Fred Johnston

Marriage is about taking the plunge. Symbolically, marriage is a balancing act that requires a synchronized rhythm between partners in order to work. Note that the male figure (husband) is doing the butterfly stroke. I chose this stroke because of its difficulty and awkwardness when not mastered. Ideally, as in this piece, when it is mastered, the ride (marriage) is a smooth one.

Left: **Tom Schiller, *Beaver Creek Summer***

1996, 21" x 21" x 2" (53 x 53 x 5 cm). Hand-rolled white earthenware, drawn on with sticks and molded over a plaster bat; added coil-formed foot; painted commercial underglazes and clear glaze; bisque fired in electric kiln, cone 04; glaze fired, cone 06. Photo by Janet Ryan

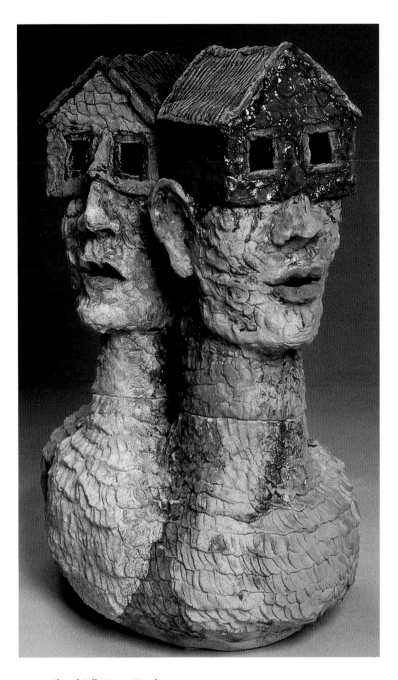

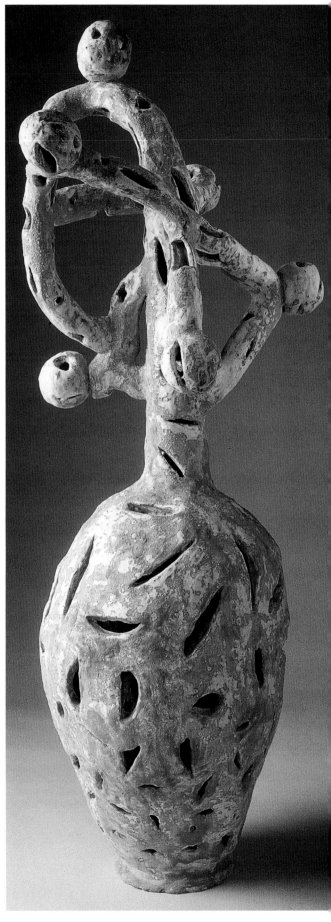

Above: **Cheryl Tall,** *House Heads*

1996, 28" x 20" x 13" (71 x 51 x 33 cm). Earthenware; started with large coil, layers added and pinched to resemble roof shingles; constructed and fired in sections; metallic oxides, slip and terra sigillata, glaze; fired in electric kiln, cone 04-02. Photo by Michael Forester

Inspired by mythology and folk art, I use the metaphors of "house" and "head" to create a story. The figures are animated, with mouths open as if to speak. The closeness of the figures suggests a communication or tension between them. The houses on the heads symbolize a relationship between the figures and their environment.

Right: **Lisa Wolkow,** *Polyoma*

1996, 38" x 15" x 11" (97 x 38 x 28 cm). Handbuilt with coils; glazes over slip; multiple oxidation firings, cone 06

Working is the reinventing of all worldly things—the recreating and reinterpreting of what we know and what we understand. Though many references abound in a mixture of the found and imaginary, I always return to one basic impulse—the desire to form.

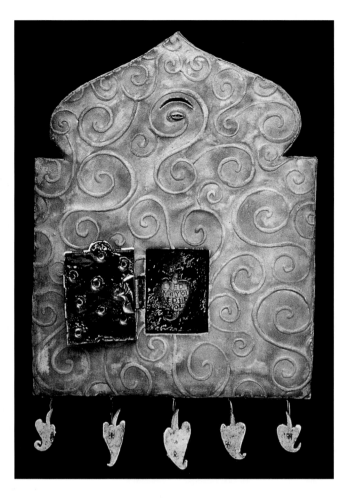

Left: **Leah Hardy, *Reconciliation: "Fatima" series***

1996, 9½" x 7½" x 1½" (24 x 19 x 4 cm). Slab-built earthenware; terra sigillata, oxide wash, luster; fired in electric kiln, cone 04. Photo by Paul Jacques

In my wall pieces, I have employed the elements of niches, "peep" holes, and most recently, doors that open and close. All of these aspects provide the element of discovery for the viewer; and in this manner, I can disclose personal experiences through a vocabulary of symbols and forms. I work on an intimate scale so that the object becomes precious and has to be experienced up close. Using a shrine-like format has been quite innate for me; it functions as a receptacle for the sacred bits of life that occur in daily activity, nightly dreams, or travel. I want the work to engage the viewer and inspire his or her own celebration of life experiences.

Below: **Judy Glasser, *Carved Vase***

1997, 12" x 15" x 6" (30.5 x 38 x 15 cm). Slab-built stoneware form, carved; stains and slips; reduction fired, cone 9. Photo by Theresa Schwiendt

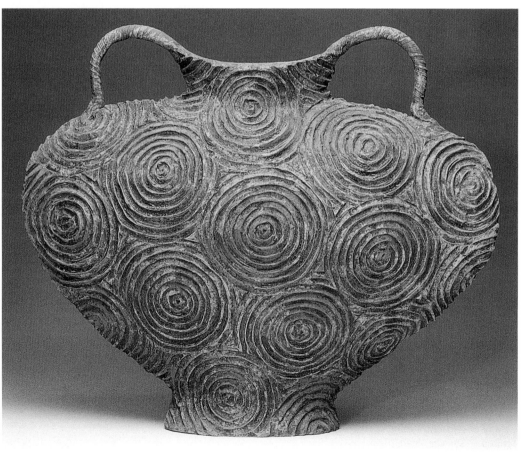

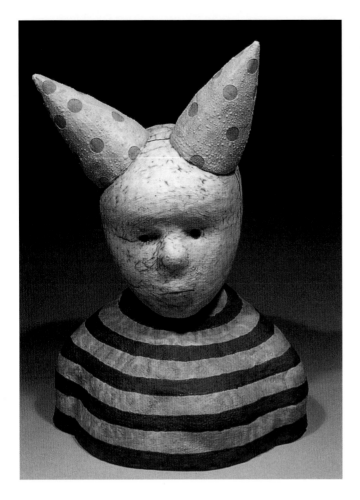

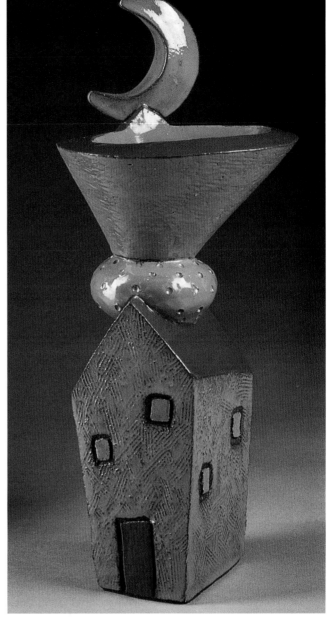

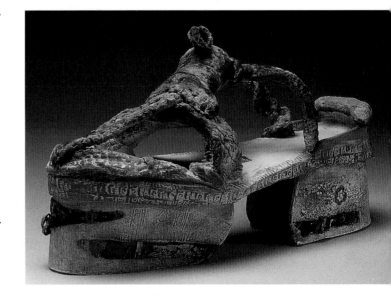

Above: **Tom Bartel,** *Double Party Hat*

1997, 28" x 22" x 16" (71 x 56 x 41 cm). Coil built; vitreous engobes and terra sigillata; multiple oxidation firings, cone 02. Photo by artist

Top right: **Angi Curreri,** *House Vessel with Moon*

1997, 14" x 6" x 6" (36 x 15 x 15 cm). Four parts hand-formed from mid-range red clay by pinching, paddling, and pounding; hollowed if necessary, refined with Surform scraper and other tools; parts attached, textured, and further refined; multiple coats low-fire commercial glazes; bisque fired in electric kiln, cone 6; multiple glaze firings, cone 06. Photo by Neal Bradbeck

My work is autobiographical and highly symbolic in color and imagery. It originates from dreams, memories, and experiences. Visual influences that inspire me include religious objects and ritu-als, cemeteries, sacred spaces and other architecture, anatomical reference books and models, Mexican imagery, Florida imagery, toys, and social and domestic ritual objects.

Right: **Lisa Maher,** *Chopine*

1997, 6" x 4" x 10" (15 x 10 x 25 cm). White stoneware; soft-slab constructed; low-fire overglaze and underglaze, oxides and ceramic inks; fired in electric kiln, cone 6 and 06; copper applied to surface after firing

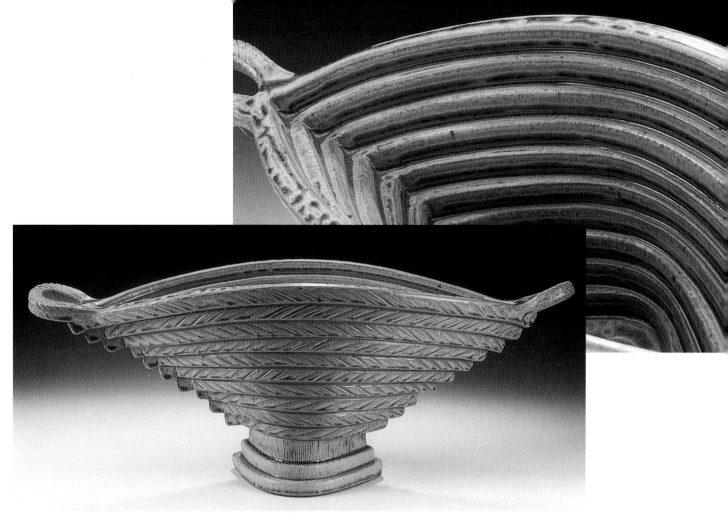

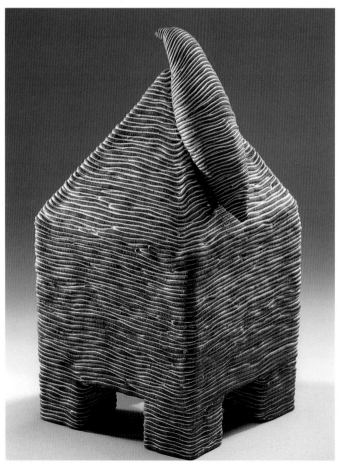

Above: **Shirl Parmentier,** *Extruded Coil Vessel*

1997, 12" x 20" x 6" (30.5 x 51 x 15 cm).
Handbuilt using extruded square stoneware coils;
slip added to the base for variance, fake ash glaze
on vessel; fired in gas kiln, cone 10. Photo by
Ralph Gabriner

*My one-of-a-kind pieces evolve over a long period of
time. Most forms shape and change in my mind before
I get the time to work on them. Many pieces change
as I'm working on them.*

Left: **Elaine Fuess,** *Unwinding*

1997, 10" x 6" x 6" (25 x 15 x 15 cm). Hard slab
construction, with coils added at leather-hard
stage; rubbed (and wiped-off) white underglaze;
bisque fired in electric kiln, cone 06; refired,
cone 2. Photo by Thomas Dix

*The house image is a metaphor for the self, and the
bird is an image of transformation. The piece speaks
about how we coil our lives into existence, the habits
and things we collect along the way, and what we see
as possible.*

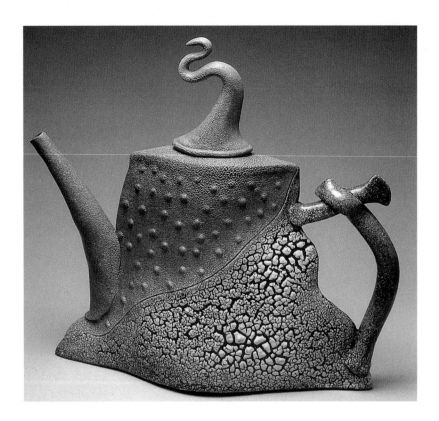

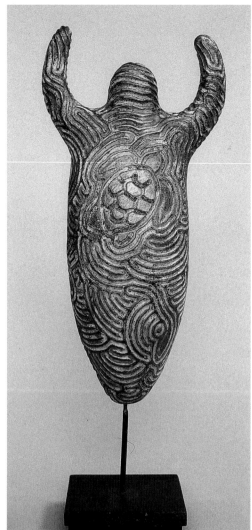

Above: **Bacia Edelman, *Lichen Teapot XII***

1997, 12½" x 13¾" x 4½" (32 x 35 x 11 cm).
Slab built; texture impressed slab before form-
ing; trailed porcelain slip dots, underglazes;
bisque fired, cone 05; terra sigillata and lichen
glaze; glaze fired, cone 6

*Texturing clay or using lichen and bead glazes for
surface excitement is my current passion. Form is
also a large part of what I think about when devel-
oping work. Not counting school, I have been form-
ing clay for 47 years. Many times, after some years
of working a certain way, I have reinvented myself.
There are still hundreds of ways to do clay, but I
have worked my way through thrown functional
pots, sawdust-fired pots, and multifired composi-
tions in bright underglaze colors. I am texturing the
handbuilt slabs or using highly textured glazes.*

Top right: **Whitney Krueger, *Earth Mother***

1997, 12" x 7" x 3" (30.5 x 18 x 8 cm). Hand-
formed and carved; slips and gold wash; fired
in electric kiln, cone 6. Photo by Siddiq Khan

*This piece is based on sacred sites in Malta
and Ireland. Through my work in geomancy,
I bring ancient wisdom and form into a contem-
porary language.*

Right: **Tom Schiller, *Freefall***

1997, 21" x 21" x 2" (53 x 53 x 5 cm). Hand-
rolled white earthenware, drawn on with sticks
and molded over a plaster bat; added coil-
formed foot; painted commercial underglazes
and clear glaze; bisque fired in electric kiln,
cone 04; glaze fired, cone 06. Photo by Janet Ryan

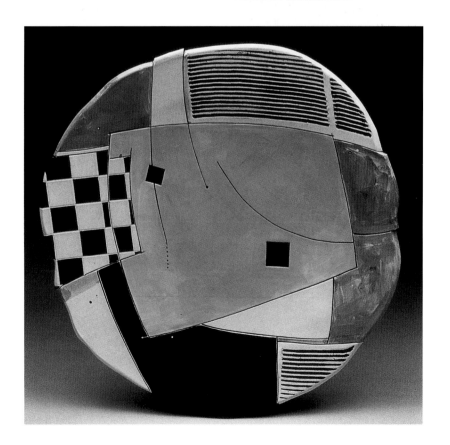

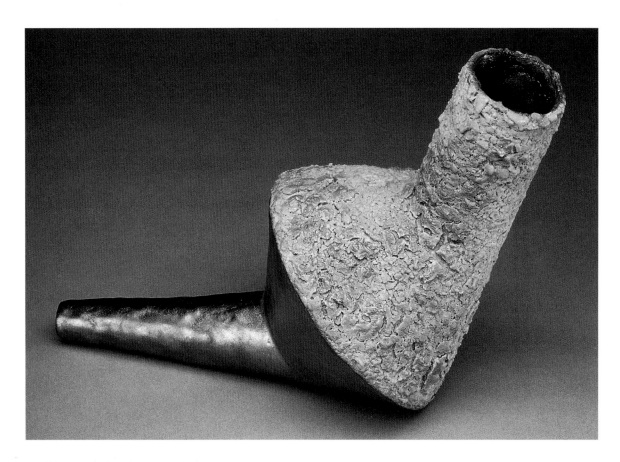

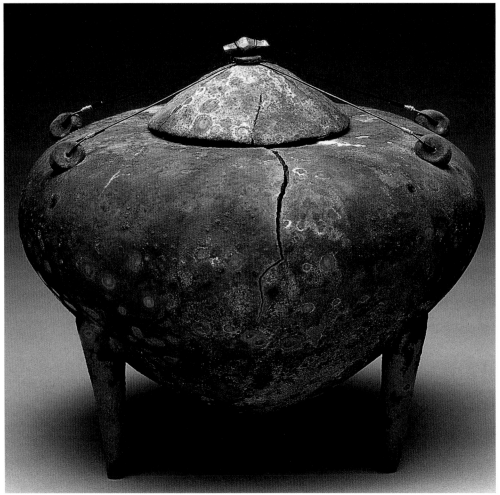

Above: **Virginia Scotchie,**
Tool Form

1997, 12" x 10" x 8" (30.5
x 25 x 20 cm). Coiled,
pinched, and paddled
stoneware; sponged glazes;
fired in electric kiln, cone
6. Photo by Peter Lenzo

*My work that I am currently
investigating is inspired by
common handheld "tools."
These objects, such as pipes,
sieves, and clubs, are abstract-
ed and reinvented into the
visual objects I create.*

Left: **Kristin Doner,**
*Cracked Amphora: "Imperial
Pinchpot" series*

1996, 9" x 11" x 11" (23 x
28 x 28 cm). Pinch pot,
hammer and anvil technique;
lithium glaze; raku fired

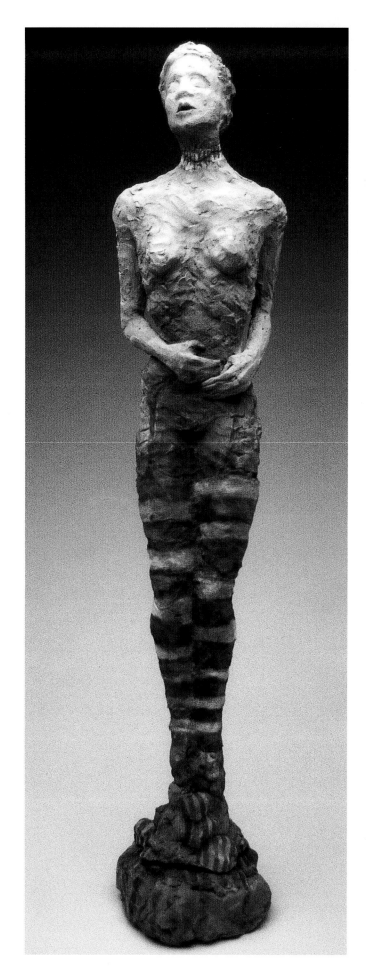

Above: **Thomas Orr, *Suns & Shadows***

1997, 19" x 7" x 3" (48 x 18 x 8 cm). Terra-cotta wall hanging; open box shape made from slab with pinched sides; white crawl glaze with stains and texture glaze (glazes reapplied between firings), glaze and paint on back; multiple firings in electric kiln, cone 06, cone 01, cone 04, and cone 06 again (twice).
Photo by Phil Harris

Left: **Carrianne L. Hendrickson, *She Echoes the American Dream***

1997, 38" x 13" x 11" (97 x 33 x 28 cm). Handbuilt, using a metal rod as armature; bisque fired in electric kiln, cone 1; painted with blend of ink, gouache, and water colors; striped stockings created by painting liquid latex on strips of gauze, wrapping strips around base, and later painting with gouache

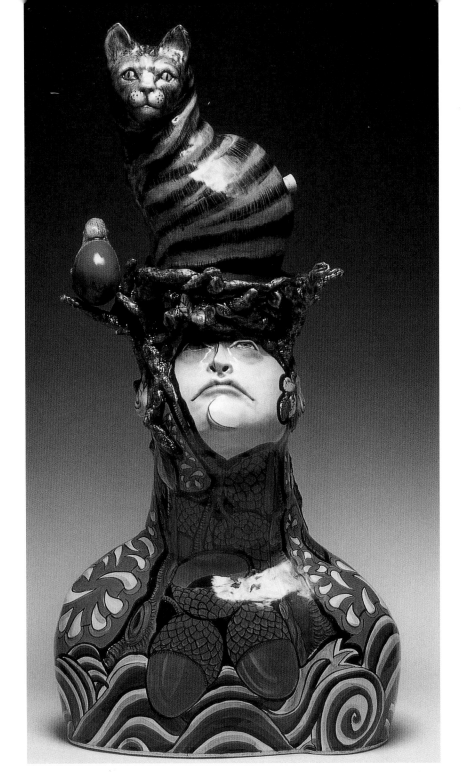

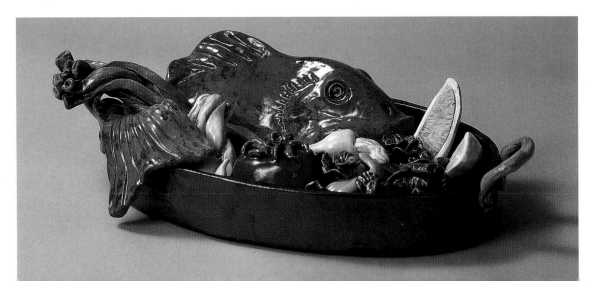

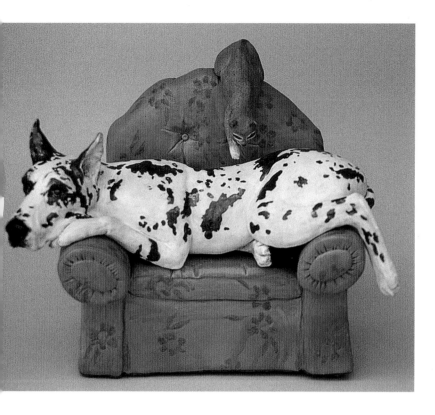

Above: **Bonnie Fry, *Bother***

1997, 11½" x 14" x 7" (29 x 36 x 18 cm). Slab built and pinched; dog: white slip and manganese dioxide; chair: underglaze and glaze; cat: oxides and slip; reduction fired in gas kiln, cone 10

Top right: **Laura Stamper, *Goddess of Good Hair***

1997, 4" x 3" x ¾" (10 x 8 x 2 cm). Pieces pinched, formed, and sculpted; underglazes, glazes, overglazes, China paints, and lusters; multiple firings in electric kiln, cone 017 to cone 8; trimmed in 22K gold, semiprecious stones, gold, and natural objects. Photo by Larry Sanders

Right: **Marie E.v.B. Gibbons, *Princess and the Pea***

1997, 16" x 18" x 14" (41 x 46 x 36 cm). Slab-built and pinched; low-fire bisque; nonfired surface treatments: prisma color pencil, acrylics, wooden twigs, glass. Photo by John Bonath, Maddog Studio,

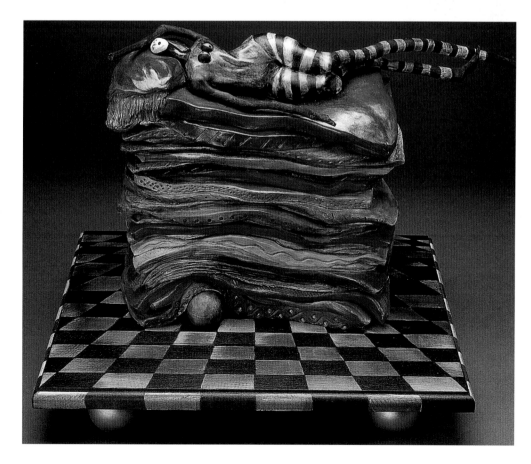

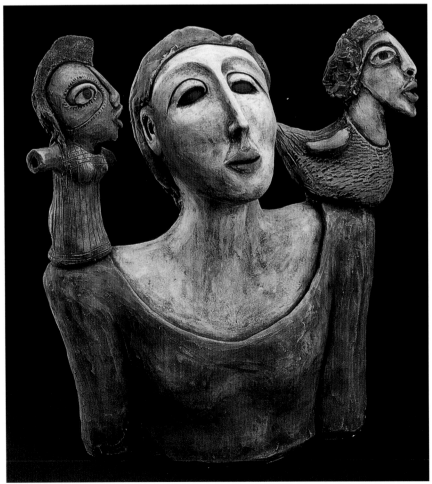

Above: **Elyse Saperstein, *The Garden***

1997, 34" x 46" x 2½" (86 x 117 x 6 cm).
Slab built and carved; brushed glazes and
washes; fired in electric kiln, cone 05.
Photo by John Carlano

*Ever since childhood, the story of Adam and
Eve has enthralled me. The multitude of
artists' adaptations and interpretations
throughout history is both curious and
inventive to me. In my depiction, I have cho-
sen to focus on these two figures' relation-
ship with one another. This takes place on
the branches in a lush garden setting, while
the snake eagerly takes the apple that is
given to him from below.*

Left: **Barb Doll, *Familiar Fear***

1997, 18½" x 18" x 8" (47 x 46 x 20 cm).
Sculpted (using coil technique) from
stoneware clay; underglazes, slips, and
engobes; oxidation fired, cone 6; then mul-
tiple firings, cone 04. Photo by Bart Kasten

*My artwork is a visual analysis and interpre-
tation of the complex mosaic of the human
psyche. The psychology of Carl Jung, for
example, posed different personality arche-
types that we repress, deny, ignore, or
choose to exemplify. Some of my favorites
are the mother, the trickster, the magician,
and the demon. I have included these per-
sonality types in my "visual vocabulary."*

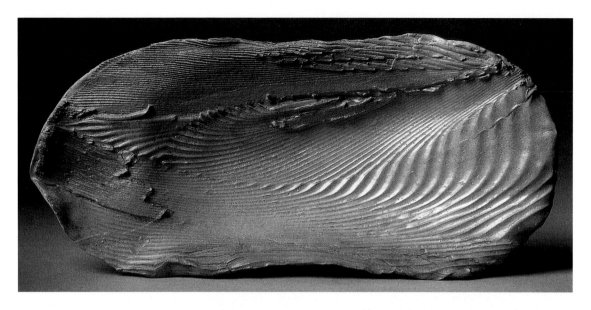

Above: Marta Matray Gloviczki, *Platter*

1997, 3" x 21" x 10" (8 x 53 x 25 cm).
Slab-built stoneware, with wire-cut relief
pattern; brushed slip; wood fired, cone 12,
with added salt. Photo by Peter Lee

*I am fascinated by waves—waves in land or
water. I like to translate into clay the harmo-
ny and rhythm of this ever-changing move-
ment, which evokes in my memory the beauti-
ful Lake Balaton and the rolling countryside
of my native Hungary.*

Right: Kathy Triplett, *Teapot #2*

1997, 24" x 12" x 6" (61 x 30.5 x 15 cm).
Slab, extruded clay, and mixed-media addi-
tions; glazes, underglazes; fired in electric
kiln, cone 05. Photo by Tim Barnwell

*The teapots in this series suggest people strik-
ing poses—sometimes arrogant, sometimes joy-
ful, sometimes dancing, usually sassy.*

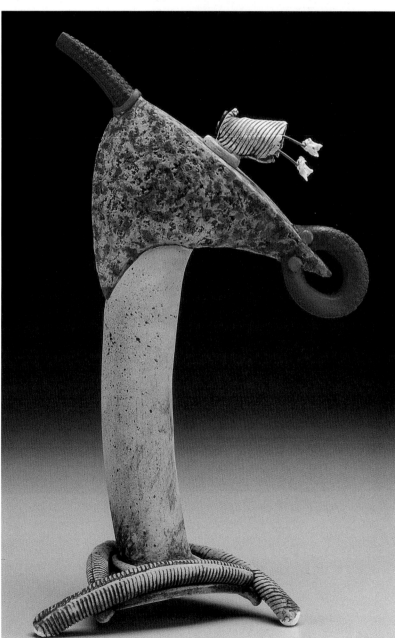

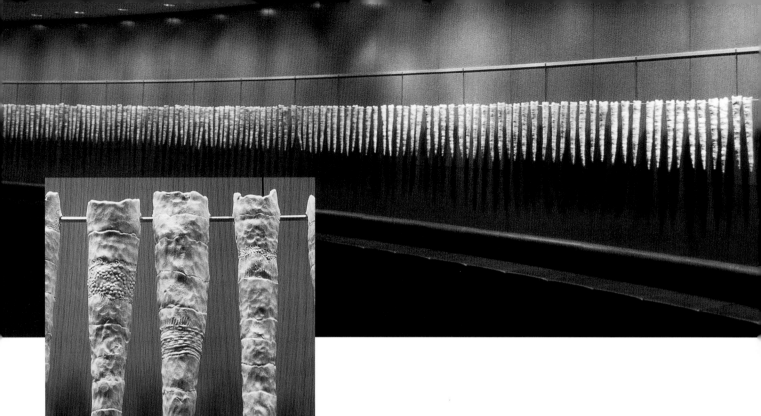

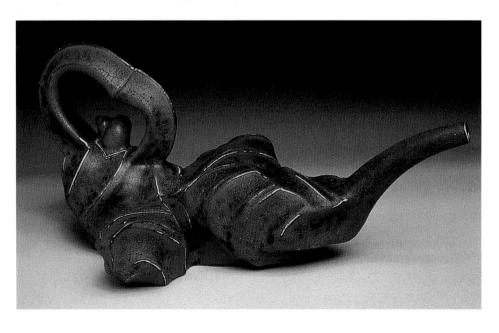

Above: **Carol Bradley,** *The Necklace*

1996, length of each: 22" (56 cm). Coil-built earthenware, steel rod and brackets; stamped, impressed decoration, glazed; fired in electric kiln, cone 04

My work often consists of a series of similar organic forms, usually presented as an installation in which the overall organization is determined by certain features of the exhibition space. The Necklace was designed to take advantage of a long, curving wall which, if continuous, would eventually close into a circle. The individual ceramic elements are reminiscent of historical clay vessels and natural objects such as bones, teeth, shells, or seed pods. The references to both nature and culture and the integration of the site into my work reflect my belief that to be meaningful and affective, art must maintain a relationship with the world.

Left: **Jim Connell,** *Red Sandblasted Carved Teapot I*

1997, 6" x 13" x 7" (15 x 33 x 18 cm). Coiled, carved, and sandblasted; reduction fired, cone 10

I am a vessel maker. My work is more decorative than functional.

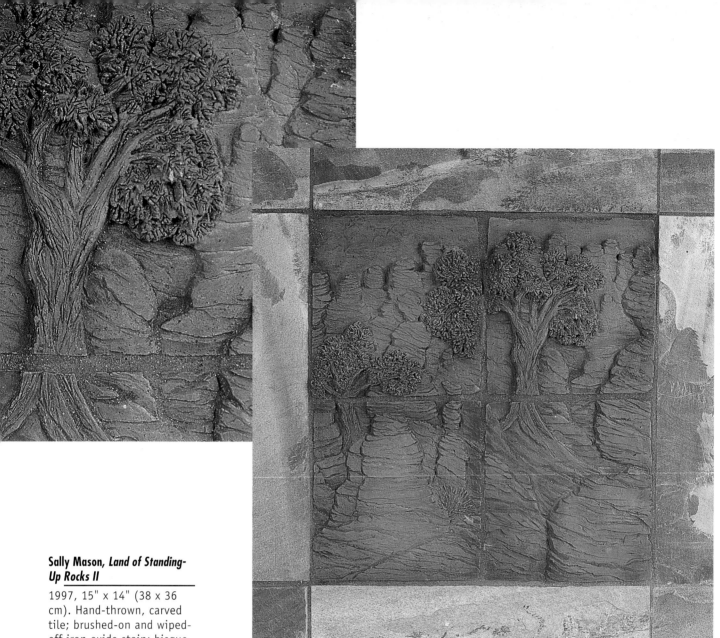

Sally Mason, *Land of Standing-Up Rocks II*

1997, 15" x 14" (38 x 36 cm). Hand-thrown, carved tile; brushed-on and wiped-off iron oxide stain; bisque fired; second firing, cone 5; mounted in slate. Photo by Lyn Sims

Les Lawrence, *New Vision Tea Pot*

1997, 7½" x 2¾" x 13" (19 x 7 x 33 cm). Slab construction, stainless steel; photo silkscreen mono print, black slip; once-fired (oxidation), cone 9. Photo by John Dixon

My sculptural vessels are constructed from thin, cast porcelain slabs decorated with a unique photographic silkscreen mono print process. Stainless steel wire and nails are fired into the clay to visually enhance the illusion of the "construction" process. Images are expressive of a complex narrative about art, life, and events current and past.

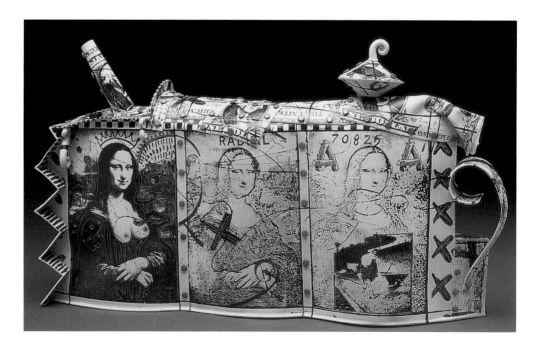

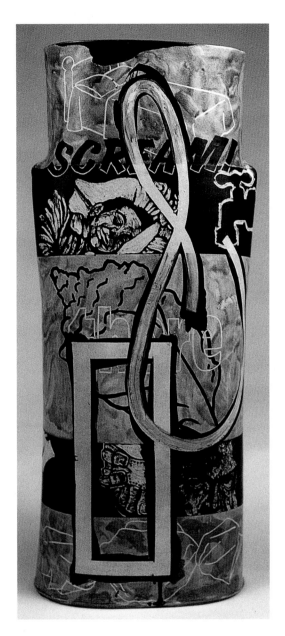

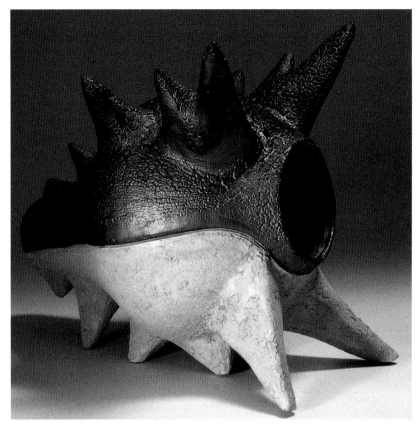

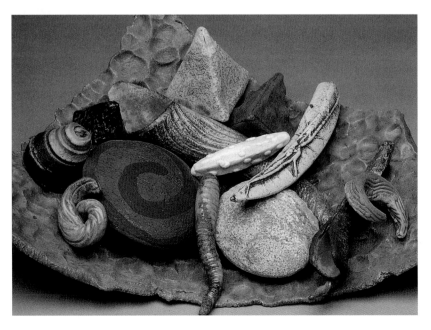

Above: **Bryan Hiveley, *Diplomacy***

1997, 14" x 9" x 18" (36 x 23 x 45 cm). Coil-built stoneware; glazed; fired in electric kiln, cone 6. Photo by Peter Lenzo

My work in ceramic sculpture is an abstraction of biomorphic forms, where I explore the relationships between form, surface, and texture. With each form, I incorporate personal meaning and historical references.

Top left: **James Klueg, *More***

1997, 22" x 9" x 5" (56 x 23 x 13 cm). Slab-built earthenware; sgraffito and overglaze decoration; oxidation fired, cone 03. Photo by artist

Pots, images, words

Left: **Dale Shuffler, *Water Bowl***

1996, 5" x 13" x 9" (13 x 33 x 23 cm). Pinched, coiled, cut and folded slab construction; impressed; painted, dipped, and trailed slip, glaze, terra sigillata; fired in electric kiln, cone 04; salt fired, cone 10, fired in electric kiln, cone 06. Photo by Bruce Blank

This body of work arose from questions about the organic nature of life—the forms, patterns, surfaces, and textures found therein. There is no attempt to copy or imitate anything, rather to establish a dialogue among the objects and the viewer.

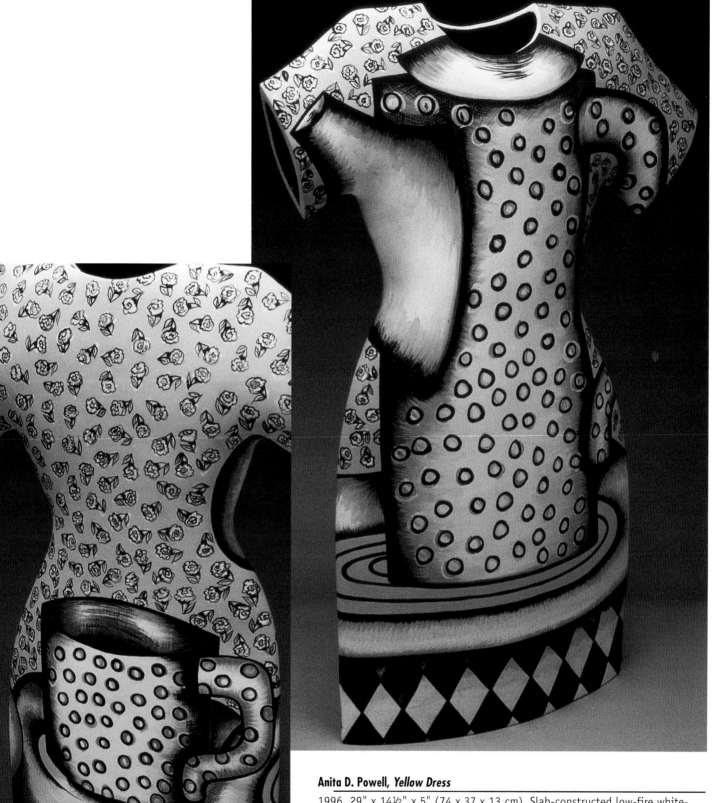

Anita D. Powell, *Yellow Dress*

1996, 29" x 14½" x 5" (74 x 37 x 13 cm). Slab-constructed low-fire white-ware; commercial underglazes outside, black glaze inside; fired in electric kiln, cone 04-06. Photo by Calvin Kimbrough

My work is an attempt to make a true rather than a false or disingenuous response to life—to detach myself from the particular feelings of shame associated with the typically feminine, by the process of owning them. This way, I can use sentimentality, domesticity, quaintness, beauty, and smallness as devices to confront those who hold negative attitudes about these traditionally female traits. I can also validate and encourage the reactions of those who can see beyond the surface to find a message of tenacity, power, resourcefulness, and the transformation of limitations into strengths.

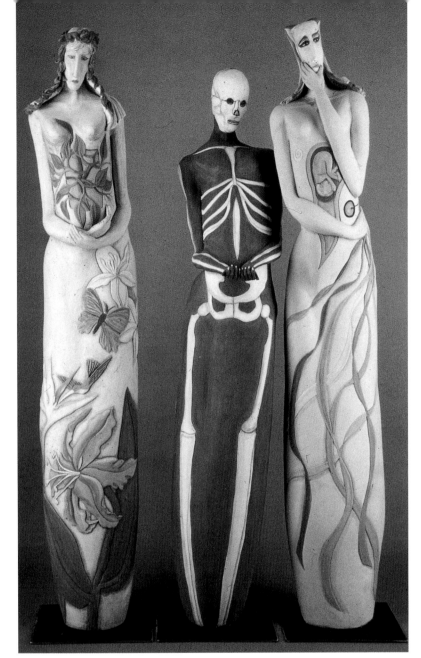

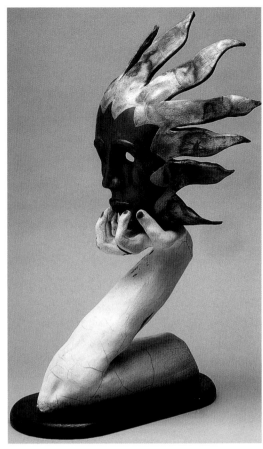

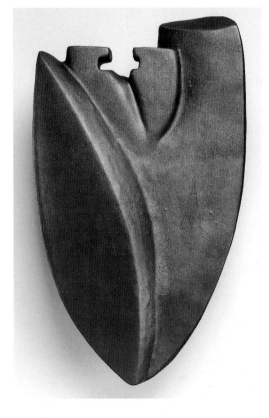

Above: **Linda Ganstrom, *Great Mothers***

1996, 51" x 30" x 10" (129 x 76 x 25 cm). Slab-constructed raku, with relief carving; underglaze painting; oxidation fired, cone 04. Photo by Sheldon Ganstrom

Top right: **Jennifer Girvin, *Contemplating Raku***

1996, 21" x 16" x 14" (53 x 41 x 36 cm). Handbuilt with slabs and coils; raku fired in two pieces, cone 05. Photo by Bob Stender

I love the immediate and unpredictable results that you get with a raku firing. This piece exemplifies how raku has taken over my waking hours.

Right: **Juan Granados, *Implement #3***

1997, 20" x 12" x 3" (51 x 30.5 x 8 cm). Slab, handbuilt earthenware; oxides, glaze, and metal pigment; fired in electric kiln, cone 05. Photo by Jon Q. Thompson

Art affects everyone differently but serves as a universal language. My work reflects a life of need, growth, and change. I create art in order to share some of my past and present memories, visions of places, and concerns about the environment as well as the human condition. To do this, I use many different elements from my life and experiences. Subject matter may be difficult to separate and identify, but I try to create work that embodies an intuitive gestalt or the flow and response around an idea.

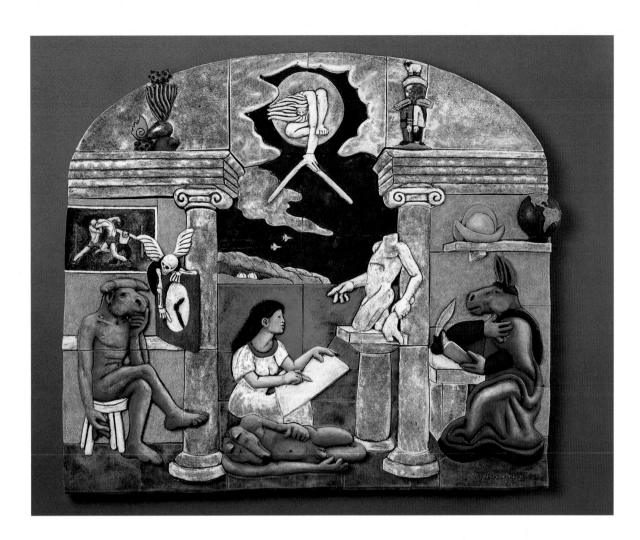

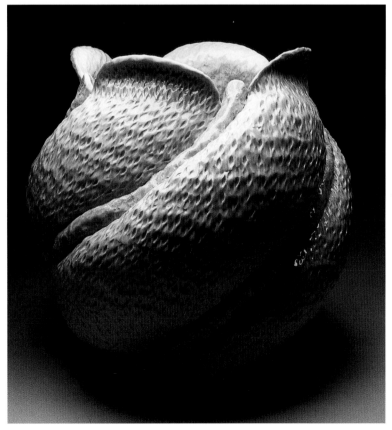

Above: **Mark Messenger,** *Tabula Rasa*

1996, 37" x 43" x 2½" (94 x 109 x 6 cm). Slab, with drawn image, added and subtracted clay; slab segmented into tiles and each hollowed from behind; underglazes and glazes; multiple oxidation firings, cone 06. Photo by Ken Von Schlegel

The work involves a narrative with a variety of characters who represent elemental components of a "self." They interact amidst an eclectic, often anachronistic array of images derived from history, religion, mythology, contemporary life, media, and art. Their drama, in a variety of often humorous situations, forms the dominant undercurrent of the work.

Right: **Laura Barov,** *Untitled*

1997, height: 21" (53 cm). Pinched coils, stamped with texture using porcelain clay; celadon glaze with copper red blush on top; reduction fired, cone 10

The forms I create come from an assimilation and recombination of many influences. Through the influence of modern vessel makers, I am constantly challenged as to the idea of "vessel." The study of science and nature has given me a sense that these forms are created like the biological process of growth. I strive to create an honest articulated form that exhibits spontaneity, natural balance, and fullness of volume.

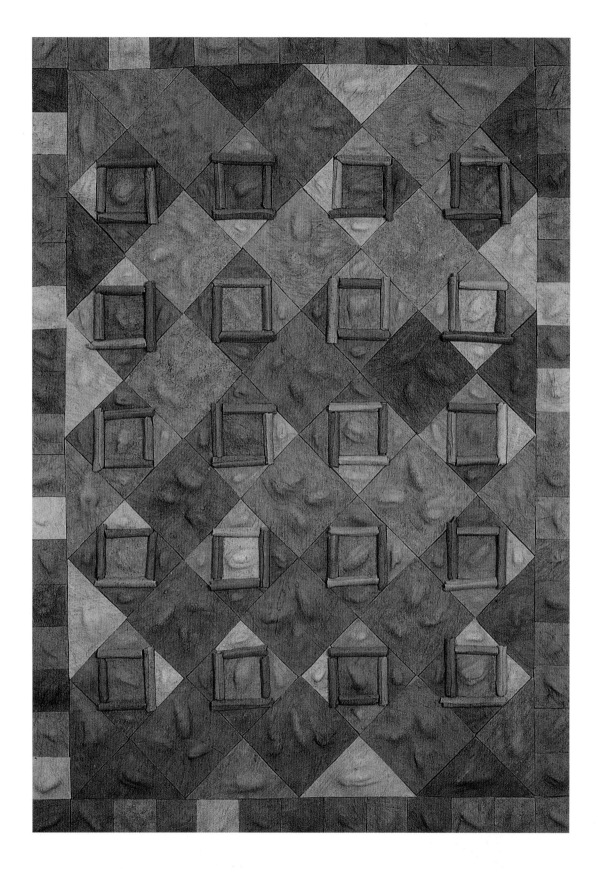

Helen Weisz, *Hobi*

1996, 54" x 38" x 1" (137 x 97 x 2.5 cm). Handmade tile; textured, relief; fired to cone 06. Photo by Randy Bye

Clay has a mind of its own: it dictates to you, indulges you, plays with you, imposes on you, forces you to see and feel, asks you to forgive and accept it, displeases you, converses with you, doesn't listen to you, and only at times does it yield and delight. Working with clay is a malady in the blood. Nevertheless, the struggle, hope, ideas, warmth, creation, pain of discovery, and search go on.

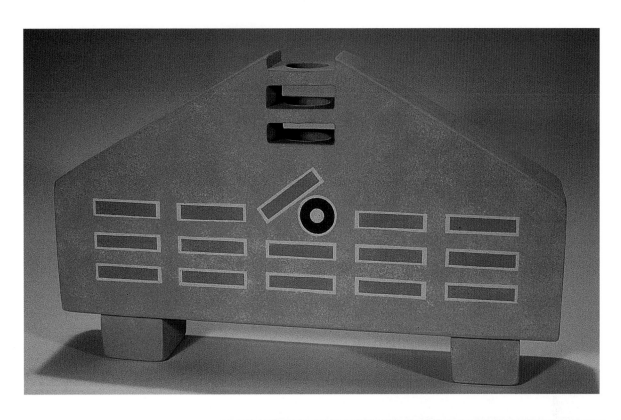

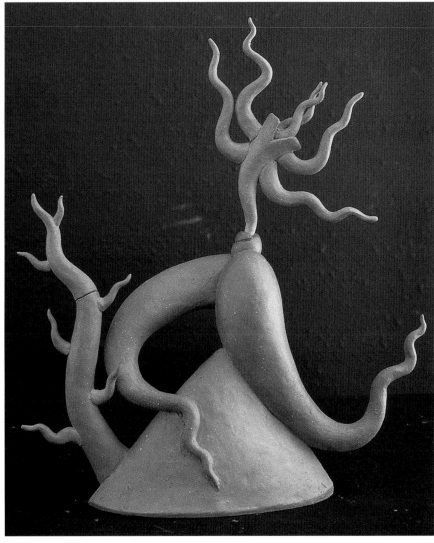

Above: **Andrew Van Assche, *Untitled***

1996, 9" x 14" x 3" (23 x 36 x 8 cm).
Slab-built stoneware; clay slips and
washes; oxidation fired, cone 5.
Photo by artist

*In this piece, my focus was on having the
surface decoration relate to the form. For
me, the slight motion in the center light-
ens things up while also referring to the
top opening.*

Left: **Michael Torre, *Dancing Shiva (tea set)***

1997, 17" x 15" x 3" (43 x 38 x 8 cm).
Hand-formed and pinch-built terra-cotta;
once-fired (oxidation), cone 05

Dancing Shiva *represents an attempt to con-
struct a traditional shiva sculpture set with-
in the form of a traditional tea set. In this
case, the legs are the teapot, the torso is
the cup, and the tree form is the tea spout.*

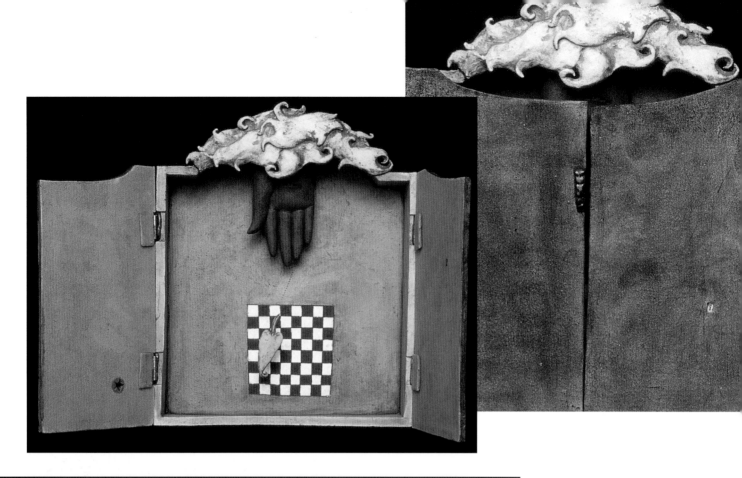

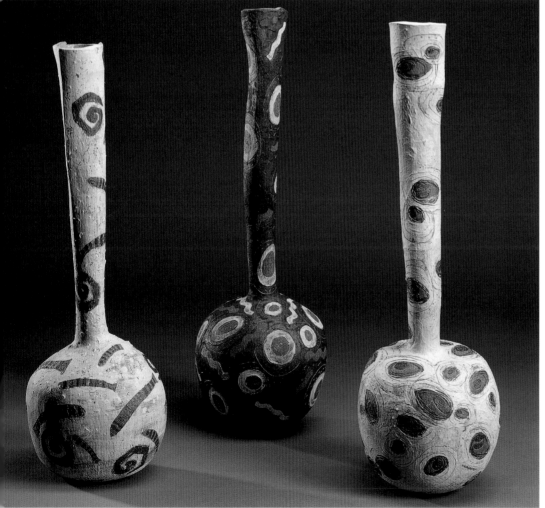

Above: **Leah Hardy, *Prognosis***

1996, 10" x 8½" x 2"
(25 x 22 x 5 cm). Slab-built
earthenware; terra sigillata,
oxide wash, glaze; fired in
electric kiln, cone 04.
Photo by Paul Jacques

Left: **Carol Townsend,
*Skeuomorphs***

1996, height: 20" to 22"
(51 to 56 cm). Pinched and
scraped narrow stoneware
slabs, started in a puki;
painted and trailed slip,
sgraffito; fired to cone 7.
Photo by K. C. Kratt

*Lessons learned from nature's
forms, with their fascinating
subtlety of movement, find
their way into my work. I have
also been influenced by the
indigenous painted pottery of
Crete, and by visits to the pot-
tery villages of Mexico and the
pueblos of the American
Southwest. Slip painting is a
joyful experience. I am always
eager to discover how the sur-
face pattern develops a collage-
like dialogue with the form
underneath.*

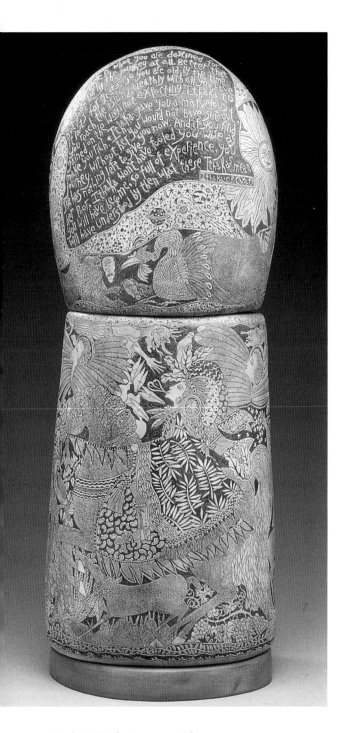

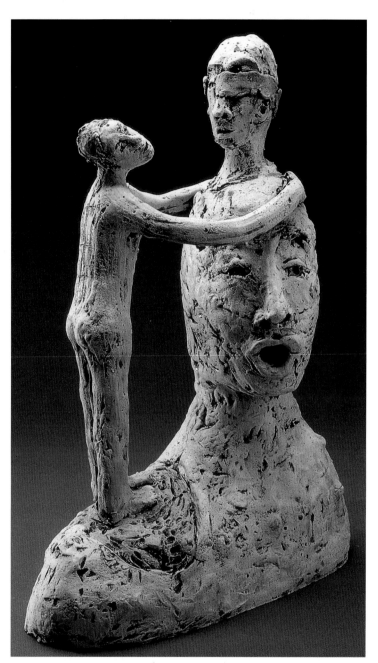

Marsha McCarthy, *Journey to Ithaca*

1996, 36" x 14" x 12" (91 x 36 x 30.5 cm). Totem pole; paddled earthenware slabs, incised when bone dry; bisque fired; underglazed; fired in electric kiln, cone 06; dyed with natural solutions, waxed, and buffed

The first time I put my hands in clay, I knew my life would change. I left my career in advertising to pursue a new career in clay and have never looked back. I found hand-building more relaxing than working on the wheel. Because my previous career required using words and images to create one idea, it seemed a natural transition for me to do the same on my clay pieces.

Debra W. Fritts, *Words of the Wise*

1997, 22" x 12" x 7" (56 x 30.5 x 18 cm). Handbuilt with slabs and coils; textured with found objects before building and after assembly; layered oxides, underglazes, stains applied between firings, diluted glazes; bisque fired, cone 02; multiple firings, cone 05 (final firing with diluted clear glaze, wiped off in some areas). Photo by Bart Kasten

The subject matter of my clay work always relates to the figure. I guess many pieces are self-portraits. The inspiration may come from my journal, relationships with people, or just a spontaneous thought in the studio. I use symbols and icons to express these thoughts. The large figure in this piece (a parent) gives advice to the child. The small head on top of the large figure is a symbol for blocking out, but also for comprehending.

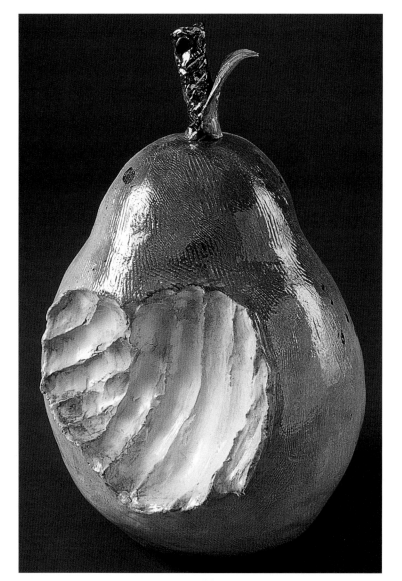

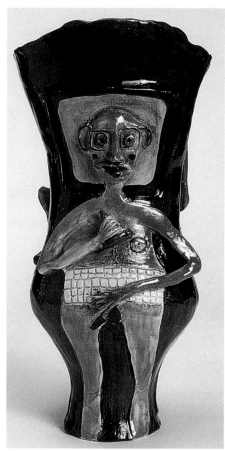

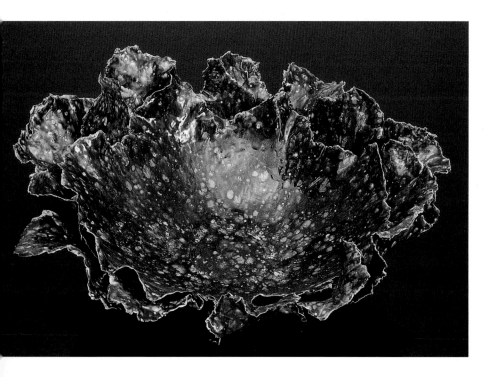

Above: **Pamela Irving, *What's Your Nick?,
I'm Joystick Man***

1997, 10¼" x 6¾" x 6¾" (26 x 17 x 17
cm). Coil-constructed white earthenware,
with modeled and cut-away clay; under-
glaze decoration, clear glaze, and low-fire
ceramic paints; bisque fired to 1000°C
(1832°F); glaze fired to 1080°C (1976°F)

Top left: **Lundin Kudo, *One Bite, Two Bites***

1997, 21" x 13" x 15" (53 x 33 x 38 cm).
Handbuilt with slabs; rasped; bisque
fired, cone 03; glaze fired, cone 04; iri-
descent, then gold; fired, cone 018. Photo
by Mark Taylor

Left: **Susie Stamm Andrews,
*Queen Victoria***

1997, 8" x 25" x 22" (20 x 63.5 x 56
cm). Handbuilt, stretched, and pinched;
multiple layers of commercial glazes;
fired in electric kiln, cone 04. Photo by Guy
Freeman, Photography

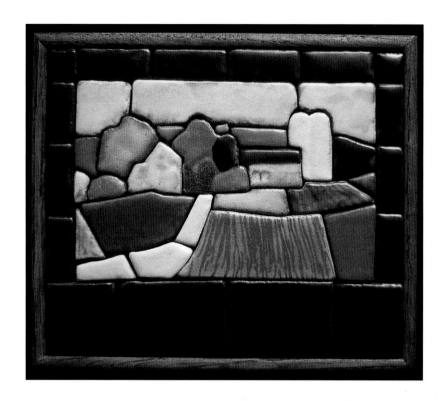

Above: **Gretchen Heuges, *Route 45***

1997, height: 7" (18 cm). Slab-constructed terra-cotta, incised, cut, and shaped; brushed underglazes; bisque fired, cone 04; glazed; glaze fired, cone 06; colors adjusted with glaze; fired again, cone 06

My mosaics measure less than 10" x 10" (25 x 25 cm) and contain between 20 and 50 pieces each. The process of working with so many small tiles is time-consuming but very meditative. I was born and raised in a suburb of Philadelphia; the move to central Pennsylvania had a great impact on the imagery in my work. The landscapes are from drawings of the farms near my new home.

Right: **Sandra Luehrsen, *Stardance***

1997, 20" x 16" x 12" (51 x 41 x 30.5 cm). Terra-cotta; coiled body and carved base assembled when leather hard, smoothed; then nichrome wire inserted, "beads" added to wire; layered slips and glazes applied at leather-hard stage and after bisque firing; fired in electric kiln, cone 06. Photo by artist

My work explores the symbolic and anatomical heart forms. Although my works are not functional, I use a vessel format. The heart form carries the same timeless quality as that of the vessel.

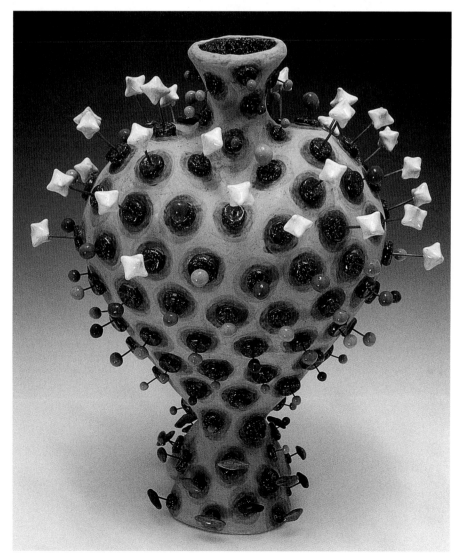

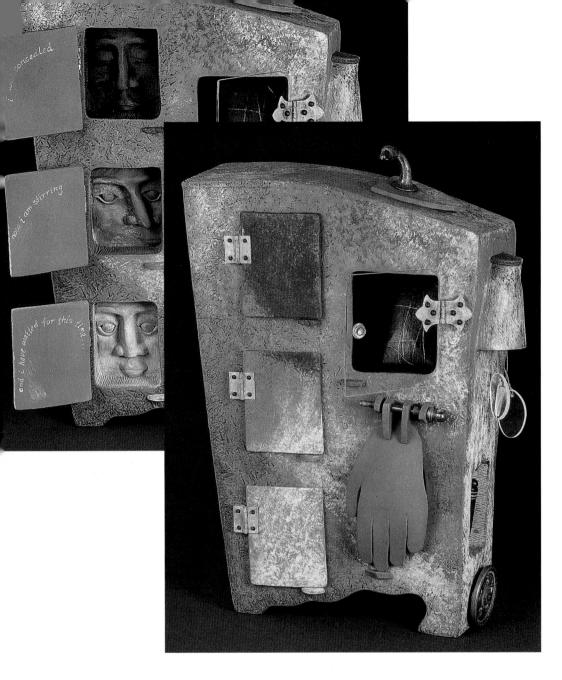

**Marjolaine Renfro,
I Was Concealed**

1997, 16" x 11" x 3½" (41 x 28 x 9 cm). Handbuilt, slab constructed, texture created with rice-covered paddles and small carving tools; oxide-tinted terra sigillata, additions of antique hardware, found objects, glass, velvet, paper, patinated copper and brass; oxidation fired, cone 04. Photo by Michael Olenick

My current body of work is in the form of boxes. These Boxes of the Soul confront the viewer with questions. What if boxes held our dreams, loves, souls, desires, memories, secrets, treasures, emptiness waiting to be filled? They are about communicating the universal journey to personal integration. As individuals, we go beyond the known to discover, to ask questions, to make the discovered tangible, and to return with our offerings. These works are my offerings. They are here for you.

Thimo Pimentel, Conefish Box

1998, 3" x 3" x 5½" (8 x 8 x 14 cm). Clay, pyrometric cones, iron key, wire; raku glazes, engobes, underglazes, chalk underglazes, torch fire on saturation engobe; raku fired, 1050°C (1922°F). Photo by artist

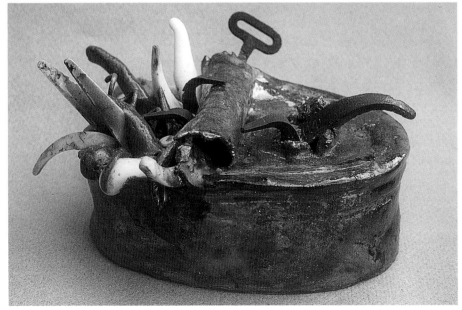

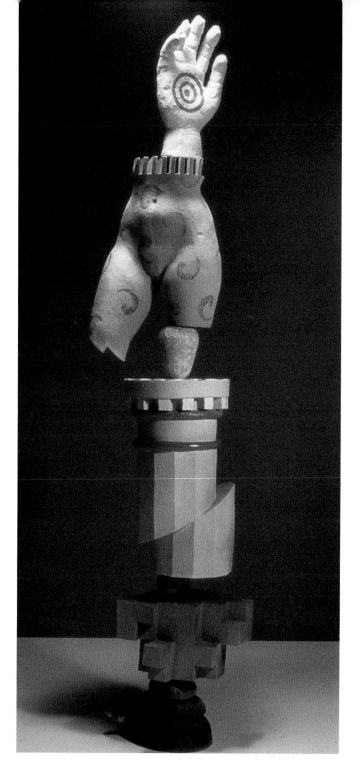

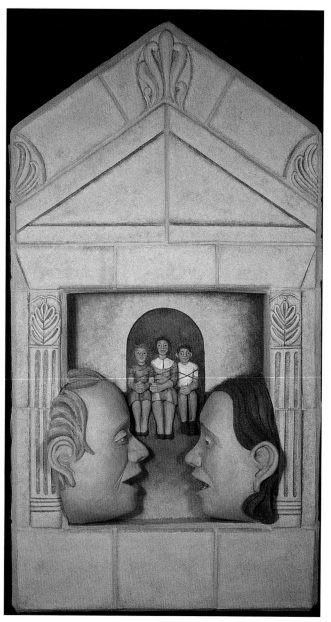

Michael Hough, *Shifted Classic Form*

1997, 81" x 29" x 27" (206 x 74 x 69 cm). Handbuilt components: coil constructed and slab assembled, with figure press-molded from found mold; all elements gravity-held on steel armature; vitrified slip, sprayed and brushed underglazes and commercial glazes, oversprayed with Gerstley borate; oxidation bisque fired, cone 1; glaze fired, cone 06-04

My attempt is to create an organization of a lot of dissimilar elements that are of interest to me. I start with a large number of "parts," placing them together in different ways, searching for a visual and emotional relationship among them. I tend to allow my intuition to make the decisions. Through a combination of elements, an overall feeling emerges, creating a subtle narrative.

Carrie Anne Parks, *In Loco Parentis*

1997, 27" x 15" x 5½" (69 x 38 x 14 cm). Pinched and slab-built terra-cotta, on wooden support with colored grout; painted underglazes; oxidation fired, cone 04. Photo by artist

My work with clay reflects an ongoing interest in historical architectural and ceramic forms while exploring contemporary themes through personal (often autobiographical) imagery. As a ceramic sculptor, I feel deeply the influence of those figures made for the tombs of ancient Chinese and Japanese nobles—Haniwa courtiers and farmers, Han dwellings and processions, T'ang horses, and Q'uin soldiers. The eloquent gestures and facial expressions of Mayan and Olmec figures and the serene dignity of Etruscan terra-cotta couples never fail to move me. While I admire the technical virtuosity of these sculptures, I find even more compelling the idea that forms so realistically specific may also be magically symbolic. That is how I would like my own work to function.

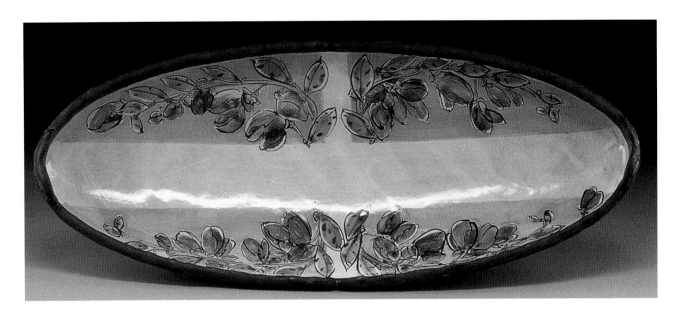

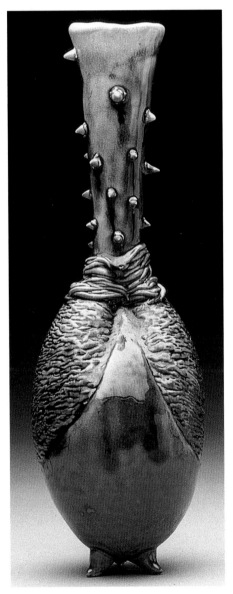

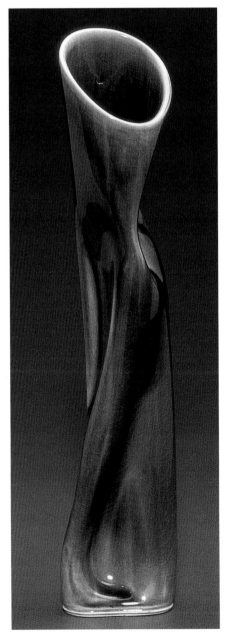

1996, 4" x 19" x 8" (10 x 48 x 20 cm). Handbuilt slab, pinched rim; majolica, colored terra sigillata on rim; fired in electric kiln, cone 03

I like a practical form with spontaneous brushwork on its surface. Modulated color and lively line quality add zip to the surface within an organized motif.

Far left: **Melissa Gaskins, *Cock-n-Bull Vase***

1997, 12½" x 5" x 4½" (32 x 13 x 11 cm). Coiled, body and surface altered and carved, handbuilt additions; underglaze with copper glaze over, wiped away in some areas to expose clay surface; oxidation soda fired in gas kiln, cone 10 porcelain

Left: **Ginny Conrow, *Silhouette Vase***

1996, 15" x 3" x 3" (38 x 8 x 8 cm). Extruded, altered, and cut; sprayed glazes; fired in gas kiln, cone 10.
Photo by Doug Yaple

My pieces exhibit my strong interest in form—sculpting the porcelain into out-of-round shapes that are organic and sometimes almost figurative. I am inspired by natural forms: rocks, flowers, shells, and coral. I use clay to discover a curve and flow of movement, and it is the hands-on moving of clay into shapes that continues to intrigue me.

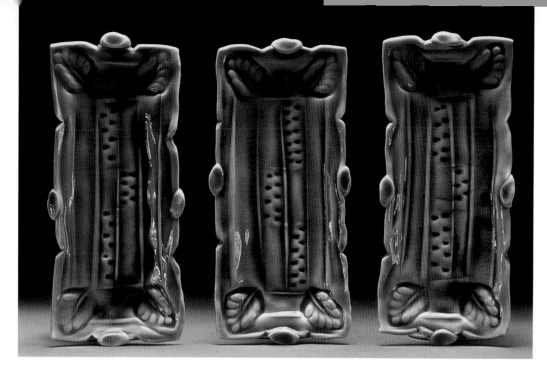

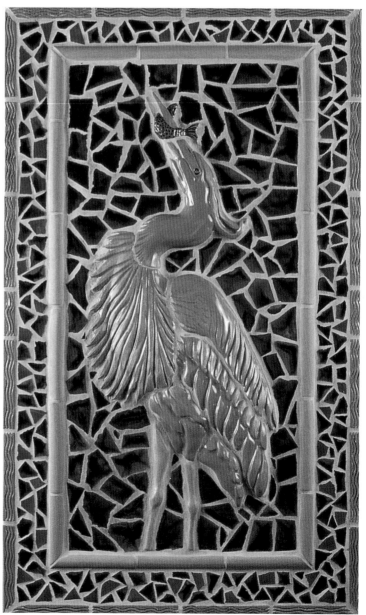

Above: **Polly Ann Martin,** *Butter Plates*

1997, 1" x 4" x 9" (2.5 x 10 x 23 cm). Slab construct-
ed, stamped detail; brushed glazes; oxidation fired
(mid-range porcelain). Photo by Frank Martin

*Handcrafted domestic pottery universally enjoys a unique
and intimate status in our lives, moving from the every-
day to the exceptional, offering itself as a participant in
the daily celebration of human activity. Whether ceremo-
nial or commonplace, pottery affords a personal relation-
ship between the user, the body, and the vessel itself.*

*It is a constant challenge to make pots that function on
many levels. My aim is to produce functional pieces in
which the visual, the tactile, and the useful are inte-
grated and coexist simultaneously. I believe that
domestic pottery can transform the home where it
exists, for it is at "home" that we are most comfortable
receiving information.*

Right: **Reneé O'Connor,** *Heron Mosaic*

1997, 48" x 30" x 2½" (122 x 76 x 6 cm). Carved
relief image with extruded moldings and handmade
mosaic pieces; glazed and unglazed pieces; fired in
electric kiln, cone 6; mounted on exterior plywood
and grouted. Photo by Courtney Frisse

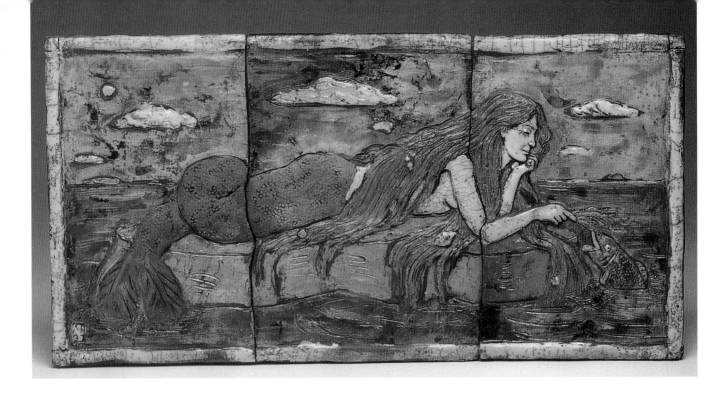

Above: **Anne Lloyd, *Mermaid***

1997, height: 12" (30.5 cm). Tiles, slab, and 3-D modeled mermaid; raku and low-fire commercial glazes; raku fired. Photo by John Carlano

Left: **Sandra K. Tesar, *Southern Morning***

1997, 11⅜" x 8¾" x ¼" (29 x 22 x .6 cm). Rolled and cut slab with hand-etched drawing; applied stained porcelains, raku and commercial glazes, underglazes; bisque fired, cone 08; raku fired between 1725° and 1750° (941°C and 954°C), reduced in newspaper and sawdust, water quenched. Photo by Jerry Anthony Photography

At two, I had a word for paper and pencil: "sash." Since then, my focus, schooling, and living have been made on paper and canvas. In 1983, I began translating these materials into three dimensions, and the result was ten years of creating Victorian architecture and gardens in clay. The last several years have been a journey, searching to blend my two-dimensional past with my three-dimensional present. This journey has culminated in hand-etched raku art tiles, urns, and classical wall pockets. Issues of the spirit, of control, and of creativity in craft as art and art as craft come together for me here.

Right: Helen Phillips, *Caught in the Madness*

1996, 29" x 10" x 12" (74 x 25 x 30.5 cm). Coil-built stoneware, scrap metal added to form; terra sigillata, raku glaze; raku fired, cone 06

A friend of mine gave me the metal to use in my animal forms. He is 88 and used to make machines with these parts. This gave him as much joy as I get from making my clay pieces. Yet today I see machines as a threat to our environment. I feel an almost desperate need to reconnect with nature in much the same way he felt the need to "overcome" it.

Below: Robin Mangum, *Raku Fiddle*

1996, 9" x 22" x 2¾" (23 x 56 x 7 cm). Hand-formed, slab-built, high-grog stoneware; tailpiece, chin rest, fingerboard, and pegs are ebony; clear crackle glaze on white body; raku fired, cone 06. Photo by Al Nuckols

Being a fiddler myself, I find it exciting to be able to combine my love of music with my life as a potter/clay artist. It is also fascinating to work with the resonant and tonal qualities of ceramic.

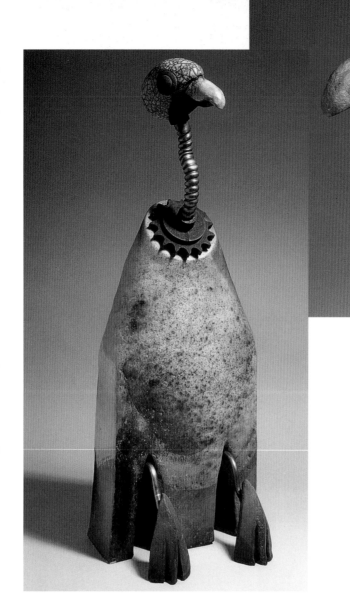

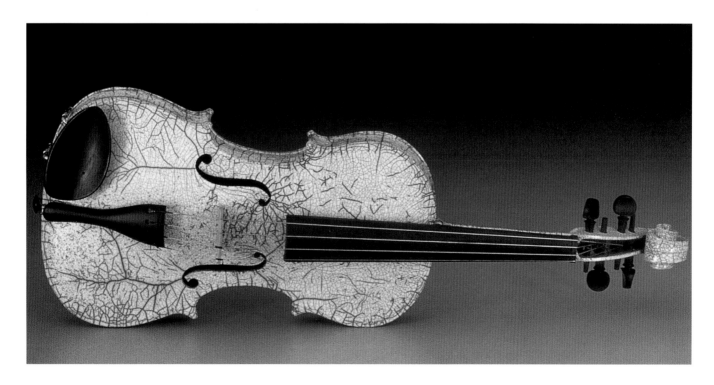

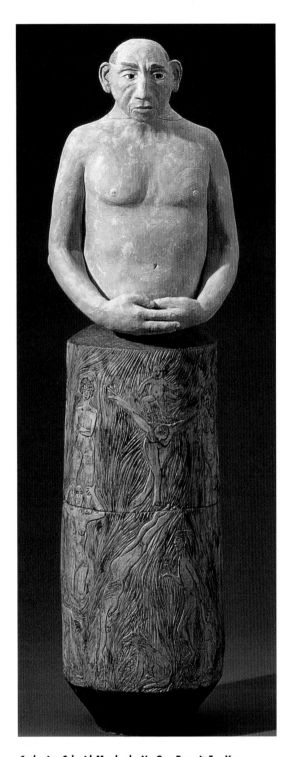

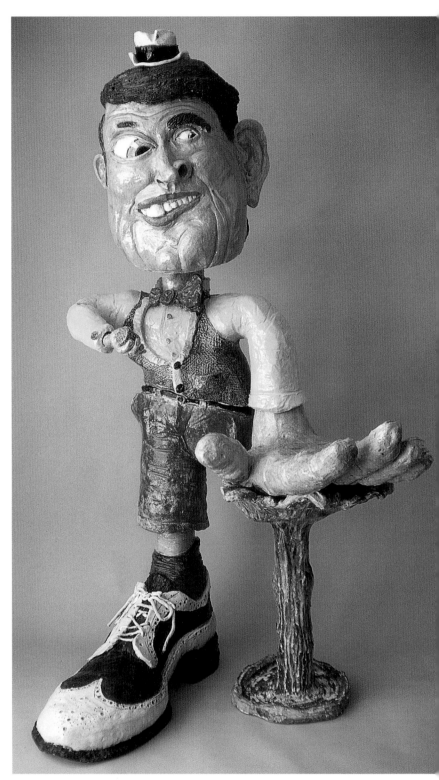

Catherine Schmid-Maybach, *No One Does it For You*

1997, 71" x 21" x 19" (180 x 53 x 48 cm). Base:
coil built on wheel and carved; coiled figure;
underglaze, matt and textured glazes; bisque fired
in electric kiln, cone 5; glaze fired, cone 05. Photo
by David Belda Photography

*As a ceramic sculptor, I use clay to give form and
meaning to my ideas and feelings. With my hands and
clay, I portray the human condition filtered through my
personal experience. Most of my sculptures are narra-
tive, embodying specific stories of my life or the more
universal stories of myths, history, and tales from
around the world.*

Tony Natsoulas, *Altered Ego*

1997, 85" x 40" x 50" (216 x 102 x 127 cm). Slab built; layered low-fire
glazes over hand-textured surfaces; bisque fired, cone 02; glaze fired, cone 06

*Lately, I have been doing sculptures that are intuitive from the start—removed
from any preconceived ideas. I just start with the shoes, and the idea and per-
sonality grow with the sculpture. The notion of creating the whole piece intu-
itively came from the frustration of trying to convey specific messages to viewers
who inevitably came up with their own interpretations, thereby missing my
point. I realized that what was important was that the image sparked a viewer
to think or react.*

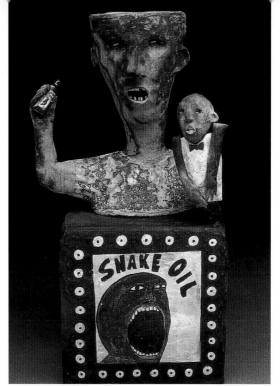

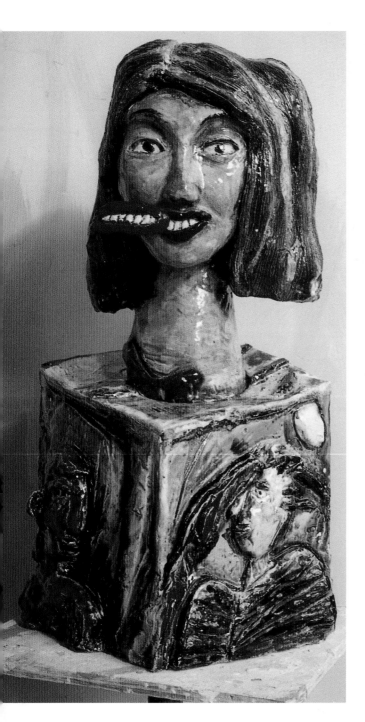

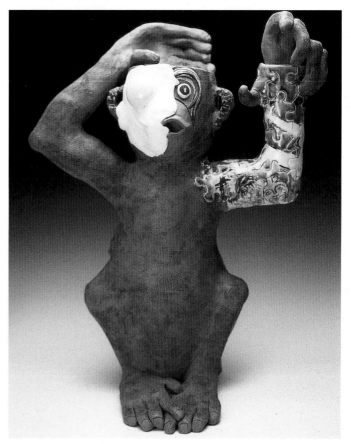

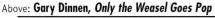

Above: **Gary Dinnen,** *Only the Weasel Goes Pop*

1997, 31" x 14" x 15" (79 x 36 x 38 cm). Handbuilt slab construction; slabs scored and wetted, shaped with hands or mallets, cut into geometric shapes to create figure; underglazes applied to greenware, gloss glaze; bisque and glaze fired in electric kiln, cone 04 and cone 06 respectively

Top right: **Wesley Anderegg,** *Snake Oil Man Cup*

1997, 10" x 6" x 4" (25 x 15 x 10 cm). Pinched and slab built; slips and glazes; fired in electric kiln, cone 06.
Photo by artist

Above: **Carol Gentithes,** *Monkey Business*

1996, 18" x 10" x 6" (46 x 25 x 15 cm). Vase; handbuilt with coils; arm with puzzle cast was cut from actual puzzle pieces and then reassembled on the arm; monkey is hollow and has an opening at the top for flowers; hand on top of head is placed to appear as if it's holding the flowers; body textured with toothbrush; colors and surface design chosen to contrast with body; multiple firings in electric kiln, cone 05. Photo by Fred Johnston

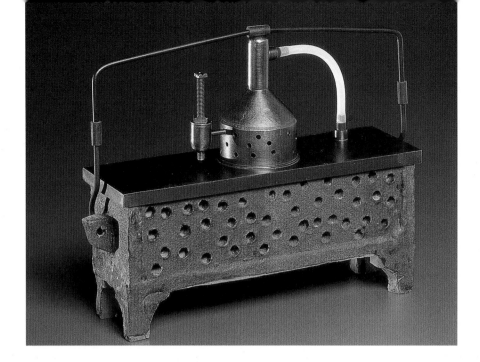

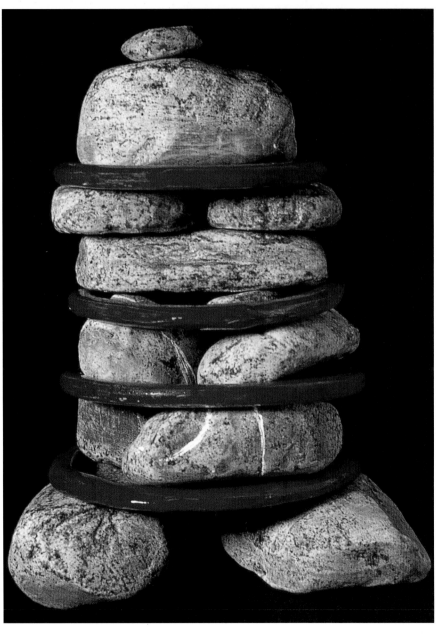

Above: **John Goodheart,** *Fra Bernardo's Sin Maker*

1996, 6" x 9" x 3" (15 x 23 x 8 cm). Slab-built earthenware body with pierced decoration on sides; copper lid, heat treated to blacken; copper tubing; oxidation fired, cone 06 and cone 010.
Photo by Kevin Montague and Michael Cavanagh

Left: **Dee Dee Hakun,** *Rock Hard Body*

1997, 22" x 14" x 14" (56 x 36 x 36 cm). Paperclay/earthenware; coiled body, extruded rings; slips and glaze; bisque fired, cone 06; glaze fired, cone 07

I cannot trust my thoughts. They lead me with promises of so many adventures, but they all finally head for the same safe cement. I find my hands the more honest and trustworthy explorers—refusing to be tricked by thought, able to circumvent my most fortified mental constructions, leading me always to a fuller mystery. I am continually surprised at what my hands do that my mind would block me from ever conceiving. In their honor, I named a recent piece Senza Pensiero, an Italian saying for "no brains." For me, it is an expression of wonder, not of loss, as I mindlessly follow my hands into wide-awake dreaming, where they insist themselves through clay.

Right: **Kevin A. Hluch,** *Yellow Teapot*

1997, 7½" x 9" x 6" (19 x 23 x 15 cm).
Slab-built porcelain, with impressed decoration; stains and glaze; oxidation fired, cone 6. Photo by Joel Breger

Below: **Kyle Hallam,** *Sunrise Over Hell*

1996, 13½" x 15" x 4" (34 x 38 x 10 cm).
Slab-constructed terra-cotta; cut slab shapes bisque fired, then individually glazed (glazes, underglazes, stains), and assembled on bisqued-tile backing, also heavily glazed; entire assembly fired in electric kiln, cone 04; parts fused by glaze

I wish I could be there in 100,000 years when they discover my artwork buried under layers of volcanic ash. That's what I like about clay—it lasts.

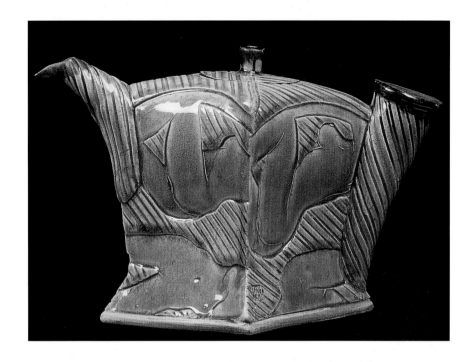

Top: **Susan MacDougall,** *Bamako Tray*

1997, 2" x 7" x 15" (5 x 18 x 38 cm). Coil and slab-built porcelain; celadon glaze with black stain sgraffito, and trailed green glaze; oxidation fired, cone 9.
Photo by Robert Nicoll

Center left: **Angi Curreri,** *Palm Tree Cup*

1997, 11½" x 10" x 8" (29 x 25 x 20 cm). Five parts hand-formed from mid-range red clay by pinching, paddling, and pounding; hollowed if necessary, refined with Surform scraper and other tools; attached, textured, further refined; multiple coats of commercial glazes; bisque fired in electric kiln, cone 6; multiple glaze firings, cone 06. Photo by Neal Bradbeck

Above: **Mia Tyson,** *Pitcher*

1997, 20" x 12" x 5" (51 x 30.5 x 13 cm). Slab-constructed porcelain, with carved rim, pulled handle, and added decorations; sprayed slip, sgraffito; bisque fired in electric kiln; fired in gas kiln, cone 11. Photo by Diane Davis

My body of work expresses an inner yearning to reach beyond what is or will be. In such a diverse world, people tend to wear many faces. Faces reveal an abundance of contradictory notions. In my attempt to capture this diversity, my work proceeds in the direction of a whimsical nature, moving this way and that, taking on images, and essences of birds, ladies, body appendages, and always in prominence—the profile.

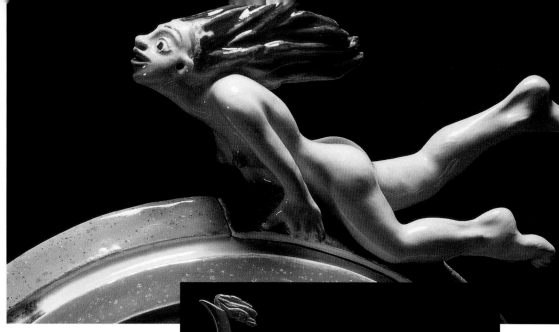

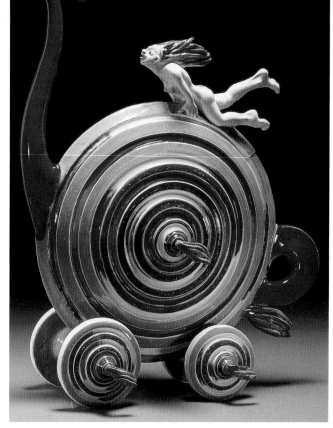

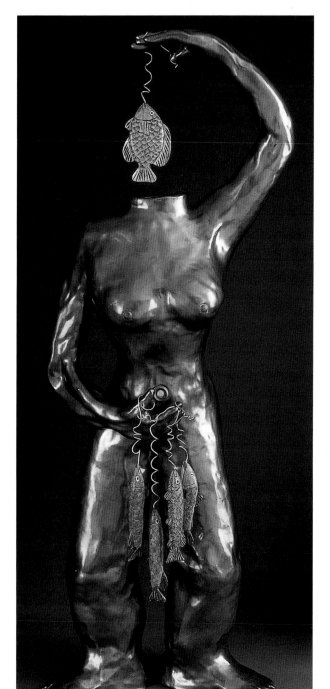

Above: **Ania Malkowska, *Wheels on Fire! #III***

1997, 14" x 14" x 5" (36 x 36 x 13 cm). Wheel thrown, altered, and sculpted; underglazes and glazes; multiple firings, cone 06, cone 05, and cone 04. Photo by Bob Kolbrener

Energy and movement are fun if you can go with the motion and stay centered, but the faster you spin, the more centered you have to be, or else the centrifugal force will send you flying. This is the heart of throwing clay. At the center of the clay there's energy, but there's stillness as well.

Left: **Gayla Lemke, *... And She Thought She Had Escaped***

1997, 28" x 12" x 8" (71 x 30.5 x 20 cm). Handbuilt using slabs, coils, and pinching; commercial "gunmetal" glaze on figure; fired in gas kiln, cone 06; balsa-wood fish hand-colored with prismacolor pencils and attached to 20-gauge wire. Photo by John Bonath, Maddog Studio

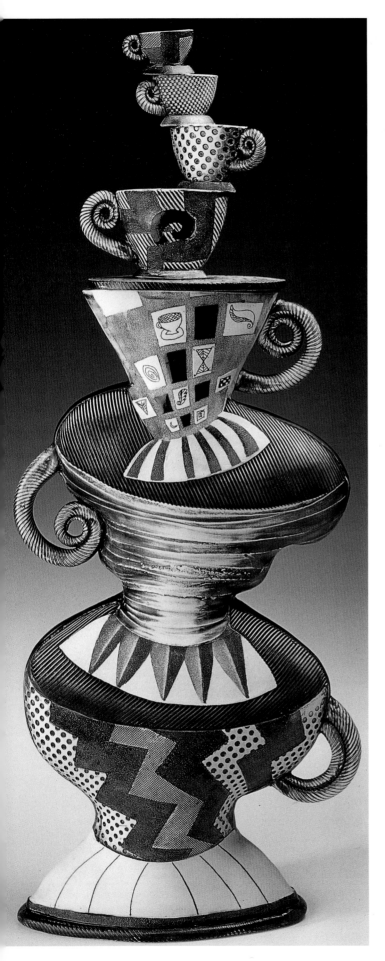

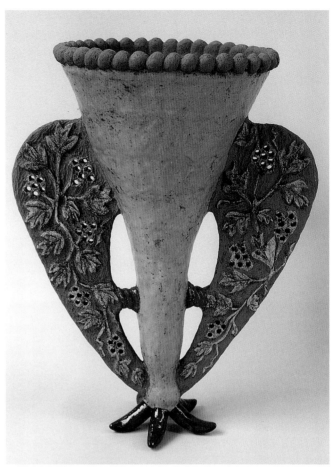

Above: **Priscilla Hollingsworth, *Moorish Vessel with Vines***

1997, 20" x 16" x 11" (51 x 41 x 28 cm). Coiled and pinched; glaze, oxide, underglaze, and overglaze; oxidation fired, cone 04-018

If I had lived in another time, I might want my work to appear to be technically perfect, with smooth surfaces seemingly untouched by the human hand. As a contemporary artist, however, I recognize that I live in a materially wealthy society in which perfect (but soulless) machine-made replicas can be purchased cheaply in any discount department store. I follow in the long line of artists from William Morris (in the mid-nineteenth century) to the present day, who make the antidote to the mass-produced object: the thoroughly handmade object of beauty meant to be present in the daily life of the home.

Left: **Anne Schiesel-Harris, *Tumbling Teacups***

1997, 29" x 13½" x 4" (74 x 34 x 10 cm). Slab built; textured, incised, and pressed; stains and glazes; oxidation fired, cone 6.
Photo by Allen Bryan

I have always been drawn to slab building. In my current work, I like playing with the illusions of three-dimensional space and flat planes. These pieces reflect my interest in figurative pieces, although they are becoming more abstract.

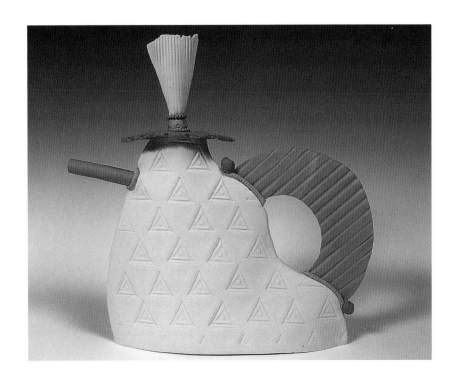

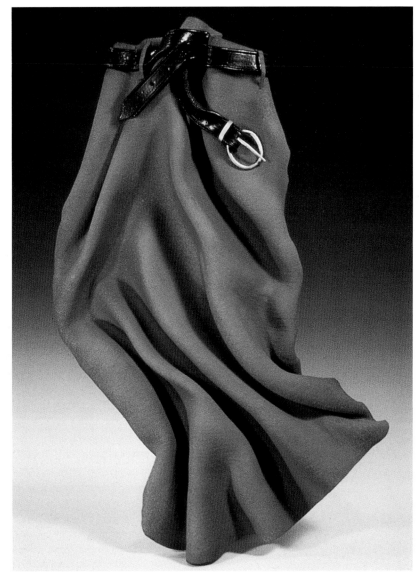

Above: **Mary Carolyn Obodzinski,** *Teapot*

1997, 9" x 10" x 3" (23 x 25 x 8 cm). Slab-formed colored porcelain; unglazed exterior, textured with stamps, gadgets, etc.; glazed interior; fired to cone 5. Photo by Ann Nevills

Function continues to be a very important aspect of how people relate to pottery. I have combined my fascination with sculpture and the need for function to create these "funky" but functional teapots. A teapot is an interesting and challenging vessel to create; the many components must meld together just right. All this, plus a little fantasy, humor, and imagination. I've given each piece a little of my own personality—funky but functional! I can't forget to mention color. For me, that's the best part and in many ways, the most important component of every piece I make.

Right: **Susan Goldstein,** *Dancing in Blue: Skirt*

1996, 30" x 16" x 2" (76 x 41 x 5 cm). Canvas-textured slab, stretched and draped; extruded belt; sprayed mason stains, brown glaze on belt, gold enamel on buckle; fired in electric kiln, cone 4. Photo by artist

The ceramic clothing series explores the relationship between motion/emotion and self-identity/dress. Both confusing and intriguing, these pieces appear to be fabric but are really clay. Although the colors and draped forms imply softness, the clay is hard and rigid, visually deceiving the viewer.

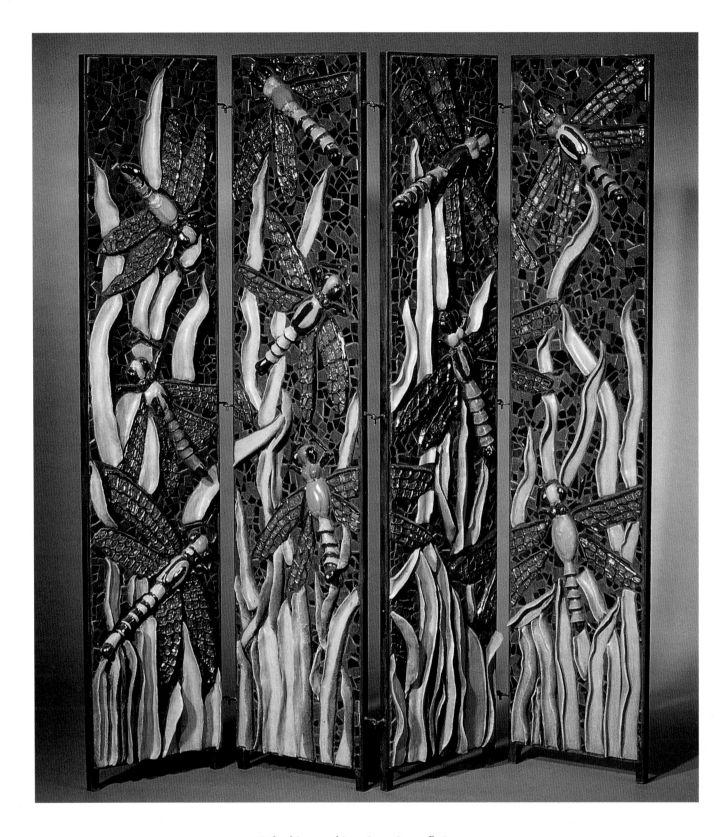

Richard Sager and Doug Scott, *Dragonfly Dance*

1997, 72" x 78" x 6" (183 x 198 x 15 cm). Hand-formed dragonflies, broken background tiles for mosaic detail, dragonfly wings covered with broken glass tile; oxidation fired in electric kiln, cone 5. Photo by Marshall Williams

The main emphasis of our work is the combination of heavy relief sculpture with mosaic, both as background and as integrated parts of an overall piece. This process results in multi-layered work, with forms ranging from tables and large architectural screens to life-sized (and larger) wall installations. Influences for these pieces come from nature and the human form.

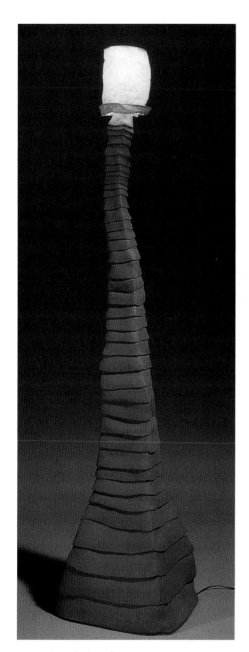

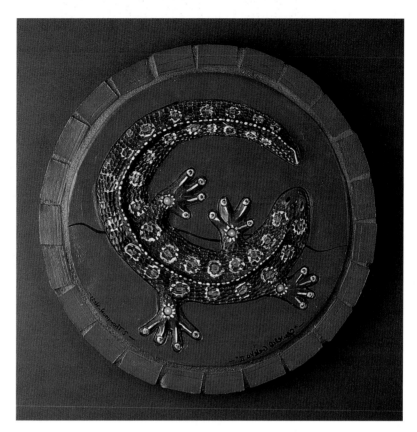

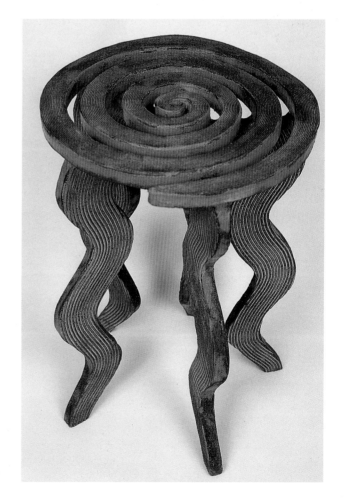

Above: **Pascale Girardin**, *Lamp*

1997, height: 68" (173 cm). Red earthenware; handbuilt, assembled in three parts; Japanese washi paper shade (also made by artist); once-fired in electric kiln, cone 02. Photo by Paul Litherland

Top right: **V. Thompson-Hess**, *Jeweled Gekko*

1996, diameter: 16" (41 cm). Hand-rolled tile mosaic wall hanging; center tile built up with added terra-cotta clay, then sculpted; underglazes and engobes on lizard; once-fired in electric kiln, cone 06. Photo by Michael Coppes

I love color, and I love to experiment. I teach art in my studio to 25 children every week, and I think they help me keep my work fresh and whimsical. I don't take myself too seriously; I have fun with the clay! If it makes others smile, I've accomplished my goal.

Right: **Debra Belcher Chako**, *Spiral Table*

1996, 17" x 13" x 13" (43 x 33 x 33 cm). Shapes cut from heavily grogged red sculpture clay slabs, then joined; iron oxide wash, matt turquoise glaze rubbed with damp sponge to reveal texture; oxidation fired, cone 6. Photo by Kate Johnson

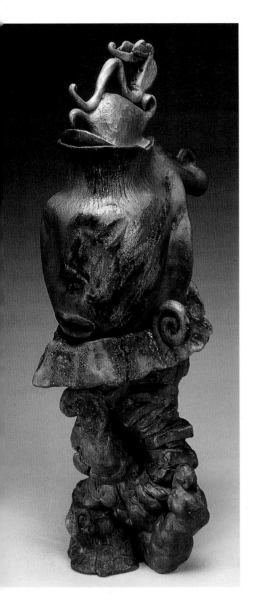

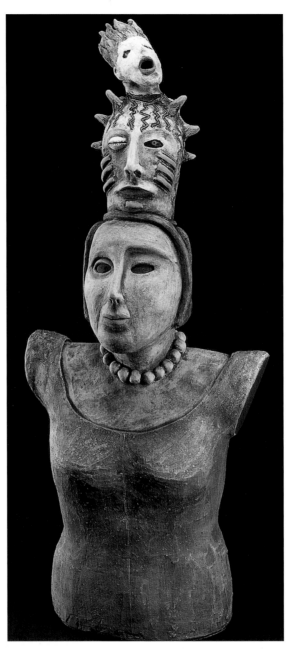

Top left: **Rosalinda Kiese, *Double Identity***

1997, 21" x 8" x 9" (53 x 20 x 23 cm). Handbuilt (coiled, pinched, slab constructed), incised, and textured; glaze, red iron oxide wash; bisque fired in electric kiln, cone 06; glaze fired, cone 6; fired quickly with sawdust

When I think of pottery, the word "creation" comes to my mind because there is no limit for an individual, like me, to create a piece of art—just by manipulating the clay. Therefore, as a potter, I prefer handbuilding because the technique lets me be "free as a child" to create a piece that I can honestly call "my own" from start to end.

Top right: **Barb Doll, *Demon Mother***

1997, 35½" x 15" x 9" (90 x 38 x 23 cm). Sculpted (using coil technique) from white stoneware clay; head can be removed; underglazes, slips, and engobes; oxidation fired, cone 6; multiple firings, cone 04. Photo by Bart Kasten

Left: **David JP Hooker, *Prophet Cups and Tray***

1997, 6" x 18" x 6" (15 x 46 x 15 cm). Slab-built tray, pinched cups with porcelain highlights; low-fire fritted glazes applied and wiped off in some areas; fired in electric kiln, cone 06

In my work, I attempt to bridge the gap between "outsider" art and "fine" art.

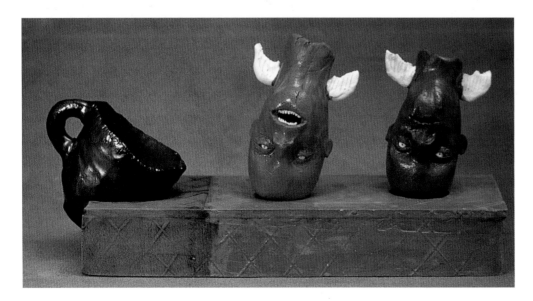

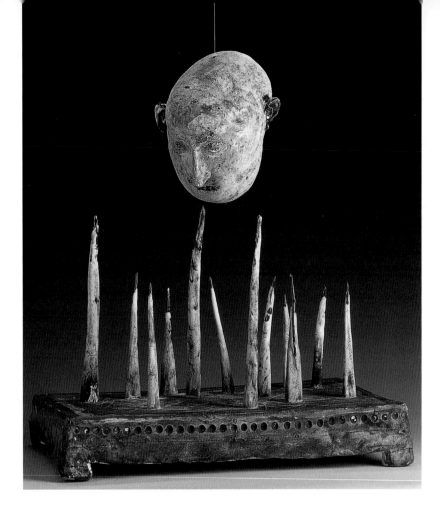

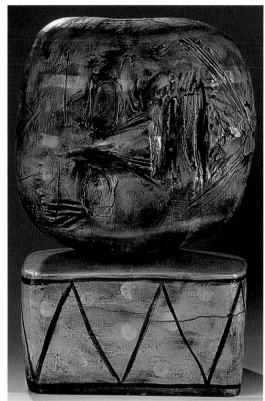

Above: **Alan E. Cober,** *Silence = Death*

1997, 23" x 19" x 12" (58 x 48 x 30.5 cm). Coil-built head, slab-built base; black underglaze, with sgraffito and low-fire glazes; head fired in electric kiln, cone 05; base fired in gas brick kiln, cone 05

For four decades years, I have been a social commentator and visual journalist. I have drawn and documented several issues, such as those related to prisons and to the aged and retarded, and events such as the Pope's tour in 1987 and the presidential campaign in 1980. In the past year, I have committed myself to making clay with many of the same social concepts. It seems to be working.

Top right: **John A. Taylor,** *Head on Block*

1996, 29" x 18" x 13" (74 x 46 x 33 cm). Coiled construction, formed and carved; slips, stains, and glazes; oxidation fired in electric kiln, cone 5-6. Photo by John Polak

Most of my work deals with the figure in a semi-autobiographical manner.

Right: **Valerie St. Jean Gilbert,** *Large Effigy Vessel: Fugit Hora #4*

1997, 20" x 16" x 18" (51 x 41 x 46 cm). Pinched coils; engobes, slips, and underglazes; multiple firings, cone 06; refired once, cone 5-6. Photo by Bart Kasten

My work is inspired by Head Effigy Vessels made by the Mississippi Indians between the 13th and 17th centuries. My effigy vessels represent the loss and restoration of the soul.

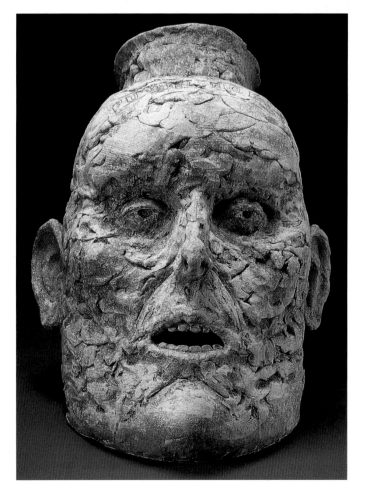

97

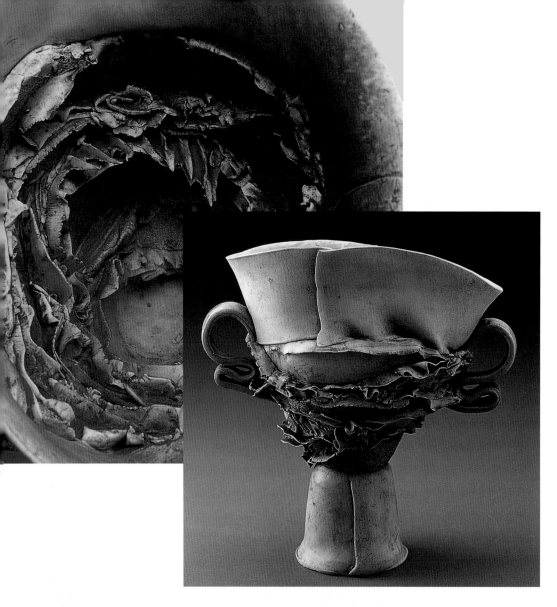

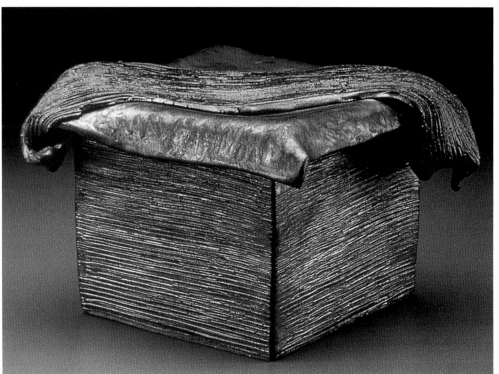

Top: Elaine O. Henry, *Loving Cup*

1997, 9" x 9" x 7" (23 x 23 x 18 cm). Base and lip built from hand-tossed slabs, built-up textural areas; layered rutile and oxides; reduction fired in gas kiln, cone 10 porcelain.
Photo by Larry Schwarm

I treat the process like a conversation with someone who has a great deal of wisdom. As the pieces take form, the clay reveals its qualities in each interaction. I talk and I listen.

Left: Susan Goldstein, *Box I*

1997, 8" x 8" x 8" (20 x 20 x 20 cm). Slab-built sides and bottom, draped slab top with combed piece on top to match sides; gold/black metallic glaze, combed surface; fired in electric kiln, cone 6 stoneware. Photo by artist

The box becomes an innovative and evolving work of art by combining traditional form with creative technique. This classical form has been transformed by my personal expression of shape, material, and color.

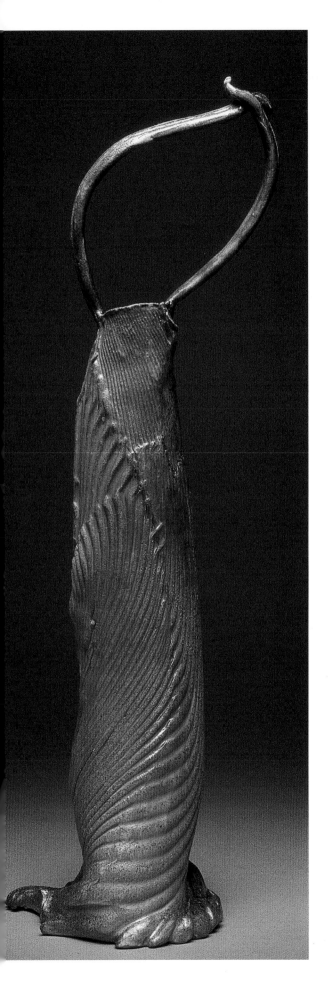

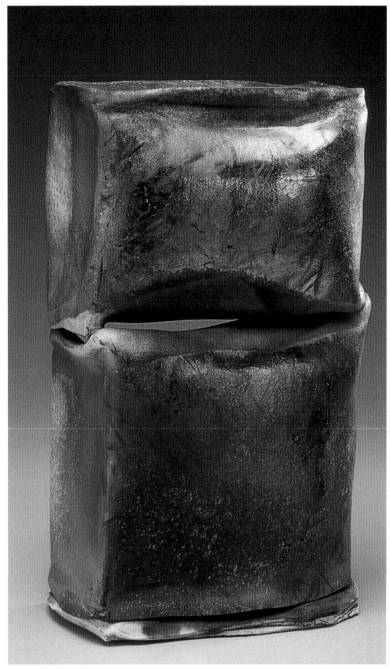

Above: **Penny Truitt, Canyon Walls III**

1996, 15" x 8½" x 5" (38 x 22 x 13 cm). Slab-built forms, paddled to fit when stacked, with separate slab-built base; raku fired. Photo by Chris Stewart

I find that making pieces from thin slabs allows an interplay of soft surfaces and decisive edges. Nonsymmetrical shapes that contain darkness demand accents which imply movement and direction toward the inner space. Involvement in the process is of central importance. To capture the marks of the smoke and flames, I fire each piece in a raku kiln and have chosen a palette of matt glazes. I want the skin of the piece to be imbued with the action of the firing—the random drift of quiet flame printed on the clay.

Left: **Marta Matray Gloviczki, Dansket**

1997, 24" x 6" x 6" (61 x 15 x 15 cm). Slab-built stoneware, with wire-cut relief pattern; brushed slip; wood fired, cone 12, with added salt.
Photo by Peter Lee

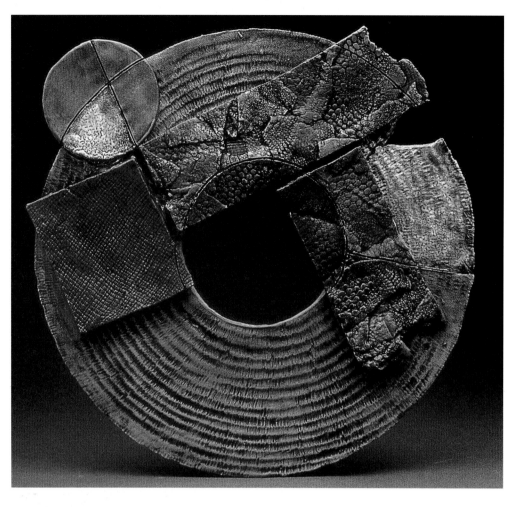

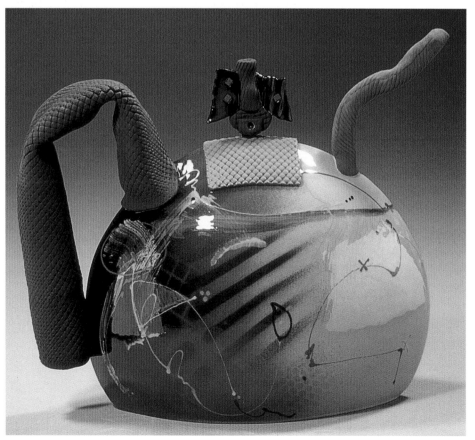

Top: **Stacy A. Phillips,**
Construction Platter

1997, 16" x 15" x 3" (41 x 38 x 8 cm). Slab built and altered, embossed texture created with baskets, lace, stamps; velvet glazes; multiple firings, cone 04-06. Photo by Brent Herridge

I like to play with clay. Texture and color are things that I respond to, and I want my pieces to reflect this. It is also important to me that the viewer want to touch the piece and have contact with the clay.

Left: **Michael Kifer, *Teapot***

1995, 15" x 13" x 6" (38 x 33 x 15 cm). Slab built, with added texture; sprayed, brushed, and slip trailed, then clear glazed (texture is underglazed only); fired in electric kiln, cone 05. Photo by artist

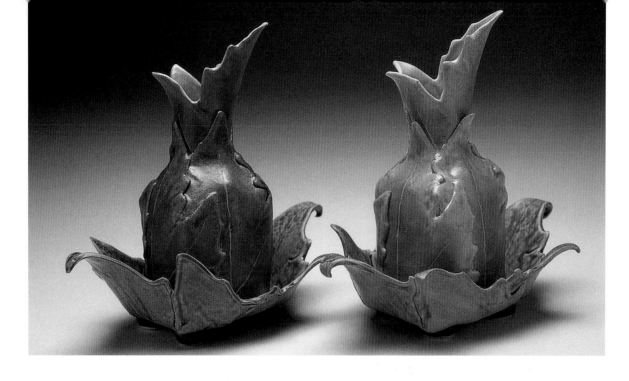

Above: Betsy A. Rosenmiller, *Syrup Pitchers*

1997, 6½" x 6½" x 3½" (16.5 x 16.5 x 9 cm). Slab built out of individual leaf shapes; glaze fired in electric kiln, cone 5; china paint fired, cone 018

My work is about organic time and the growth process. This is why nature, and specifically leaves, play such an important role in the surface design of my pieces. For me, leaves represent change and the annual cycles of life and death and growth and decay. Even in the process of dying, leaves are incredibly beautiful. I hope to become co-creator with nature by attempting to encompass both the sublime and the beautiful amid the cycles of life and death.

Right: Lisa Mandelkern, *Florence*

1997, 10" x 8" x 4" (25 x 20 x 10 cm). Slab constructed, with molded, pinched, and coiled additions; glazes and underglazes; fired in electric kiln, cone 06. Photo by artist

I build and decorate my teapots with places and their art on my mind. I have traveled extensively in Europe and have spent hours of wonder and joy in museums. Through my teapots, I revisit some of the splendor of times gone by.

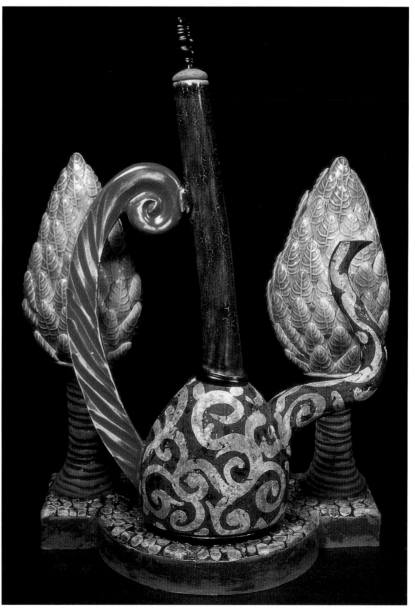

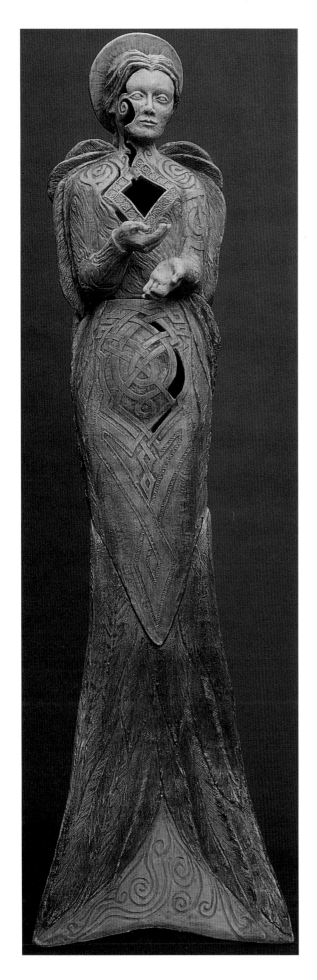

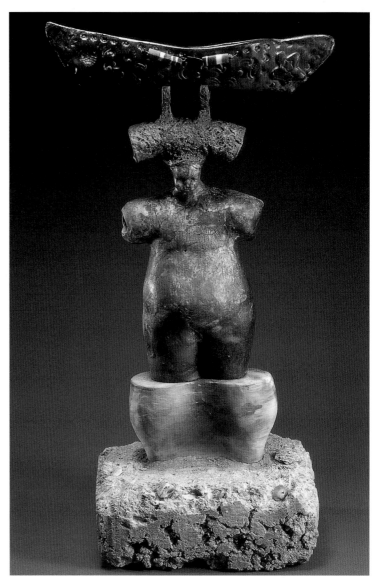

Above: **Jimmie Irelan, *Maiden Voyage***

1997, 26" x 14" x 10" (66 x 36 x 25 cm). Coil-built pedestal, adobe base with inserted metal rod to secure the figure, molded raku clay figure, slab-built headpiece and canoe; all constructed in a totem form; burnished terra sigillata and glazes, markings created with copper wire and vegetation; copper wire strung through canoe, with attached shells and stones; bisque fired, cone 06; raku fired slowly; smoke fired. Photo by Bart Kasten

There is a core—a universal antediluvian spirit that transcends time and civilization. I seek to create forms using colors, textures, and the firings themselves that remind me of that primal terrestrial/celestial "core" that embraces the body, the community, the mind, the land's gifts, and the "collective journey."

Left: **Tana Patterson, *Sparrow Child Angel***

1996, 64" x 15" x 12" (163 x 38 x 30.5 cm). Coil built in sections, smoothed, carved, openings cut, shelves built inside the figure; white slip, rutile oxide and mason stain colored slips; bisque fired, cone 06; brushed, diluted stains and oxides, Gerstley borate; glaze fired, cone 4

I build visual homages to the desire for guardian spirits or angels. Clay has a benevolent essence well suited for materializing such thought.

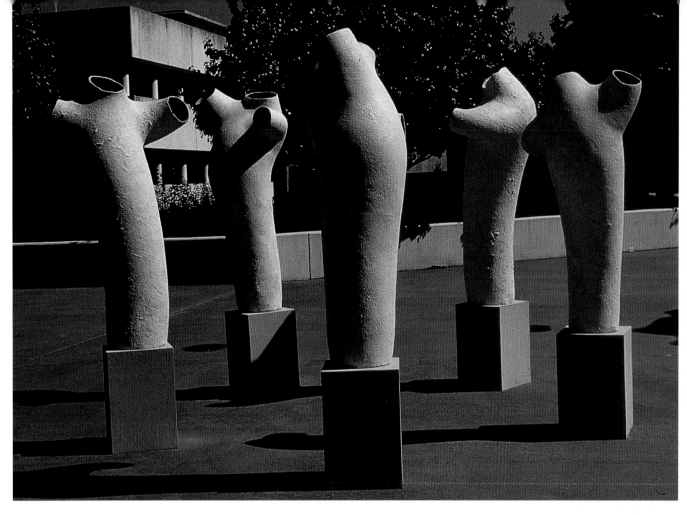

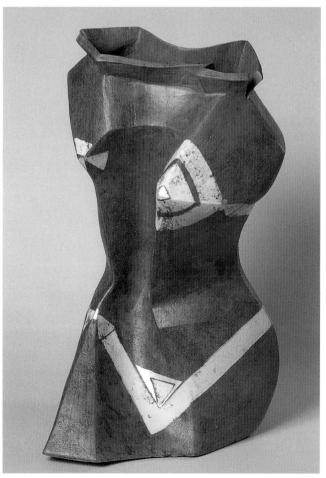

Above: **Ralph Paquin,** *Circle*

1996, height: 108" (274 cm). Slab-built low-fire stoneware, five hollow forms; glaze with high carbon content (for rough surface) and chrome/tin pink; oxidation fired, cone 04

My sculptures revolve around one central interest—metaphysical tensions among and between the physical and spiritual worlds. Although I derive most of my art from personal experiences and visions, I am influenced by artists like Jun Kaneko, Peter Voulkos, Kiki Smith, Rodin, Arp, and Brancusi. Generally, I use the figure as a "bank of forms" from which I select various parts of the body— whole or isolated parts, inside and/or out—whatever the form needed for attaining or disguising my message(s). Currently, the torso is an icon that I use to emphasize the significance of that area of the body and concept of the piece, not only as an important physical form, but also as one of spiritual significance.

Right: **Jennie Bireline,** *Bikini Aphrodite Pot*

1997, height: 23" (58 cm). Coiled, paddled, and rib-scraped earthenware; decorated at bone-dry stage (no masking elements used), brushed terra sigillata, 23K gold leaf; each pot once-fired in loose brick kiln, cone 04. Photo by Michael Zirkle

I have been making large pots that suggest the human form for several years. The earlier pots were pretty abstract, with the emphasis on the suggestion of movement and the balance required to maintain the pot's equilibrium. These "torso" pots have evolved from that series. Their scale mirrors our own.

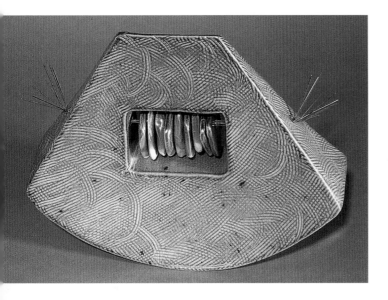

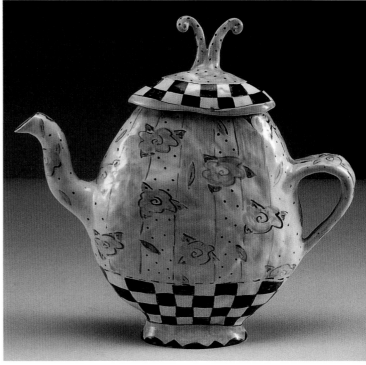

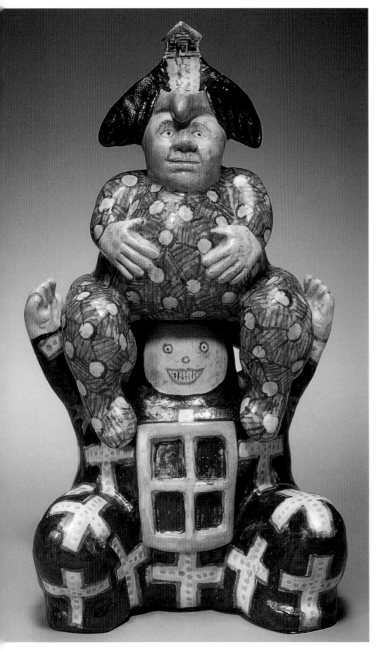

Above: **Nancy Gardner,** *Teapot*

1997, 12" x 9" x 4" (30.5 x 23 x 10 cm). Pinched and coiled terra-cotta; white slip, underglaze, and glaze; oxidation fired, cone 05

My surface patterns are inspired by foliage, flora, fabrics, and painting, particularly still life, interiors and the patterning and decoration movement of the seventies, in which tight repetition opened to expressive interpretation. I am also inspired by old china and wallpaper patterns, and hope that my pieces could fit comfortably into a collection of old and new pottery. My method of working is pinch and coil because I like a handmade look. I resist the urge to clean things up too much.

Top left: **Jacqueline Davidson,** *Rocking Form with Noise Makers*

1996, 6½" x 8½" x 2" (16.5 x 22 x 5 cm). Slab-built form; noise makers cut from scraps and threaded onto brass wire; surface textured with serrated tool; salt fired to about 2400°F (1315°C). Photo by Mark Saffron

My recent work has been inspired by a photograph of an antique Japanese axe. The elegance of the curved edge fired my imagination. I realized that by broadening the cutting edge, I would achieve a rocking form, thereby adding the possibility of movement and, in some pieces, sound to the sculpture.

Left: **Marilyn Andrews,** *"Stacked" Salt and Pepper*

1996, 10" x 5" x 5" (25 x 13 x 13 cm). Pinched and coiled; painted slips on greenware, clear glaze; fired in electric kiln, cone 5-6. Photo by Bob Barrett

My focus as I work is to create an object which embodies an image that can be a useful tool for understanding. I like clay because working with a material that undergoes such radical changes and working in three dimensions help me integrate the sensuous and the intellectual. I often use functional objects as forms for images because they assert the scale of ordinary life. This is where I believe we need art to function.

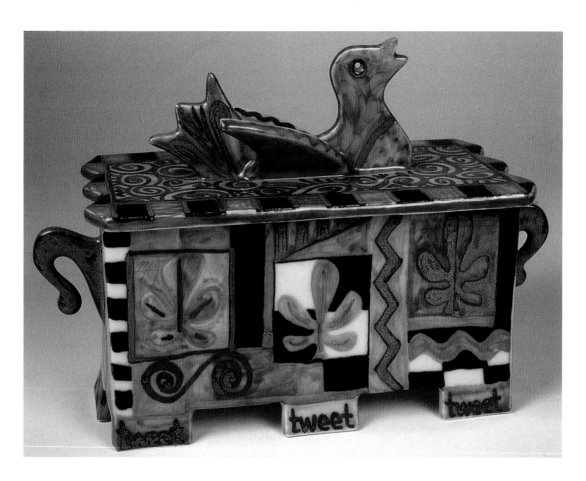

Above: Clare Pousson, *Flights of Fancy*

1997, 9" x 12" x 4" (23 x 30.5 x 10 cm). Handbuilt, cut slab porcelain; high-fired underglazes; oxidation bisque fired, cone 04; glaze fired, cone 8. Photo by Ray Balheim

I like to make things; I always have. If I could spend all my time in my studio just letting all my ideas come to fruition, I would be at my happiest. If my piece makes you smile, then I have accomplished my goal. There is enough serious art out there already. I just want to have some fun.

Right: Angelica Pozo, *Ohio: Buckeye Platter*

1996, 24" x 22-3/4" x 3-3/4" (61 x 58 x 9.5 cm). Platter handbuilt, using slab and coil techniques; wall piece made up of mosaic tile cut from slab, mounted on plywood, and grouted; clear glaze over underglaze painting; platter: bisque fired, cone 01 and oxidation glaze fired, cone 04; mosaic tiles: oxidation glaze fired, cone 04. Photo by artist

This piece is one of a series of state tree and state flower dinnerware pieces that I am working on, in which the state is the wall display mount for the dish or dishes. In this piece, I have cut out mosaics in the shapes of all the Ohio counties. Toward the bottom of the state, two counties jut out on pegs and serve as the holder for the platter.

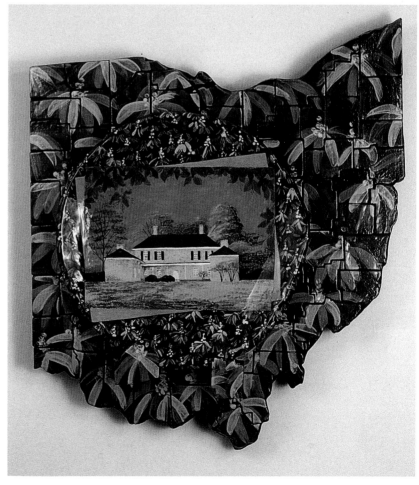

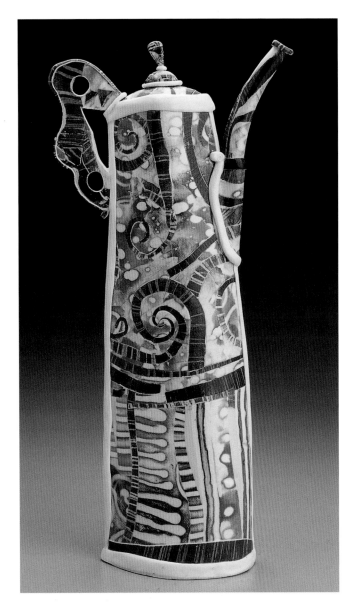

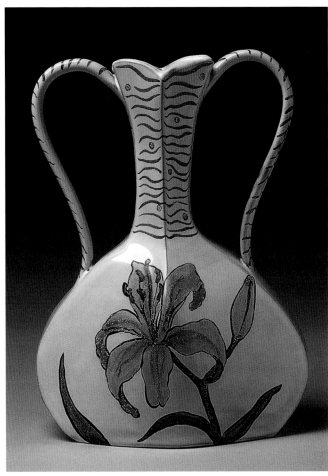

Above: **Beverly Crist,** *Pillow Pot*

1997, 11¼" x 8" x 5½" (28.5 x 20 x 14 cm). Slab built, with pulled handles; majolica; bisque and glaze fired in electric kiln, cone 04. Photo by Tracy Hicks

With my forms, I strive for a combination of control and spontaneity. By virtue of the hard-slab handbuilding method I use, my shapes are very clean, precise, and controlled, and yet through the use of curved lines and scalloped edges, I give them a lively feeling which lends itself to a spontaneous freehand style of glazing.

Top left: **Barbara Chadwick,** *Teapot*

1997, 14" x 4" x 2" (36 x 10 x 5 cm). Slab-constructed porcelain; colored slips, clear glaze; fired in electric kiln, cone 8. Photo by Greg Kolanowski

Below left: **Dale Shuffler,** *Skin and Bones*

1996, 5" x 15½" x 15½" (13 x 39 x 39 cm). Pinched, coiled, cut and folded slab construction; impressed; painted, dipped, and trailed slip, glaze, terra sigillata; fired in electric kiln, cone 04; salt fired, cone 10; fired in electric kiln, cone 06. Photo by Bruce Blank

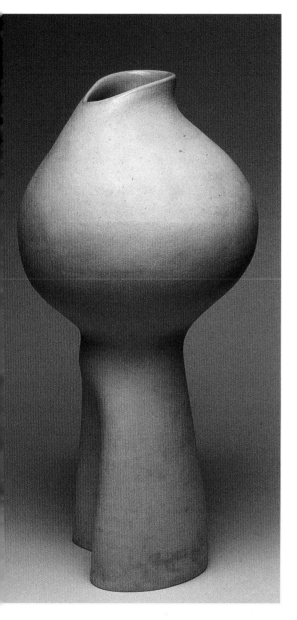

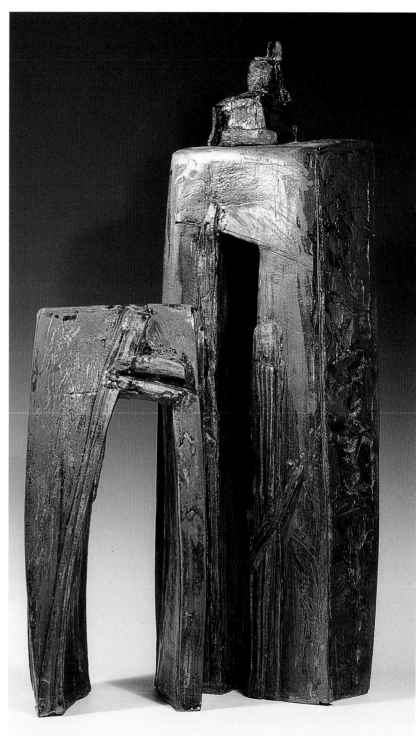

Una Mjurka, *On the Other Side*

1996, height of taller piece: 26½" (67 cm). Slab built; colored slips, underglazes, and glazes; reduction fired, cone 10. Photo by Poshlin Zhou

Through my artwork I would like to establish a dialogue between my inner world and the outer world. This dialogue is not literal; my visual associations are an abstract language. My approach to making expressive forms is geometric—primarily slab-built work— which responds to and respects the materials and their qualities.

Dorothée Deschamps, *Vase #2*

1997, 18" x 10" x 10" (46 x 25 x 25 cm). Coiled white stoneware; sanded exterior, transparent glaze only on interior; fired in electric kiln, cone 6. Photo by René Funk Photographe©, Montreal, Quebec

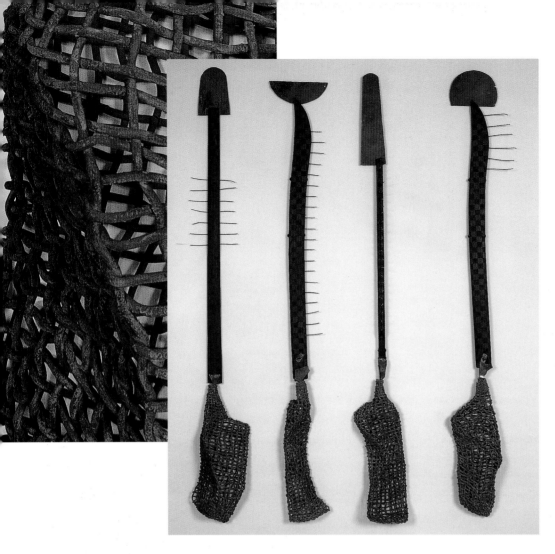

Left: **Phyllis Kudder Sullivan, _Enigma Variation 46_**

1997, 84" x 72" x 8" (213 x 183 x 20 cm). Extruded coils, woven stoneware; engobes and colored slips; multiple firings, cone 6, cone 04.

Photo by Joseph O. Sullivan

Below: **Phillip Harris, _Interlocking Pyramids_**

1996, 36" x 72" x 1" (91 x 183 x 2.5 cm). Slab-built porcelain, found materials pressed into surface; stains drawn on bisqued surface, glazes; oxidation fired, cone 6

This imagery is a combination of industrial/technological patterns and textures with the expressive language of drawing. The motif is built upon contrast.

Right: **Francisco (Pancho) Jimenez,** *Marker*

1996, 84" x 13" x 13" (213 x 33 x 33 cm). Geometric shapes carved around commercially extruded flues; fired in beehive kiln, cone 1

I am intrigued by the mystery of meaning that I find in ancient art, much of it in ruins found in Mexico or anywhere else in the world. In my art, I attempt to capture that mystery, that "eternal presence" of ancient art forms, which elicit particular emotions in me that may be universal and timeless. My intention is to create art forms that bring the eternal presence of the past to the present, and that inspire reflection on contemporary time and space.

Below: **Ho-Jeong Jeong,** *Flowing*

1997, 18" x 80" x 42" (46 x 203 x 107 cm). Hollowed-out solid piece of clay; white glazes; oxidation fired in gas kiln, cone 04

This sculpture employs water as the metaphor for human emotions. Given its fluid nature, water itself does not have its own particular form of existence. Influenced by its external environment, however, water creates various forms that suggest specific human emotion. I hope that as reflections on the nature of water, my works purify viewers' minds.

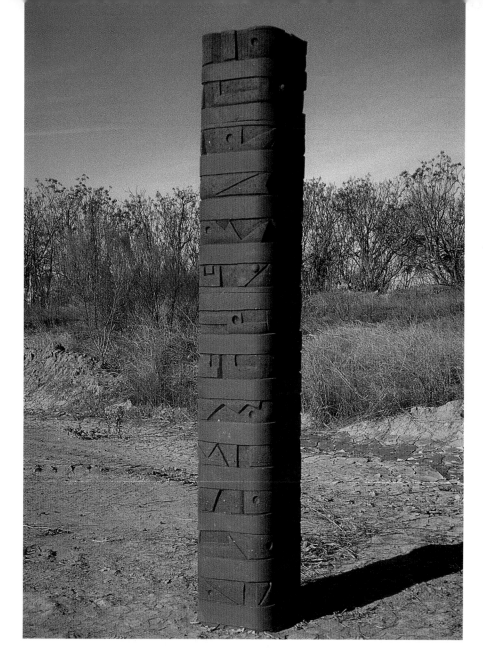

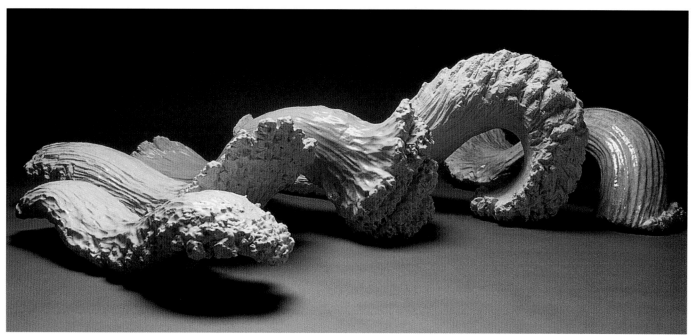

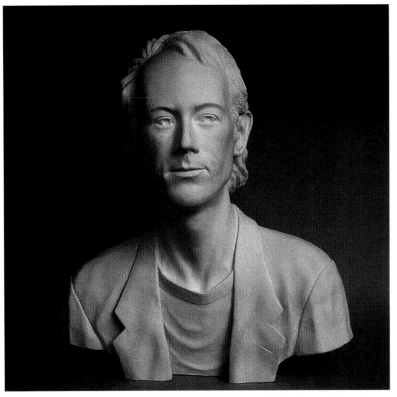

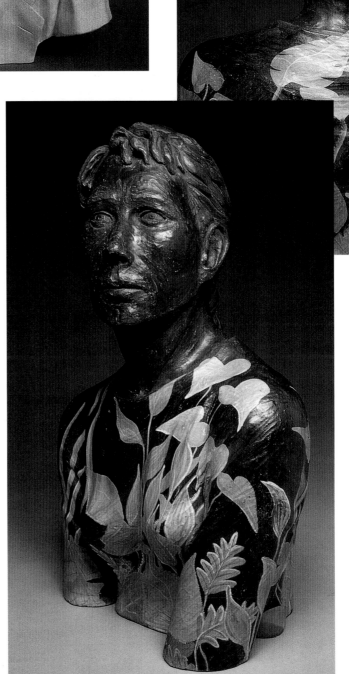

Above: William Davis, *(Portrait) David*

1997, 19" x 17" x 10" (48 x 43 x 25 cm).
Handbuilt stoneware, hollowed, modeled
with wooden tool; no armature used
except for a single upright for wet support
at the neck; rough form trussed with
cheesecloth until outer surface stiffens;
interior hollowed out when outer shell is
leather hard; burnished, scraped, carved,
scored, wet-brushed, sponged, chamoised,
sanded; oxidation fired in electric kiln,
cone 02 (multiple firings to progressively
higher temperatures). Photo by artist

Right: Judith N. Condon, *Untitled*

1996, 25" x 18" x 11" (63.5 x 46 x 28 cm).
Slab built over paper armature; slip, wax;
fired in electric kiln, cone 03

*My art is old ghosts that speak themselves
into clay, revealing their persistence in
extremes. They are ambivalent voices to be
heard by more than me. The strength tumbles
out with small provocation: a song, a picture,
a word. Their meaning is revealed by years.
My hope is that the figures are more than
personal mysteries, that they speak of politi-
cal and universal ironies, particularly fear of
difference and all its consequence.*

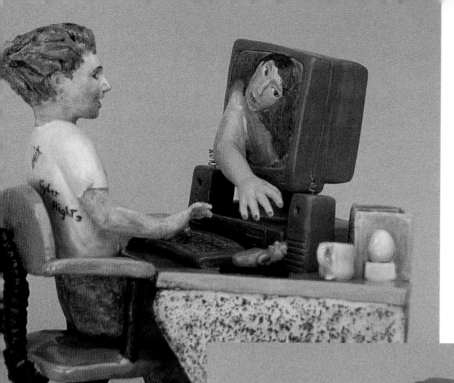

Bonnie Fry, *Code Warrior*

1997, 10" x 12" x 12"
(25 x 30.5 x 30.5 cm).
Slab built and pinched;
underglazes and glazes,
some magnesium oxide
on desk legs; fired in
electric kiln, cone 5

I find the process of making sculpture is like having a conversation with myself. I use clay to produce symbols that express my feelings about the world around me. I like to say something about life with a combination of humor, love, and sensitivity. I hold a feeling when I do a piece that will be strong enough to reach others (at the heart-and-soul level) that will give them a spiritual experience of some kind. I try to reach those depths in myself, in the hope that it will help others reach that, too. I have respect for or love the piece and watch for the nudges about what to do next. It's an adventure to see how the piece turns out.

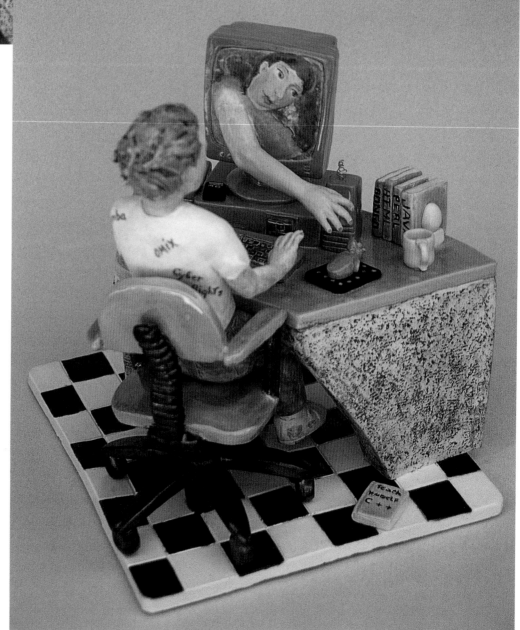

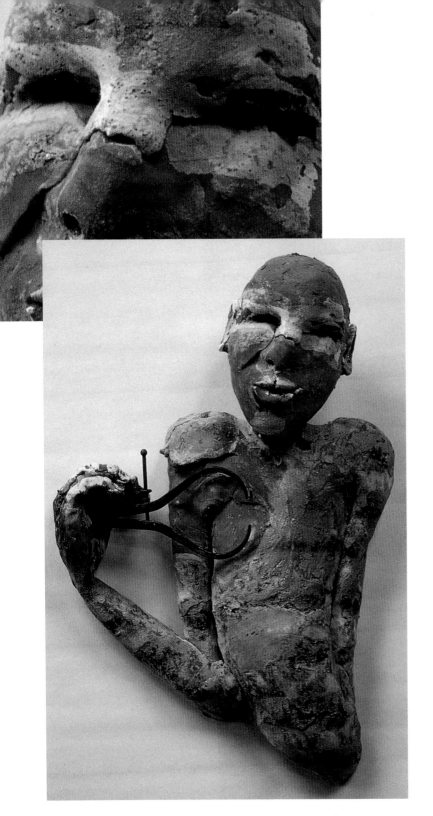

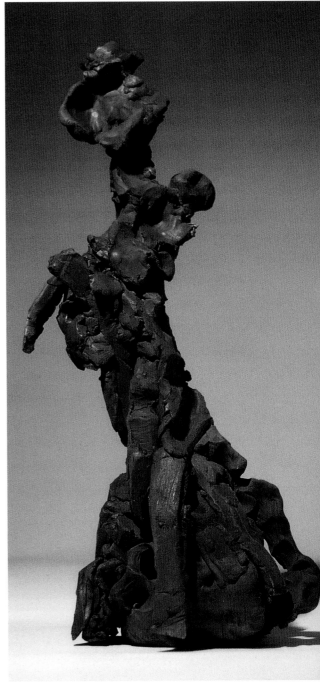

Susannah Israel, *Tool-Box Boy #1: Caliper*

1997, 34" x 27" x 10" (86 x 69 x 25 cm). Slab and coil-built wall relief; found materials added at wet clay stage and fired with the piece; layered slip glazes over oxide wash; oxidation fired in electric kiln, cone 3 and cone 06

The Tool-Box Boys is a series inspired by my nephews, whose passion for playing with odd objects matches my own. Each piece has a portrait component, but expresses universal aspects of play and drama as well.

Brian Grow, *Manual Pieces*

1997, 22" x 8" x 6" (56 x 20 x 15 cm). Terra-cotta; pinched and conglomerate-built from scrap elements; oxidation fired, cone 04

My sculpture incorporates subconscious imagery into conscious material. My imagery tends to be figurative, with reference to myself or my wife. Clay in its rough state best realizes my imagery, and spontaneous firing styles like raku or low-fire salt give these images life.

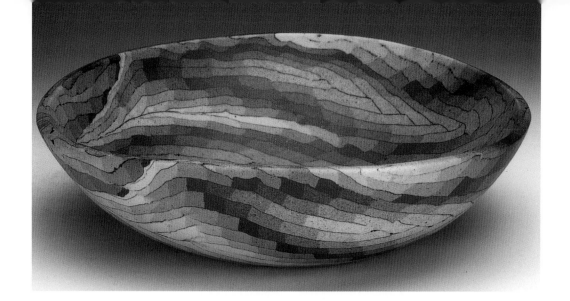

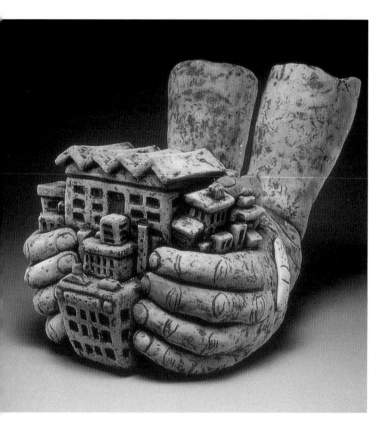

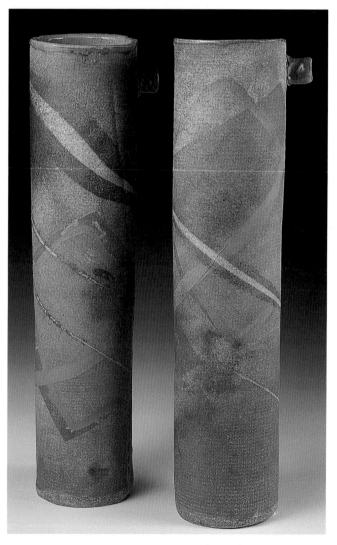

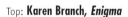
Top: **Karen Branch,** *Enigma*

1997, diameter: 9¼" (23.5 cm). Handbuilt; "neriage" (stacked and sliced oxide-colored clays); airbrushed clear glaze on greenware interiors; once-fired (reduction) in gas and wood kiln, cone 10. Photo by Michael Crow

I like the kiss of the fire you get from adding wood to a reduction firing—the occasional blush of the pots, the wood ash specks that melt into glaze. The firing characteristics bring excitement to the pots. Making pots and firing the kiln bring joy and sanity to my life!

Center left: **Allan Rosenbaum,** *Cradle*

1996, 15" x 14" x 21" (38 x 36 x 53 cm). Pinch and coil-constructed terra-cotta; copper oxide stain, underglaze, and glaze; multiple oxidation firings, cone 05. Photo by Katherine Wetzel

Above: **Amedeo Salamoni,** *Untitled*

1996, 15" x 3" x 3" (38 x 8 x 8 cm). Slab-built stoneware vases with coil attachments; colored clay inlays, applied slips, dusted and printed stains and slips, glazed interior; reduction fired, cone 10. Photo by artist

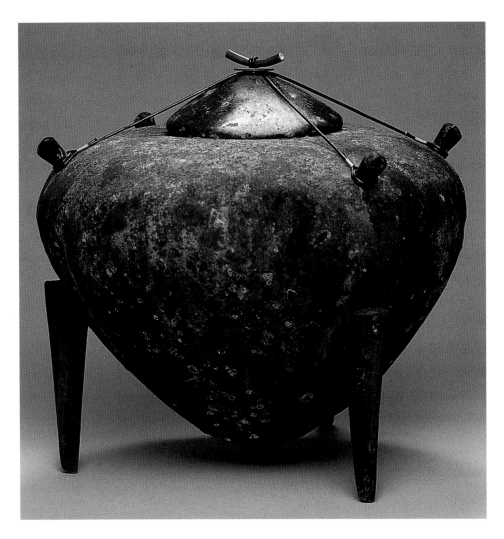

Left: Kristin Doner, *Unearthed Amphora: "Imperial Pinchpot"* series

1997, 11" x 10" x 10" (28 x 25 x 25 cm). Pinch pot, hammer and anvil technique; lithium glaze; raku fired

Ancient history and the mystery surrounding it captivate me, including the rituals that previous civilizations may have used, the cultures they may have lived in, and the spiritual roles that vessels played. Working with clay, I seek to express a timeless connection to things past and future, through the use of vessels.

Below: Thomas Orr, *Iowa Suns*

1997, 8" x 15" x 3" (20 x 38 x 8 cm). White stoneware wall hanging; open box shape made from slab with pinched sides; white crawl glaze with stain, texture glaze, Lana's chartreuse glaze (glazes reapplied between firings), glaze on back; multiple firings: cone 06, cone 11 in six-chamber wood kiln, cone 04, and cone 06 again (twice). Photo by Phil Harris

After years as a potter firing work in one glaze fire, it is refreshing to keep reglazing and refiring until I find that moment when I think the "painting" is done. Maybe I'll change my mind next year and fire it again.

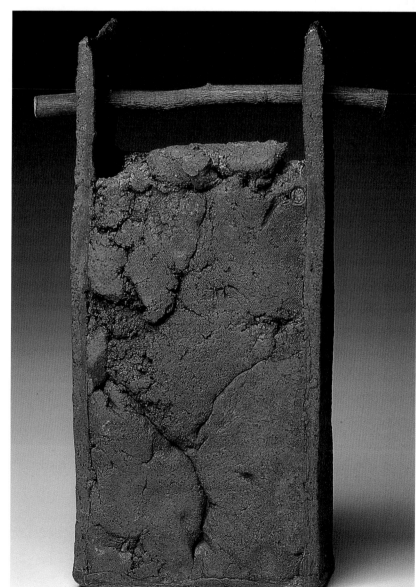

Above: **Vincent Burke,** *Untitled*

1997, 6" x 10" x 22" (15 x 25 x 56 cm).
Pinched form; mixed media; fired in electric
kiln, cone 04

Right: **Ginny Marsh,** *Flower Arranger*

1995, 16½" x 6½" x 4" (42 x 16.5 x 10 cm).
Handbuilt with tossed and textured slabs;
stained and sponge wiped, interior glazed;
reduction fired in gas kiln, cone 9.
Photo by artist

*I like to use basket forms because the handles
assist with making flower arrangements. Though
the design of the pot should be complete in itself,
I like vases which in use become the background.
They should call attention to the flowers, not to
themselves.*

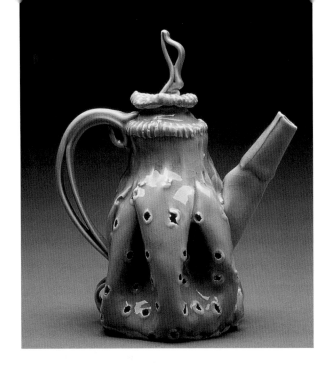

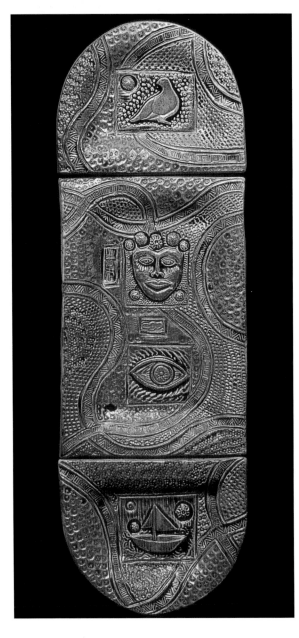

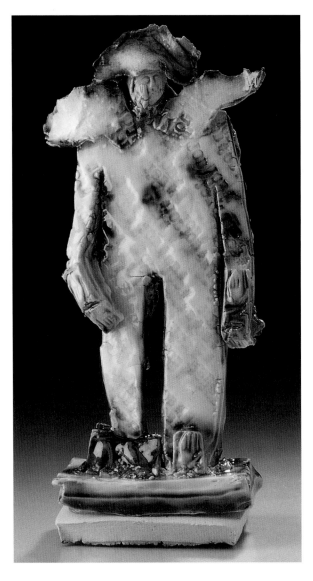

Above: **Inge Roberts,** *Witness XIV*

1997, 10½" x 4" x 3" (27 x 10 x 8 cm). Handbuilt, with pressed and stamped details; clear glaze, oxide stain; oxidation fired, cone 10. Photo by Lee Fatherree

Top left: **Janet Buskirk,** *Lingerie Teapot*

1996, 8" x 7" x 6" (20 x 18 x 15 cm). Slab-built porcelain, double walled: inner wall is functional, outer wall is pierced; celadon glaze; reduction fired in gas kiln, cone 10. Photo by Bill Bachhuber

I try to keep my work lighthearted and fun. This series began with an outer wall of woven clay and eventually evolved into the current pierced pieces.

Left: **Lisa Tevia-Clark,** *Safe Passage (Mounted Wall Relief)*

1997, 22" x 7" x 1½" (56 x 18 x 4 cm). Slab-built porcelain; impressed relief images (repoussé) from hand-carved clay reliefs; sprigged medallions; ash glaze; reduction fired, cone 10-11. Photo by James Tevia-Clark

Working with clay, its particles as ancient as the earth itself, gives me a sense of geological time and alchemy, and a connection to people and cultures all over the world, through all time.

MOLD-MADE WORK & ADDITIONS

Four thousand years ago, potters molded clay by smearing it into woven baskets and burning the baskets to leave hardened clay forms. Today, potters use any number of objects as molds, including handmade, bisque-fired pieces of clay; and carved or poured plaster shapes. Molding techniques vary. Moist clay may be pressed or draped into or over molds; extrusions or coils may be woven over or in them. Slip-cast molded work is made by pouring liquid clay (known as clay slip) into a mold consisting of one or more pieces. Molded clay forms, like wheel-thrown forms, may also be altered.

Because molds enable potters to create replicas of any given piece in a relatively short period of time, they're often used to expedite production of functional ware, from mugs to dinnerware and vases. As many of the photos in this section illustrate, however, ceramic artists also use molds (frequently handmade) to create stunning one-of-a-kind pieces or to create small or large portions of finished forms.

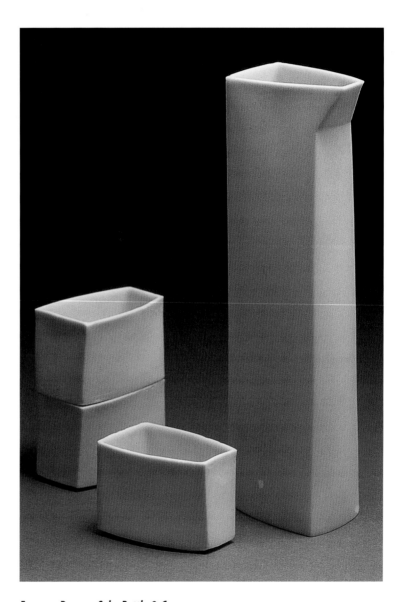

Francesc Burgos, *Sake Bottle & Cups*

1997, bottle height: 6¾" (17 cm). Slip-cast porcelain; oxidation fired, cone 5-6. Photo by Steve Keen

These pieces are part of a larger series of sake sets. This body of work explores issues of form, but also of tactility, intimacy, and ritual.

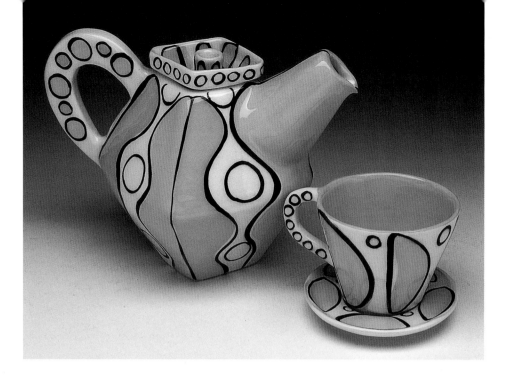

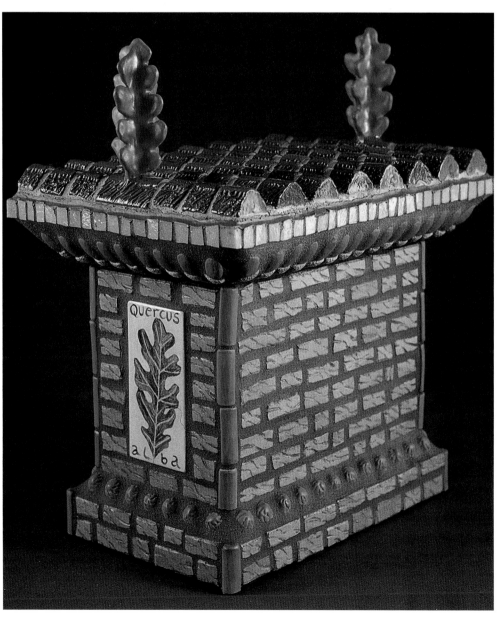

Top: **Matthew A. Yanchuk, Teapot and Teacup**

1996, teapot height: 6½" (16.5 cm). Slip-cast white earthenware, parts assembled; painted; fired to cone 04-06

I hope that people enjoy my work when they use it or look at it. I've been inspired by ancient pottery, particularly the Mimbres pots of the Southwest.

Left: **Angelica Pozo, White Oak Temple Box**

1997, 17¾" x 10¾" x 16" (45 x 27 x 41 cm). Press-molded, extruded, and hand-formed pieces; mosaic tile hand-cut from slab; image: underglaze with clear glaze; other tile: glazes and terra sigillata; oxidation fired, cone 04; all mounted on wooden lidded box substructure. Photo by artist

I like working with tile components because doing so provides me with many opportunities to alter color, shape, size, depth, and texture. I am able to work with a rich and varied palette of surfaces as I move from relief, to painted images, to textured surfaces, or to mosaics. The temple box represents my interest in architectural form, as well as my devotion to making sacred pieces in homage to our natural environment.

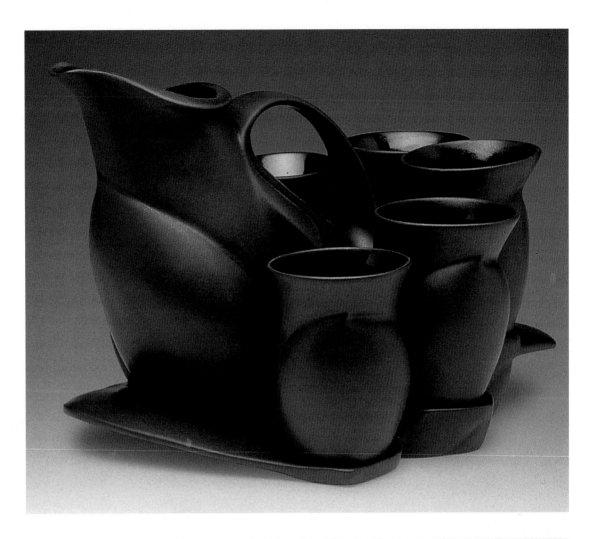

Above: **Peter Saenger,** *Pitcher with Tumblers*
1997, 13" x 12" x 10" (33 x 30.5 x 25 cm).
Cast porcelain; satin matte exterior, gloss
interior glazes; oxidation fired, cone 6.
Photo by Kenn Snyder

Puzzles have a power over me. I obsess over
solving them. I am intrigued to discover the
solutions. It is like meeting someone new and
getting to know them piece by piece. As a
designer, I create an object's persona and mold
its elements together to make something that is
exciting to see, use, and touch. I am looking for
something that is dynamic and in motion,
something that is lively and fun, sensuous and
soft to the touch, with a bit of sophistication. I
design for both beauty and utility because I
want this work to have more than a symbolic
life. A puzzle's solution is a greater challenge
when it has to work on many levels. Life is mul-
tilayered, complicated, and can be fun.

Right: **Kristin Sherlaw,** *Untitled*
1997, 7¾" x 7" x 10" (20 x 18 x 25 cm).
Press-molded and assembled parts, hand-
formed lip; mask and resist, underglaze and
clear overglaze; multiple oxidation firings,
cone 04

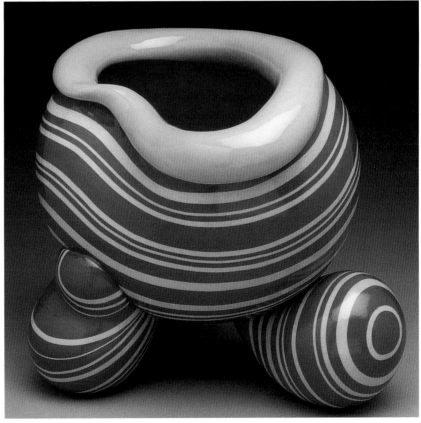

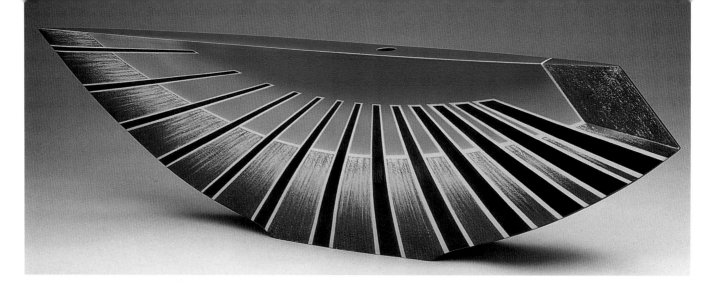

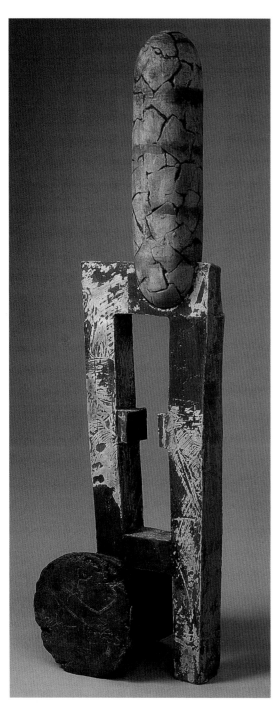

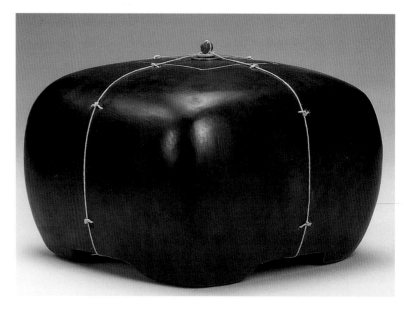

Top: **Garry Bish**, *Vessel/Vessel*

1996, 8½" x 28¼" x 3" (22 x 72 x 8 cm). Slip-cast white stoneware, cut and altered; wax resist, stencil with brushed glaze, airbrushed glaze and stains; bisque fired, cone 09; reduction fired in gas kiln, cone 9

My recent works explore the interaction between visual illusion and three-dimensional ceramic form. Of particular interest to me is the potential of surface graphic image to reshape our perception of the ceramic object.

Center: **Sang Roberson**, *Why*

1997, 6" x 8" x 8" (15 x 20 x 20 cm). Cast and altered terra-cotta slip; burnished with terra sigillata; bisque fired in electric kiln, cone 010; glaze fired in electric kiln, cone 08-06; pit fired, cone 020, in hay and sawdust; bound with waxed linen, coral, and bone beads; metal coin on lid.
Photo by Tim Tew

Bound boxes keep the secrets safe.

Left: **Nathan Falter**, *Spool and Part*

1996, 53" x 14" x 12" (135 x 36 x 30.5 cm). Press-molded spool and lozenge form, slab-built structure; slips and oxide washes; multiple firings, cone 04. Photo by Bobby Hansson

I try to let my ideas and my pieces become completed at the same time. The piece fits the idea, and the idea fits the piece.

Right: Ginny Conrow, *Envelope Vase*

1997, 8½" x 8½" x 3" (22 x 22 x 8 cm). Slip cast, cut, and altered; sprayed glazes; fired in electric kiln, cone 10.
Photo by Roger Schreiber

Below: Jennifer Townsend, *Tincture Bottle Set*

1997, 11" x 16½" x 4" (28 x 42 x 10 cm). Press-molded, pinched, rolled slab; black engobe; fired to cone 6; multiple firings, cone 06, with glazes. Photo by Bart Kasten

The tincture or elixir bottles are part of a wizardry or magic theme that has to do with an ability to transform ourselves and our lives. The organic motifs in the work refer to the nature of energy or power and to our vital connection with the earth.

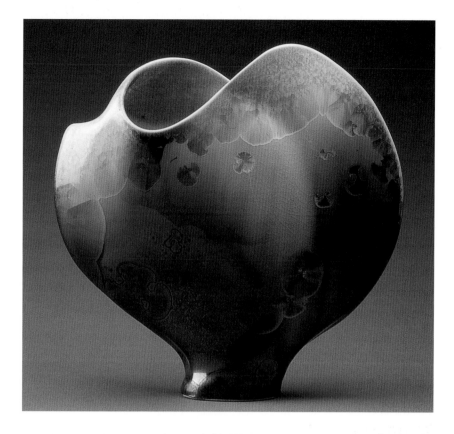

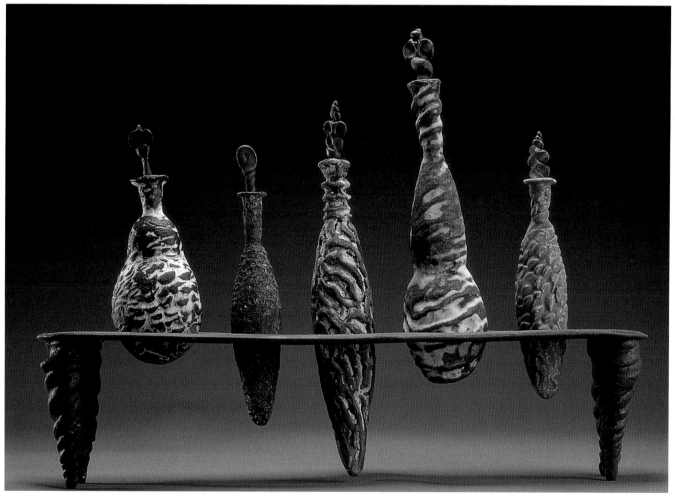

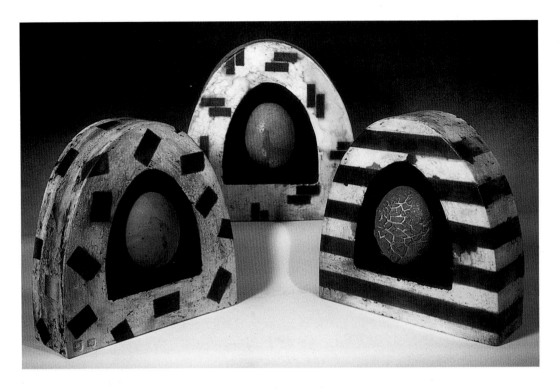

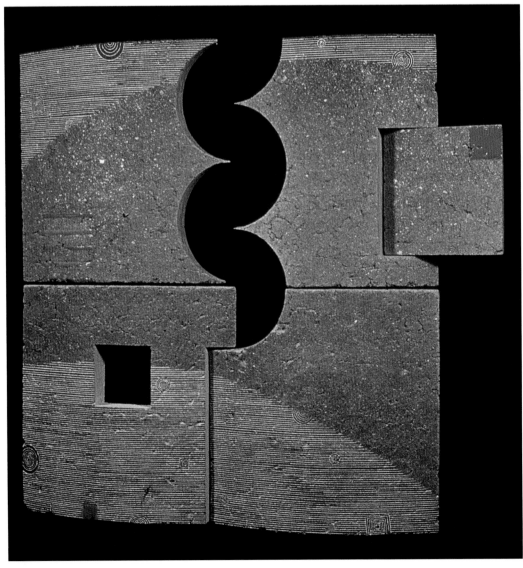

Top: **Christine Kunze, FABERGÉ**

1997, each: 11" x 11" x 5" (28 x 28 x 13 cm). Eggs hump-molded and joined; handbuilt slab construction; smoke fired, with masking-tape resist shapes, heavily grogged slip; eggs fired with low-fire glaze, cone 05

During the last several years, my focus has been on handbuilding wall and sculptural pieces. My work also tends to gravitate toward more primitive firing techniques. At the moment, I'm engrossed in smoke firing. It's an exciting medium, with so many directions to explore. No one can do it all, but you can spend a lifetime trying.

Left: **Joseph Detwiler, Critical Edge**

1997, 31" x 31" x 2" (79 x 79 x 5 cm). Press-molded and cut earthenware; glazes and stains; oxidation fired, cone 06; post-firing sgraffito on white field

My work in ceramic wall reliefs blends elements of painting and sculpture in varying degrees, but always calls attention to its material, ceramic structure, and surface.

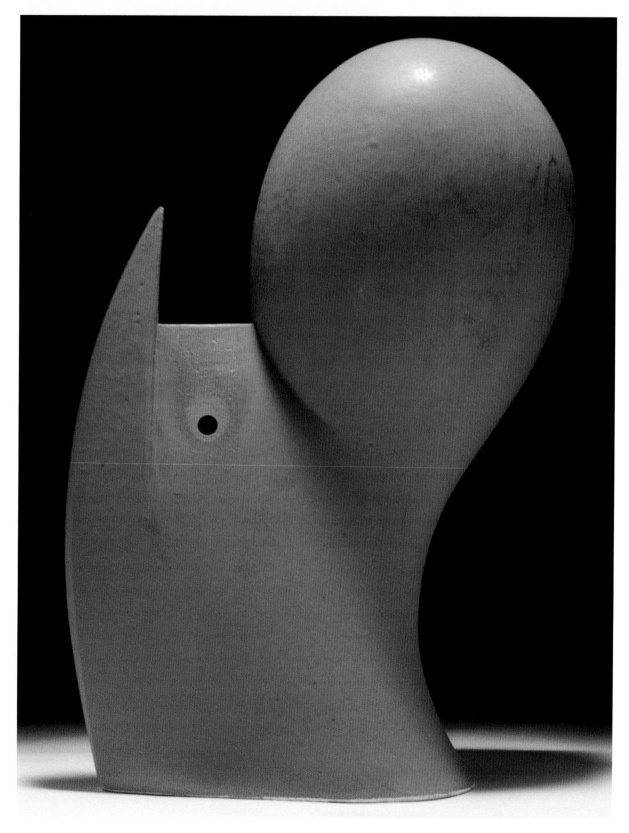

Yih-Wen Kuo, *Naive*

1997, 25" x 17" x 9" (63.5 x 43 x 23 cm). Slab/molded; glazed; fired in gas kiln, cone 06-04

In my work, the only passage between the inside and outside is the small windowlike opening; like a peep-hole window of a medieval castle, it suggests withdrawnness. This window also gives an indication of how large my "building" is; if you look for a door to get into the space, you will find no entrance. The building is encapsulated; it is a space trap—a great cavern with all its potential for expressing apartness, mystery, and entombment. It serves as a metaphor for a tomb, retreat, or the womb, providing a symbolic dwelling for the human spirit. In order to create more depth of visual space on the surface, I apply different thicknesses of glaze on my pieces. Due to heat and gravity, the glaze melts and moves spontaneously during the firing. This process creates a surface similar in feeling to abstract Chinese landscape painting, showing a dreamlike illusion and the great force of nature.

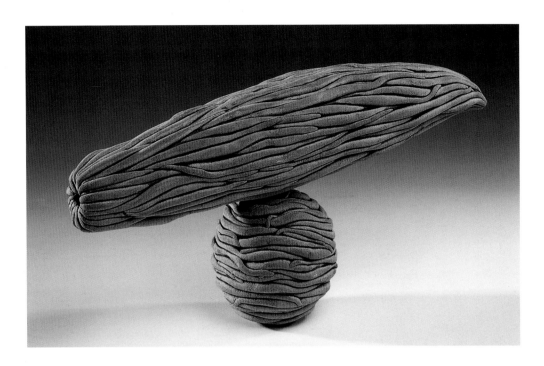

Above: **Elaine Fuess, *Flight***

1997, 4" x 9" x 6" (10 x 23 x 15 cm). Bird: molded, cut in half, hollowed, then rejoined; ball: two assembled pinched halves; coils added at leather-hard stage; bisque fired in electric kiln, cone 06; black underglaze rubbed in and wiped off; refired, cone 2; two forms held together with dowel. Photo by Thomas Dix

The bird is a transformational image, in this case sitting on a ball which is an image representing the collections—physical and emotional—made through a lifetime.

Left: **Jim Parmentier, *Handbuilt Stoneware Basket***

1997, 16" x 8" x 3" (41 x 20 x 8 cm). Handbuilt stoneware; extruded coils for weave, slab and extruded base; constructed over rigid foam form; fake ash glaze; fired in gas kiln, cone 10. Photo by Ralph Gabriner

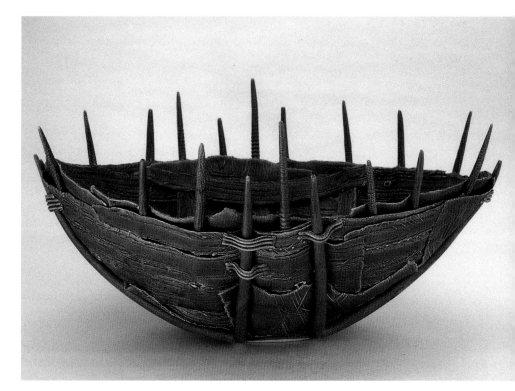

Above: **Peter Powning, *Discus***

1996, diameter: 16" (41 cm). Slip cast with paperclay; gold leaf over copper-rich matt glaze; fired in electric kiln, cone 04. Photo by artist

I've been a potter and a general object maker for many years, on a lifelong quest for balance in my work and my life. I try to keep my work about "living a living," not "making a living," while selling enough to make that possible.

Right: **Laurie Rolland, *Vessel of a Daedalid***

1997, 6" x 11" x 8¼" (15 x 28 x 21 cm). Thin layers of textured clay shaped in bisqued press mold, with leather-hard sticks placed between the soft layers; twice dipped in thin slip glaze washes; fired in electric kiln, cone 6. Photo by artist

Disciples of Daedalus were called Daedalids. Daedalus was said to "have flown up into the region of the air and crossed the (Icarian) Sea."

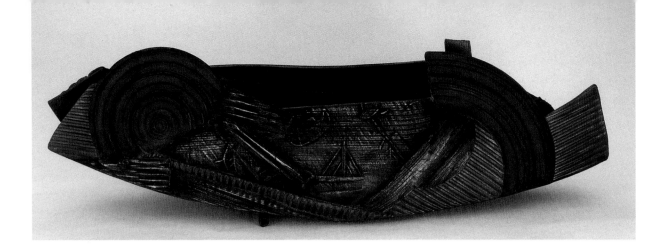

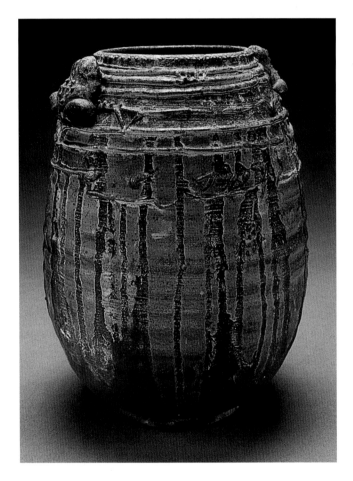

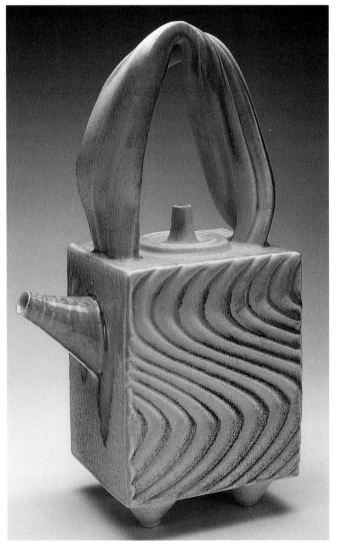

Top: **Laurie Rolland, *Aerial Swimmer***

1994, 4¼" x 15¾" x 4¼" (11 x 40 x 11 cm). Handbuilt over bisqued drape mold, using slabs and wheel-thrown sections; oxide-saturated glaze and a stain, some areas sanded; oxidation fired in electric kiln, cone 6. Photo by artist

The title of this piece refers to the close connection of sea and air that becomes evident when the language of flight describes the swift movement of a ship.

Center left: **John Hodge, *Frog Fetish Vase***

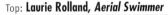

1997, 9" x 6½" x 6½" (23 x 16.5 x 16.5 cm). Wheel thrown, with molded additions and extruded slip decoration; mixed media, including metallic particle paint with acid washes; oxidation fired, cone 04. Photo by Gary Vitrano

I am inspired by surfaces of walls, doors, gates, etc.

Above: **Mark Cruz Eaton, *Yellow Rippled Teapot***

1997, 12" x 6" x 4" (30.5 x 15 x 10 cm). Slab-built white stoneware (slabs cut with stretched spring wire), wheel-thrown spout and lid, extruded and altered handle, press-molded feet; sprayed white matt glaze, airbrushed ash glaze on top surfaces; fired in electric kiln, cone 5. Photo by Thurber Photographic © 1997

I have long been influenced by the raw quality of Japanese pottery and the serene, intimate quality of Chinese Yi-xing teapots. That was my starting point. As the work on the teapots progressed, I noticed that each one had developed its own unique personality.

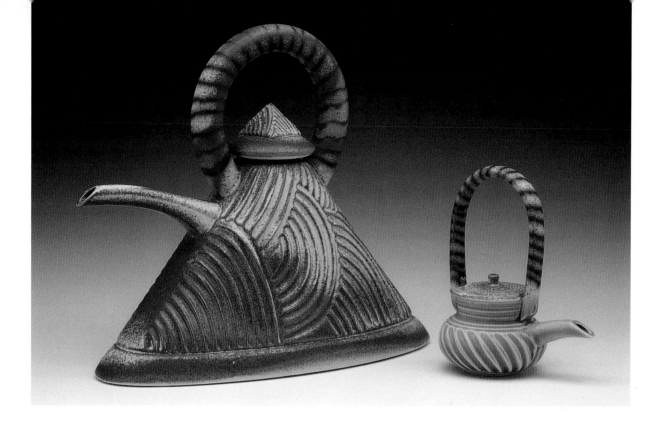

Above: Stephen Fabrico, *Teapots*

1997, height of larger teapot: 13" (33 cm). Slip cast, extruded, wheel thrown, and carved; handles wrapped with copper wire at bisque stage and then glazed over; copper burns out during firing to leave black lines; reduction fired in gas kiln, cone 10. Photo by Ralph Gabriner

Right: Douglas Kenney, *Dimensional Tile*

1996, 26" x 18½" x 3½" (66 x 47 x 9 cm). Textured, molded slab wall tile; wooden blocks, throwing bats, and round caps employed to achieve three-dimensional quality; carved geometric shapes; air-brushed, painted, and splashed underglazes over masking-tape resist, sprayed clear glaze, painted gold luster and overglazes; bisque fired in gas kiln, cone 010; oxidation glaze fired, cone 9; overglaze and luster fired, cone 018. Photo by Carl Scayan

Inspiration for this tile comes from my plates and a desire to make them three-dimensional. The tile works become wall sculptures and lend themselves to architectural applications. My plates work as drawings or sketches for the tiles, but the tiles are more complicated, with their three-dimensionality making them more challenging to execute. Natural textures combined with cityscapes, computers, and architecture form the basis for the abstract designs. American abstract expressionist painters and Japanese prints also have influence on the tile works.

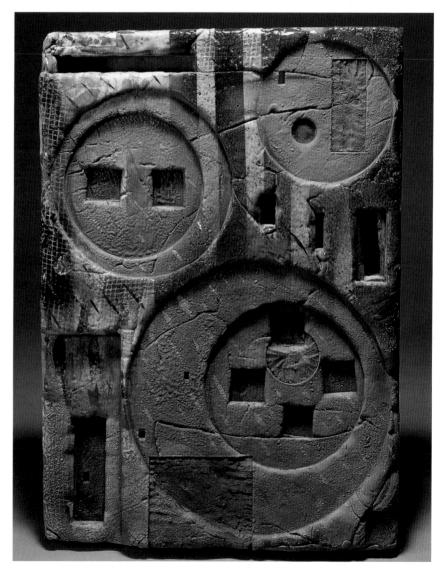

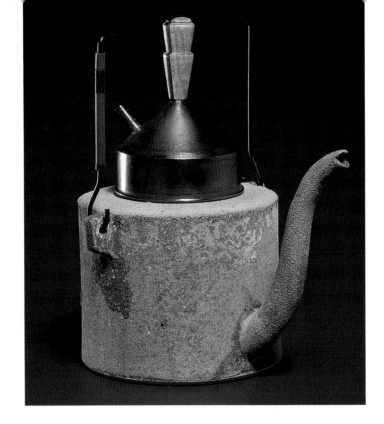

Top: **John Goodheart, *Blue T***

1995, 9" x 6" x 7" (23 x 15 x 18 cm). Earthenware; wheel-thrown body, press-molded spout, copper lid with hand-turned wooden knob, plastic and rubber handle accents; overlapped glazes of different thicknesses; multiple oxidation firings, cone 06 and cone 010. Photo by Kevin Montague and Michael Cavanagh

Nineteenth-century Early American Pottery has always been a significant inspiration in my work. The concern for utility steered this work, directing artisans to produce simple and straightforward forms in response to the needs of the time period. As a potter, I am interested in reinterpreting the spirit of these pots in a contemporary visual language. My recent series of ceramic vessels uses functional pottery as subject; however, the content is intentionally mysterious and reminiscent of cultural artifacts out of context. The pieces ultimately are intended to celebrate the aesthetics inherent in daily routines.

Left: **Paul McMullan, *Snake***

1997, 18" x 18" x 2" (46 x 46 x 5 cm). Molded slab; photo-silkscreened underglazes, slips, and copper wash; oxidation fired, cone 04

Art making, which has become my voice, is a way of communicating with others about our shared existence. I first experienced this language called art when I was sixteen, as I stood in front of a Willem de Kooning painting. It spoke to me in a language that I'd never heard before—a language I could read and understand. It had symbols that I could feel and spoke to me about movement, breath, anger, and love. De Kooning's painting put a thousand words in my mind and showed me a form of communication in which I didn't need to verbalize or spell.

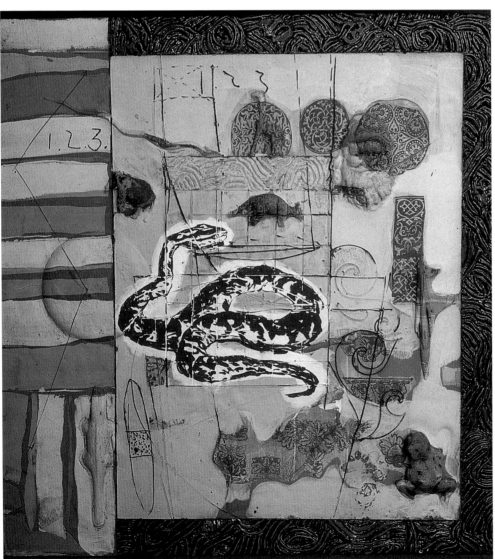

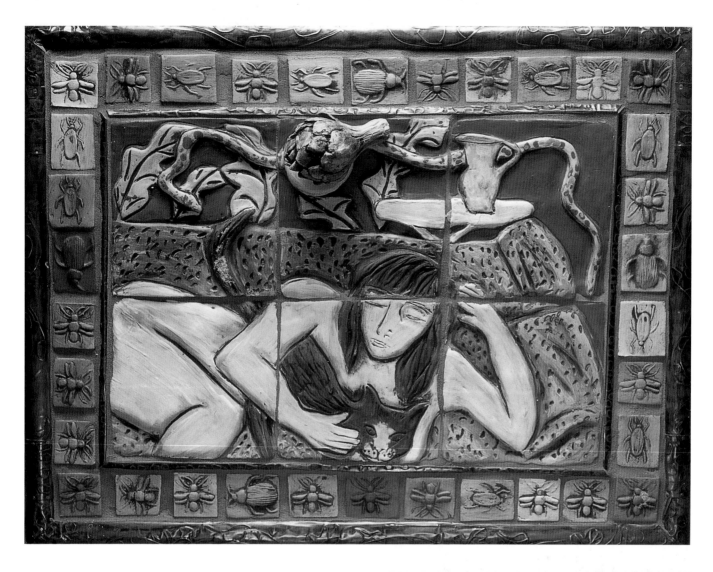

Above: Diane L. Sullivan, *Contemplating*

1997, 28" x 31" x 4" (71 x 79 x 10 cm). Press-molded earthenware, carved; terra sigillata and low-fire glazes; frame covered with patinated copper drawings; fired in electric kiln, cone 04

Right: Douglas Kenney, *Geometric Interface*

1996, diameter: 38" (97 cm). Plate hand-jiggered on the wheel, with a large clay slab on top of a mold; coiled feet wheel-thrown into foot rings; trimmed lip; underglaze painting after bisque firing; airbrushed, painted, and splashed underglazes over masking-tape resist, sprayed clear glaze; fired in gas kiln, cone 010; oxidation glaze fired, cone 9. Photo by Carl Scayan

My work is a combination of my past experiences. I am making an abstract statement about how nature and humans coexist. The geometric shapes represent aspects of our culture such as architecture, computers, cities, and other artists' work. Organic backgrounds are employed to show a relationship between the man-made and natural beauty. The careful blending into a meaningful harmony of these two disparate elements (the organic and geometric) is my goal. I enjoy working large scale to create a lasting impression of my work on the viewer.

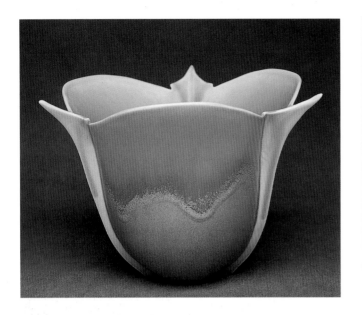

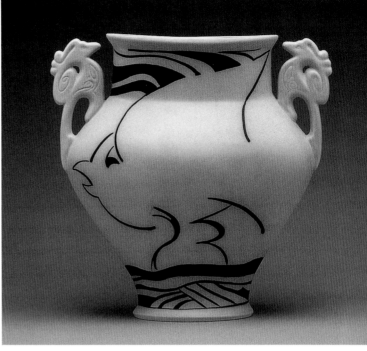

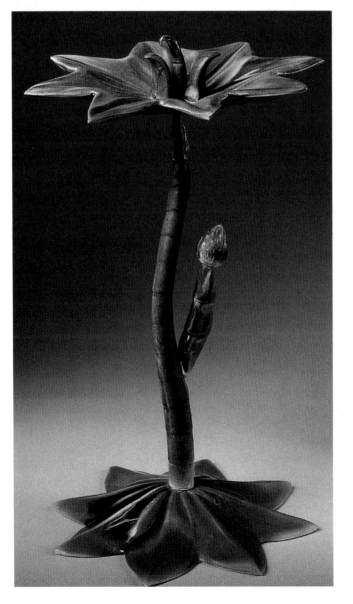

Above: **Paul Rozman, *Vase***

1997, height: 13" (33 cm). Slip-cast china; black stain wash on titanium matt glaze; oxidation fired, cone 6. Photo by artist

Top left: **Alan and Brenda Newman, *Tulip Bowl***

1997, 7" x 11" x 11" (18 x 28 x 28 cm). Molded and altered porcelain; copper colored microcrystalline barium matt glaze with airbrushed chrome, tin stain; oxidation fired, cone 6. Photo by Michael Lowery

We love the challenge of porcelain because its qualities of translucency, delicacy, and whiteness are a perfect canvas for our forms and glazes. We find that developing our own glazes is a rewarding but often humbling experience. Living in Oregon, we draw our inspiration from the abundant plants and flowers in our surroundings.

Left: **Geoffrey Wheeler, *Sweetmeat Dish***

1996, 22" x 12" x 12" (56 x 30.5 x 30.5 cm). Porcelain; press-molded top and base, slab-built stems, slip-cast finial pieces; sprayed, layered copper glazes; eight separate pieces oxidation fired in gas kiln, cone 10; epoxy and threaded-rod assembly. Photo by Peter Lee

Inspired by eighteenth-century European porcelain, this series of sweetmeat dishes explores the relationships between the vessel, flowers, and the human body.

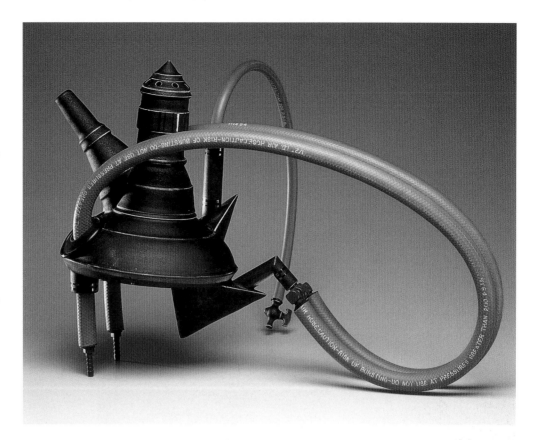

**Right: Ole Morten Rokvam,
*No. 5 - 8738***

1997, 14" x 8" x 21" (36 x 20 x 53 cm). Assembled from press-molded, wheel-thrown, handbuilt parts; added rubber hosing and found metal objects; glazed and sandblasted; reduction fired, cone 10

**Below: Jacqueline Thompson,
*Homage to Stepanova***

1997, platter diameter: 18" (46 cm). Wheel-thrown platter, molded coffee pot, attached slab handle, wheel-thrown lid; underglaze decoration; bisque fired in electric kiln, cone 03; glaze fired, cone 05½. Photo by artist

This work was inspired by the Russian artist, Varvara Stepanova. I have always enjoyed painting and ceramics, so combining the two seemed a logical direction to take.

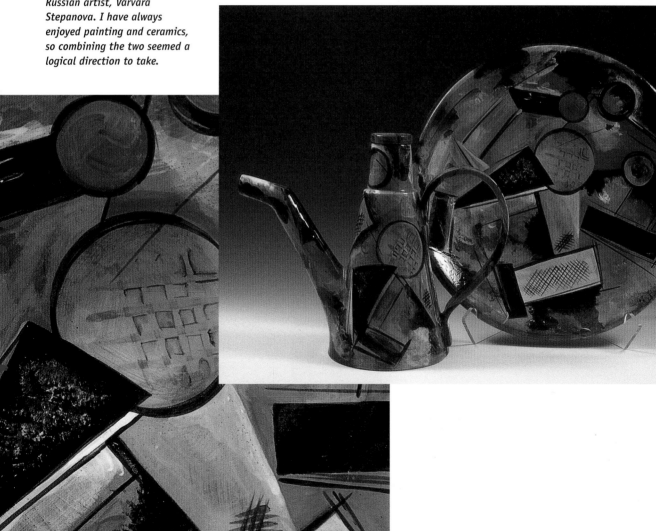

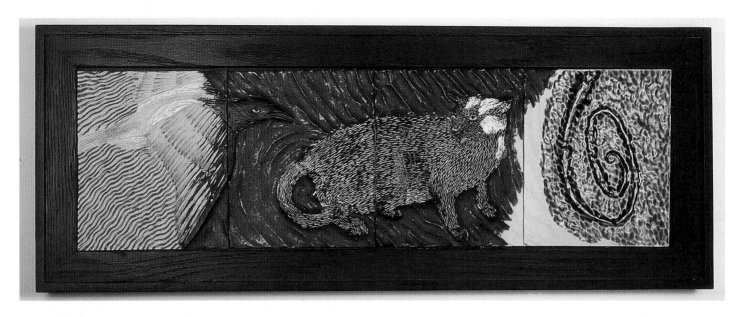

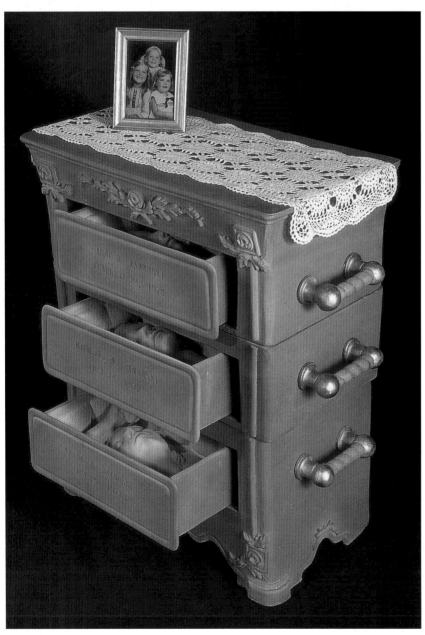

Above: **Amanda Jaffe,** *In and Out of Darkness*

1996, 9" x 24" x 1" (23 x 61 x 2.5 cm). Slip-cast, carved tile; glaze and terra sigillata; fired in electric kiln, cone 5 and cone 06. Photo by artist

" ... for there is something about being in water that alters my mood, gets my thoughts going as nothing else can ... Swimming gave me a sort of joy, a sense of well-being so extreme that it became at times a sort of ecstasy." —Oliver Sacks

Oliver Sacks writes of the soothing nature of being in water. It is this intrinsically soothing quality of water that I wish to evoke in this piece, not just the comforting feeling of the beauty of the pool. I also want to spark the viewer's memory of the calming effect of being in water and of its soothing sound. My piece provides a pool of water, within our anxiety ridden and tension filled environment, that can allow us to escape momentarily to a more soothing spot. Water is only one aspect of this piece; it also contains images of the stress in our lives that leads us to seek out the relaxing effect of a pool of water. Here, the pool is the peace for an irritated animal.

Left: **Carrie A. Rambuski,** *My Girls*

1996, 44" x 35" x 23" (112 x 89 x 58 cm). Slab built with mid-range clay, with structural supports added to main frame; press molds applied to exterior and interior; fired in gas car kiln, cone 1; airbrushed acrylic enamels. Photo by John Robert Hermsdorfer

Within my work, I embrace the duality between the innocence of a child and the dilapidating aggressiveness of incest. Generally, the duality of the chance at life and the impending feeling of death is communicated. I am interested in creating an emotionally charged environment that resembles a child's memory. I investigate incestuous scars through furniture, toys, pacifiers, and text. These symbols operate as a source of contention.

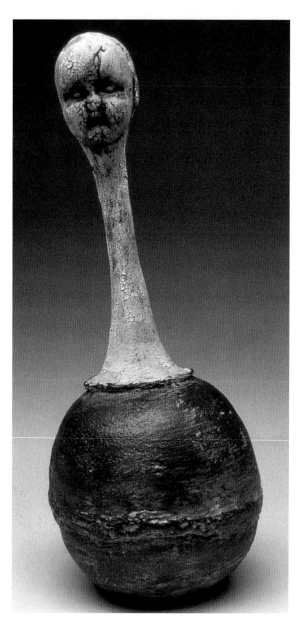

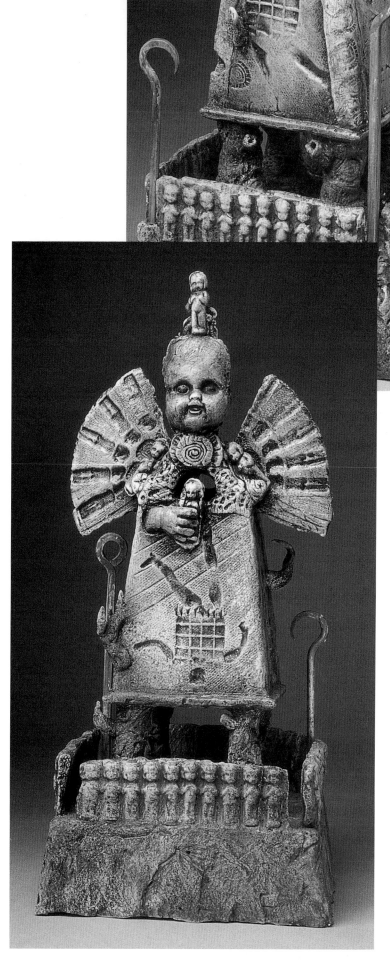

Above: **Kathi Roussel, *Rattle***

1997, 18½" x 6½" x 6½" (47 x 16.5 x 16.5 cm). Molded, pinched, and wheel thrown; fired to cone 6 and cone 06

Right: **Jane A. Archambeau, *Fall from Grace and the Angel Protects You!***

1996, 16" x 10" x 10" (41 x 25 x 25 cm). White earthenware; press molded, handbuilt, stamped, and carved; found objects; fired in electric kiln, cone 04-06; commercial underglazes (sprayed, spattered, and stained), commercial glaze, and underglaze pencils.
Photo by Corey Gray

My work most often employs the use of the simple house form combined with the human baby-doll form. My objective is to create sanctuary. This work was made one winter after I was diagnosed with chronic fatigue and immune dysfunction syndrome, in what I now call a period of "growth by guts." Oddly enough, this illness and recuperation, as well as this piece, have brought much more color (however subtle) and texture into my life and work.

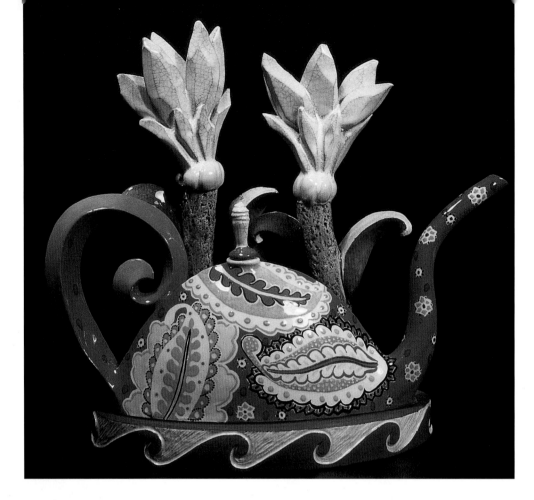

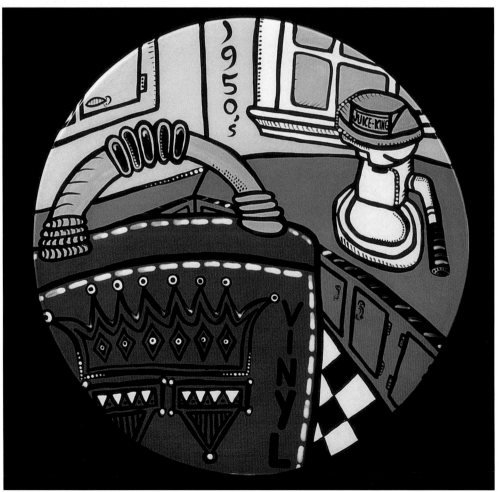

Above: Lisa Mandelkern, *Paisley*

1997, 10" x 10" x 4" (25 x 25 x 10 cm). Slab constructed, with pinched and coiled additions; glazes and underglazes; fired in electric kiln, cone 06. Photo by artist

Left: Scott R. Jones, *1950's Vinyl*

1996, 17" x 17" x 3" (43 x 43 x 8 cm). Low-fire white clay; drape-molded form, foot of plate added on wheel; clear commercial glaze over layered commercial underglazes and slips; bisque fired in electric kiln, cone 04; glaze fired, cone 05. Photo by artist

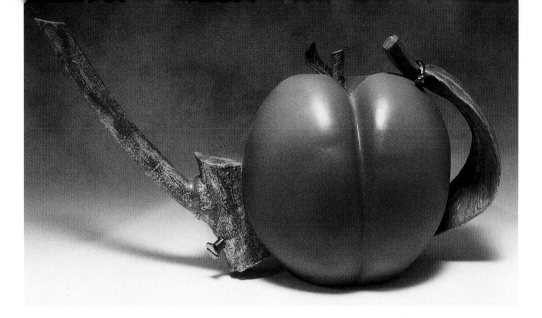

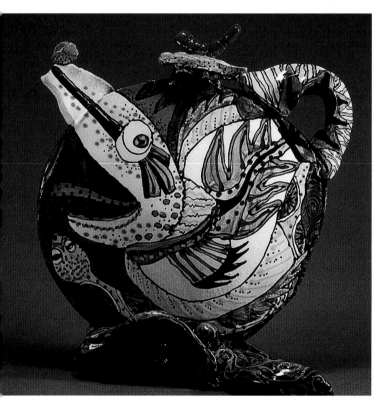

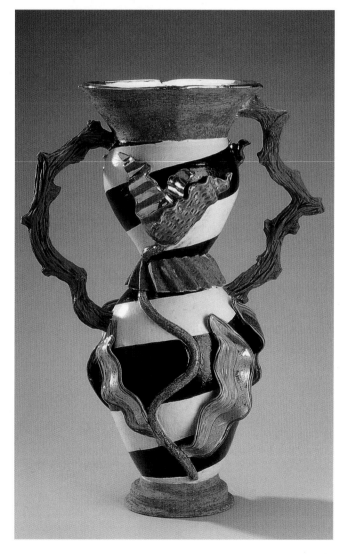

Top: Robin Campo, *Georgia Peach Pot*

1996, 11" x 5" x 7" (28 x 13 x 18 cm). Slip cast, assembled, and handbuilt; brushed glazes, airbrushed underglazes, lusters; bisque fired, cone 01; multiple firings, cone 06; luster fired, cone 018. Photo by artist

Center left: Ron Korczynski, *Origin of the Species or Lift the Lid*

1996, 14" x 13" x 8" (36 x 33 x 20 cm). Slab built, molded, and coiled; brushed and trailed underglazes and slip, clear over-glaze; fired in electric kiln, cone 04

Carol Gouthro, *Vase, Spiral*

1997, 24" x 18" x 11" (61 x 46 x 28 cm). Wheel thrown in two sections, both attached to slip-cast middle section; slip-cast base, coiled and carved handles, coiled and pinched flower forms; slips, underglazes, glazes, and lusters; bisque fired in electric kiln, cone 04; glaze fired, cone 05; luster fired, cone 018. Photo by Roger Schreiber

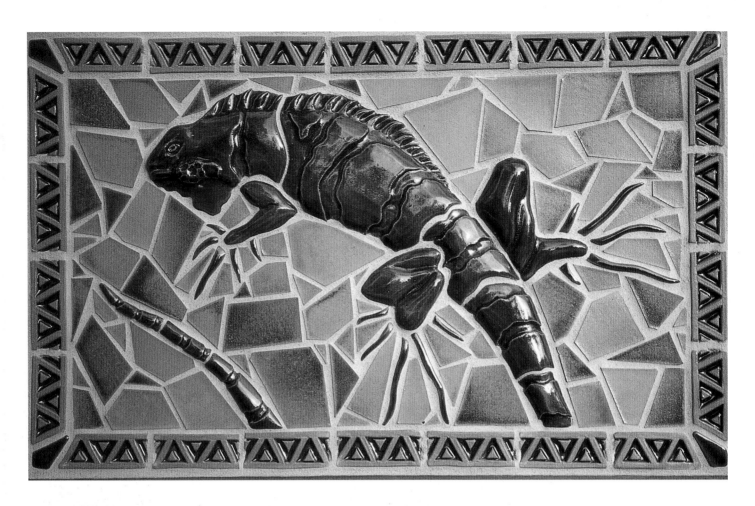

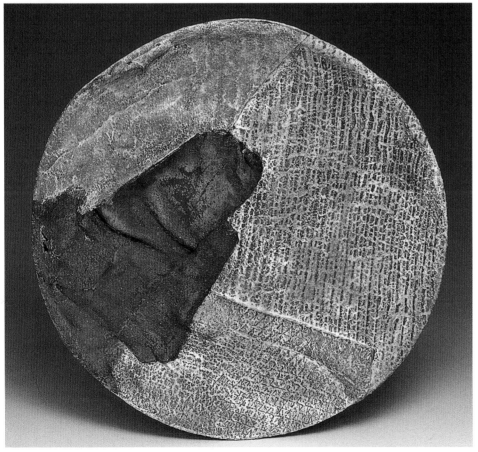

Above: Reneé O'Connor, *Iguana Mosaic*

1997, 15" x 29" x 1½" (38 x 74 x 4 cm). Carved relief image, hand-made mosaic pieces, and hand-pressed border tiles; glazes and stains; fired in electric kiln, cone 6; mounted on exterior plywood, grouted, and framed in wood. Photo by artist

Left: Ravit Birenboim, *Untitled*

1996, diameter: 12" (30.5 cm). Clay cut with coiled wire and stretched thin; pieces molded and joined in bisqued plate mold; sponged diluted oxides and glaze; oxidation fired, cone 9. Photo by Theresa A. Schwiendt

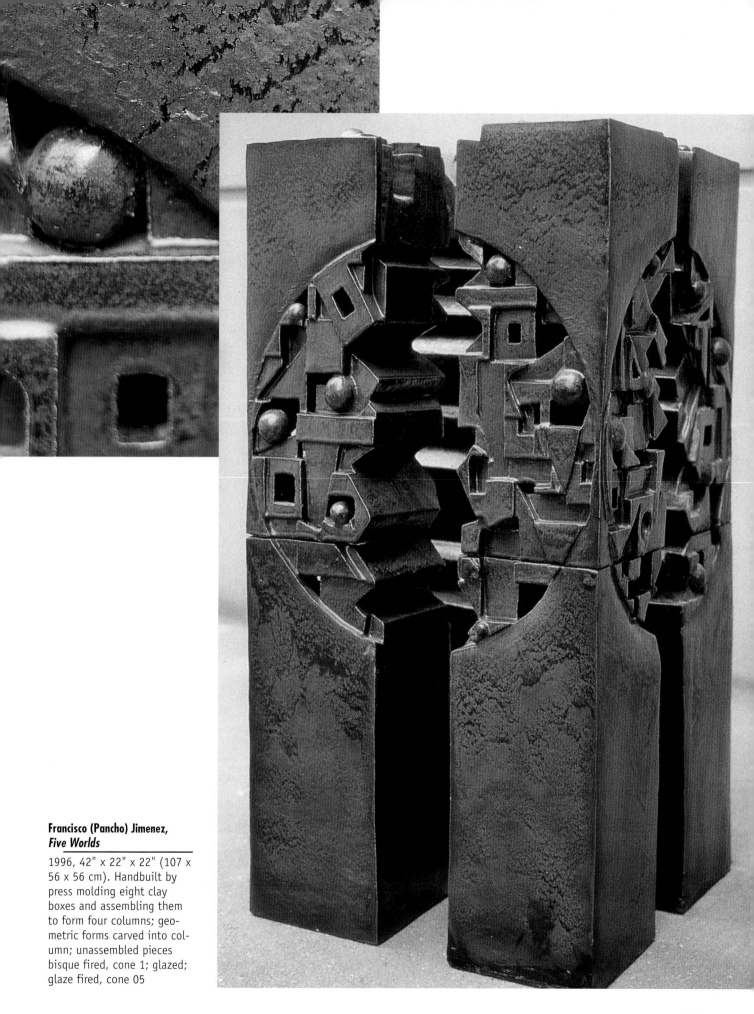

Francisco (Pancho) Jimenez,
Five Worlds

1996, 42" x 22" x 22" (107 x 56 x 56 cm). Handbuilt by press molding eight clay boxes and assembling them to form four columns; geometric forms carved into column; unassembled pieces bisque fired, cone 1; glazed; glaze fired, cone 05

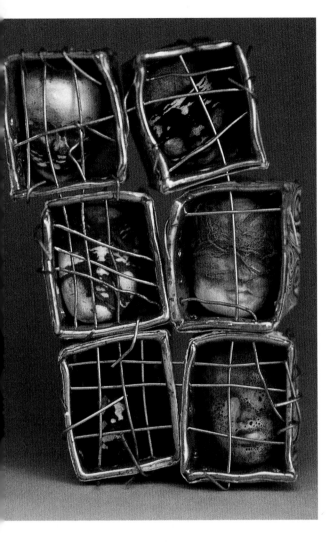

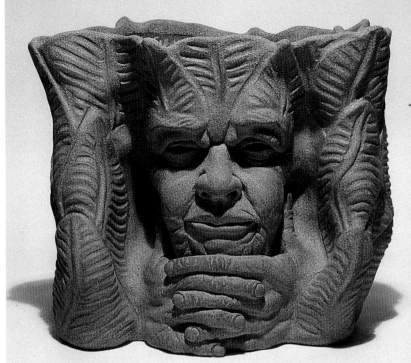

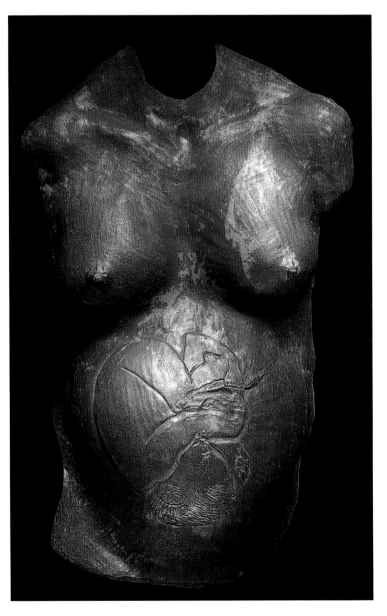

Above: **Nathalie A. MacDonald, *We Live in Pretty Houses***

1996, 3¼" x 2½" x 1" (8 x 6 x 2.5 cm). Slab-constructed boxes, molded faces; clear glaze, gold luster, paper on boxes; burlap soaked in underglaze on faces; boxes oxidation fired, cone 6 and luster fired, cone 022; faces oxidation fired, cone 6

Top right: **Alan Paschell, *Pandora***

1996, 13" x 14" x 14" (33 x 36 x 36 cm). Coiled and modeled planter; stoneware reduction fired, cone 10

Right: **Mary Walyer, *The Pregnancy***

1996, height: 28" (71 cm). Press molded in plaster mold made from torso of an eight-month-pregnant woman; ultrasound of fetus with the correct gestation period used to carve fetus; shino glaze; fired in gas kiln, cone 10. Photo by Courtney Frisse

I have been working with the human form for several years. The pregnancy series was a dream that became a reality. I was able to complete all three trimesters. My favorite of the series is the third trimester.

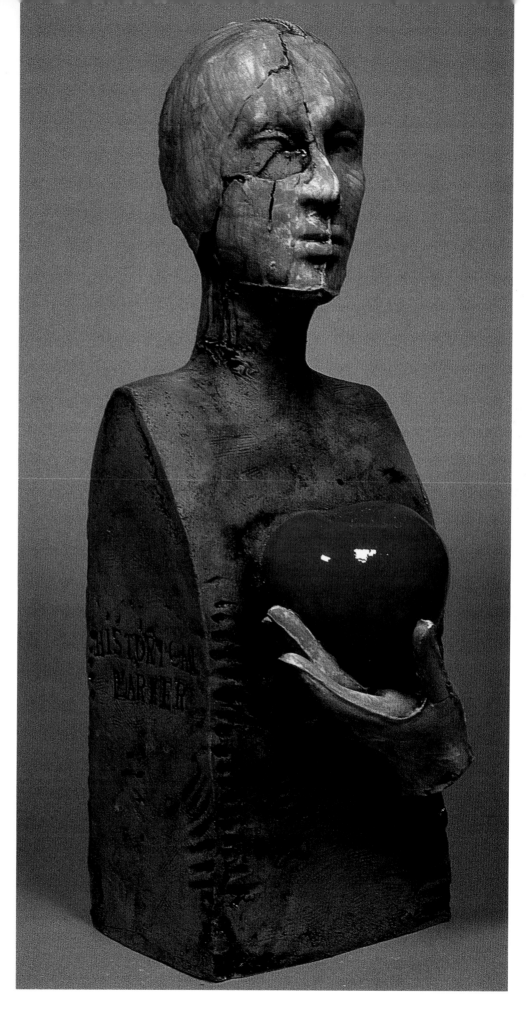

Cara Moczygemba, *Historical Marker (Wakefulness)*

1997, 26" x 9" x 9" (66 x 23 x 23 cm). Slab and coil built, with slip-cast additions; terra sigillata, underglaze stains, and commercial glaze; multiple firings in electric kiln to cone 04 and cone 1.
Photo by artist

This work combines my love of clay with my love of assemblage. I slip-cast from molds of found objects and assemble them on sculpted forms.

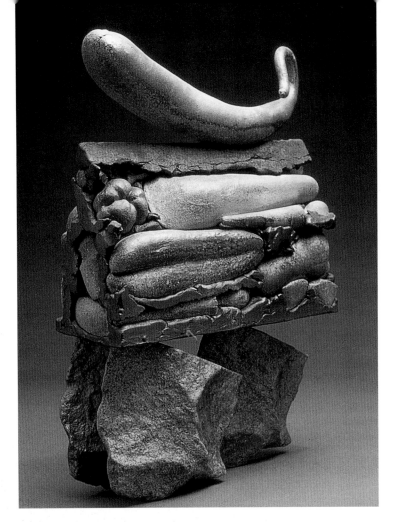

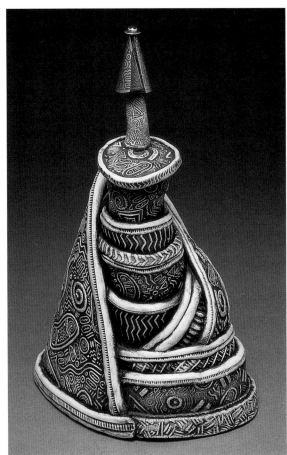

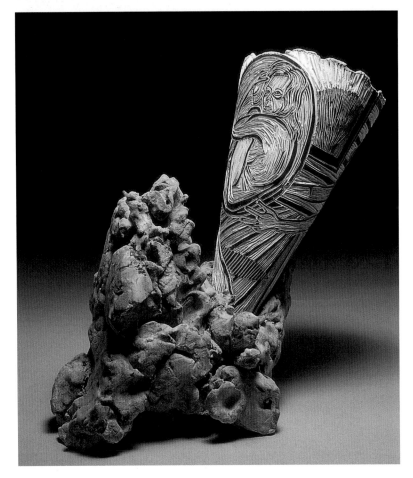

Above: **Marko Fields, *Vessel for the Tactile Impaired***

1997, 14½" x 10" x 7" (37 x 25 x 18 cm).
Handbuilt, using slabs (some press molded) and
coils, with wheel-thrown spout/stem; incised,
black underglaze (wiped off), red underglaze,
clear glaze; nickel silver, sterling, carnelian; oxi-
dation fired, cone 6

Top left: **Kevin W. Hughes, *Traveling the Great Journey***

1995, 24" x 17" x 7" (61 x 43 x 18 cm). Regular,
white, and black stonewares; three groups of
assembled press-molded pieces: base, middle (or
house), and top forms (house-form mold lined
with premolded objects); middle and top forms
joined as greenware, base form attached with
epoxy after firing; wood-fired stoneware, cone 12.
Photo by artist

Left: **Victoria Martin, *No Room in the Womb***

1997, 15" x 10" x 9" (38 x 25 x 23 cm). Cone:
soft slab pressed into form; base: pinched and
paddled; sgraffito, slips, and low-fire glazes; oxi-
dation bisque fired, cone 5; oxidation glaze fired,
cone 04

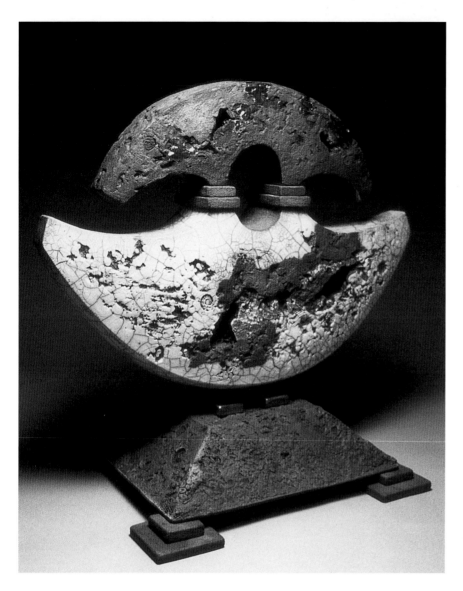

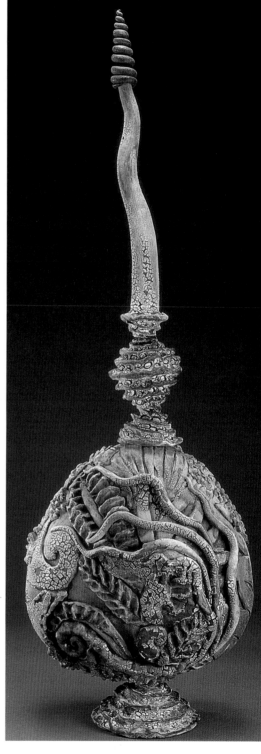

Above: **Sheldon Ganstrom,** *Altar*

1997, 20" x 20" x 14" (51 x 51 x 36 cm). Slump mold and slab construction; clear crackle raku glaze and black engobe, silver nitrate/bismuth subnitrate overglaze in metallic areas; raku fired in electric kiln, cone 07, reduced in newspaper. Photo by artist

Exploring the emotional connection between ceremonial vessels and the temples that house them is the primary concept behind this body of work. Inspired by both ancient and contemporary architecture and vessels, this series investigates man's spiritual response to the buildings he creates and the utensils contained within. In the past, man designed monuments and temples to worship and appease his gods; vessels of great beauty and power served both man and the gods in mysterious rituals. Modern man has shifted his creative drive to designing great buildings dedicated to commerce and science, yet the spiritual urge for ritual, mystery, and service still remains. These works represent the inner rituals and imaginary ceremonial centers needed by modern man.

Right: **Jennifer Townsend,** *Elixir Storage Bottle*

1997, 34" x 12" x 7" (86 x 30.5 x 18 cm). Press-molded, pinched, rolled slabs; black engobe; fired to cone 6; multiple firings, cone 06, with glazes. Photo by Bart Kasten

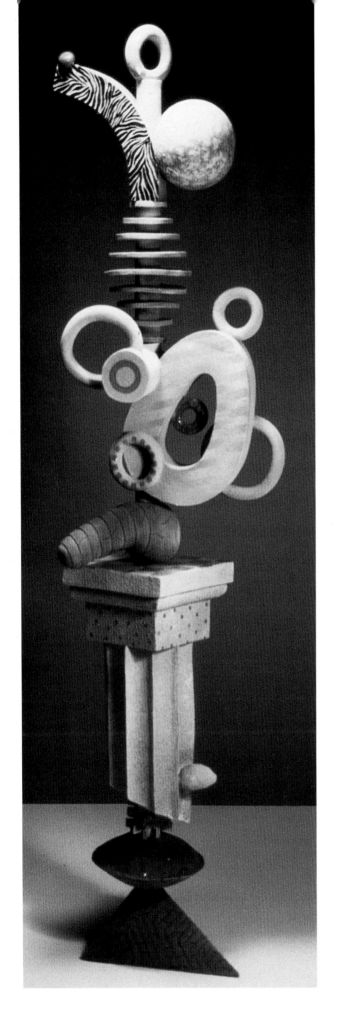

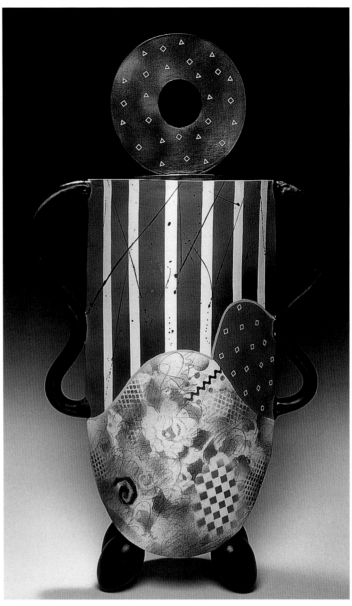

Above: **Colleen Zufelt, *Urn I, Female***

1996, 48" x 20" x 10" (122 x 51 x 25 cm). Cut, draped, and assembled slabs, extruded coils; design airbrushed over stencil, masking tape and graphic press-apply stickers, pencil accents and scribbles; bisque fired in electric kiln, cone 04; glaze fired, cone 06. Photo by Carson Zullinger

This vessel was the first of this series, and I had to make it big. It was difficult, especially designing the right balance for the feet. I measured, drilled, and the balance was perfect. It will probably never happen again! I love the process of parts right now—a lot of pieces that come together to make a final form. These "urn" forms are containers, but are based on the human body ... containing what?

Left: **Michael Hough, *Capitalized Portal***

1997, 92" x 27" x 22" (234 x 69 x 56 cm). Handbuilt components, coil constructed and slab assembled; all elements gravity held on a steel armature; vitrified slip, sprayed and brushed underglazes and commercial glazes, oversprayed with Gerstley borate; oxidation bisque fired, cone 1; glaze fired, cone 06-04

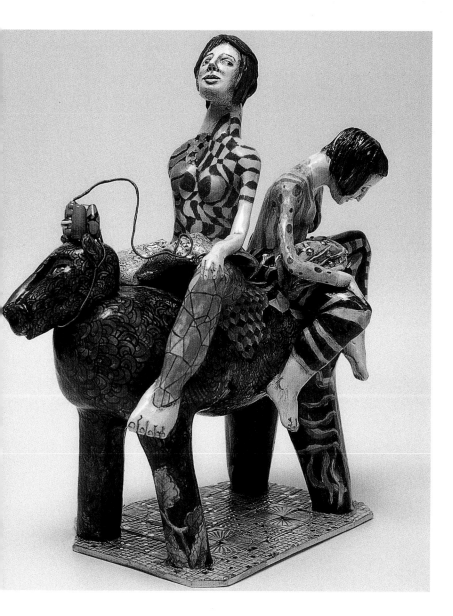

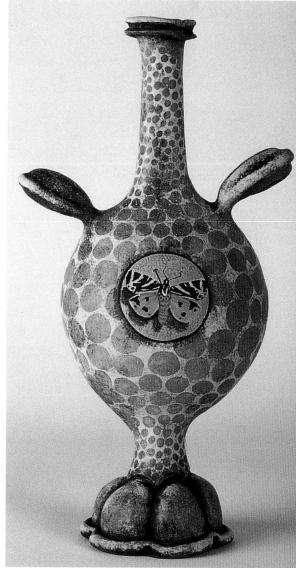

Above: MaryLou Higgins, *I Dreamt I Went Ariding with My Inner Self*

1997, 16½" x 15" x 7" (42 x 38 x 18 cm). Phoenix stoneware; slab parts first formed over cardboard cylinders, PVC pipe, foam shapes, and/or wood forms—then joined; bisque fired in electric kiln, cone 07; underglaze paint and pencils, clear glaze; glaze fired, cone 7; gold, platinum and/or pearl luster; luster fired, cone 018. Photo by Edward Higgins

Right: Sara E. Bressem, *Atticus Luna*

1997, 12" x 7" x 5" (30.5 x 18 x 13 cm). Handbuilt earthenware, with press-molded, pinched, and coiled parts; slips, mason stains, underglazes, oxides, and glazes; patterns built up through layering and resist techniques; multiple firings in electric kiln, cone 04 to cone 1. Photo by Oliver Scott-Mumby

Times spent in my father's garden serve as some of my most vivid childhood memories. The abundance of growth and vegetation enthralled me and fueled my imagination with thoughts of what lurked amongst the leaves and stalks. The work is an amalgamation of my fascination for historical ceramics, kitsch, and insect and animal structures and behaviors—all translated through my personal history. I hope to develop a narrative in the piece through my exploration of how the surface and form relate.

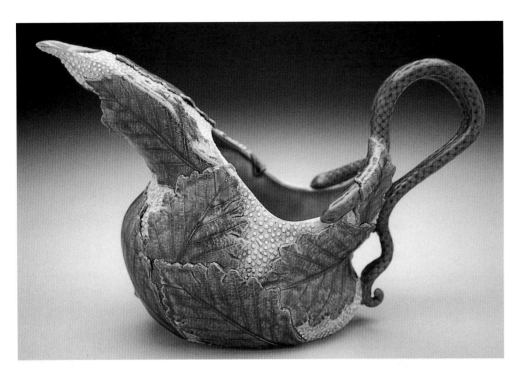

Left: **Betsy A. Rosenmiller,** *Pitcher*

1997, 7" x 11" x 4½" (18 x 28 x 11 cm). Cast body with added texture; individually cast and applied leaves, added textured-coil handle; glaze fired in electric kiln, cone 5; china paint fired to cone 018

Below: **Allen Bales,** *Raku Free Form Platter with Spheres*

1997, 26" x 22" x 4" (66 x 56 x 10 cm). Slab-rolled construction with added and subtracted clay, impressed with found objects, and drape molded; multiple layers airbrushed acrylic paint; additions of copper, variegated copper or gold leaf; bisque fired, cone 08, masked, sprayed with raku crackle glaze; raku fired, cone 08, reduced with wood shavings.

Photo by Linda Mooney Photography

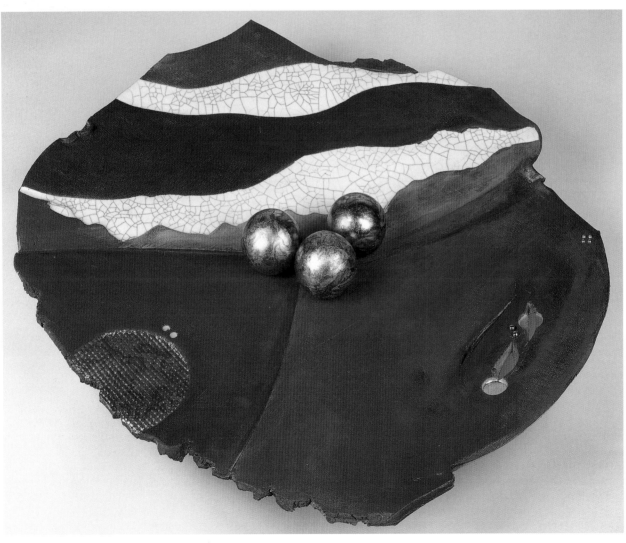

COMBINED TECHNIQUES & MATERIALS

In order to translate particular visions into clay, ceramic artists sometimes choose to combine two or more clay-shaping techniques. An elegant coiled platter, for example, may have a wheel-thrown foot or mold-made additions. Elements of an intricate slab-built or hand-sculpted vessel may be press-molded, coiled, and/or pinched. No matter what type of work is created—pottery, vessels, sculptural work, or architectural installations—combining techniques in this fashion not only affords ceramic artists the advantages specific to each technique, but allows them to express through their claywork effects that might not otherwise be possible. As you study the outstanding examples in this section, you may notice that in some pieces, a single technique is clearly predominant. In others, combined techniques are balanced in such a way that none appears to dominate the work as a whole.

Some ceramic artists use a variety of materials in their claywork, from stones and shells to wood and paper. We've included several examples of mixed-media work in this section, although clay is the predominant material in all the pieces shown.

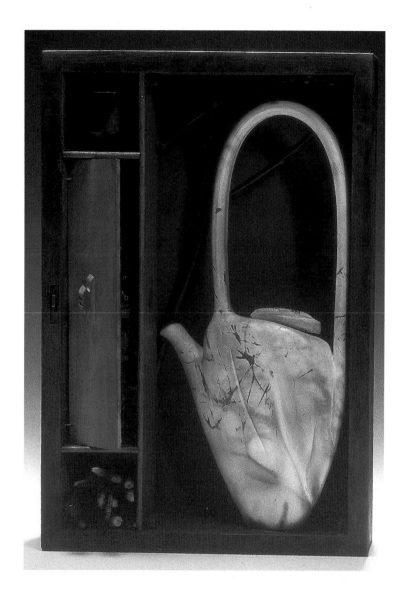

Judith E. Motzkin, *A Room for Tea*

1997, 12" x 9" x 4" (30.5 x 23 x 10 cm). Wheel-thrown and altered teapot, pulled handle, wheel-thrown spout (carved), coiled clay sticks, wheel-thrown cup; other elements include wood, antique writing box, oil paints, screen, tea, branches, and wax; polished terra sigillata; saggar fired in gas kiln, cone 06. Photo by Bob Barrett

Tea and clay come together in meaningful ways. The teapot in this series has become a metaphor for ourselves in the moments and stages of our lives. Earth, fire, water, leaves—the alchemy of these elements is transformative.

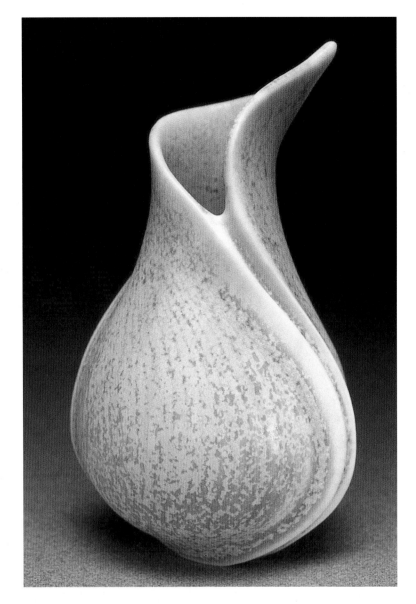

Top: **Sandra Byers,** *Swirl*

1997, 3½" x 2" x 2⅛" (9 x 5 x 5.3 cm) Wheel-thrown, pinched, cut, and handbuilt porcelain, with extruded additions; incised, microcrystalline matt manganese glaze; oxidation fired in electric kiln, cone 9½.
Photo by artist

Nature's details are an endless source of inspiration—the swirl of a tightly closed bud, the range of colors on a spring hillside. I work to make flowing curves and forms that spring to life. I encourage glazes to break and crystallize with their own life. Then I return to the natural world with new eyes.

Left: **Margaret Freeman Patterson,** *"a tisket ... a tasket"* **series**

1997, 9" x 16" x 8" (23 x 41 x 20 cm). Raku clay; wheel-thrown and altered sides, slab bottom, hand-formed and attached handles; parts assembled while clay soft; incised, weathered bronze glaze; reduction fired in gas kiln, cone 10.
Photo by Bart Kasten

When I began my assistantship in the pottery program at The Callanwolde Fine Arts Center in Atlanta, Georgia, very round, very smooth pots came from the potter's wheel—so perfect, I was unable to disturb them. Because I felt that wonderful surfaces and shapes are achieved through altering the thrown pot, I wanted to reach through my personal reluctance to do so. And that I did! Each piece in my exit show from the program was thrown and altered.

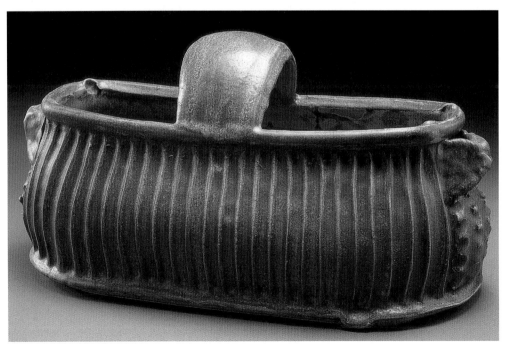

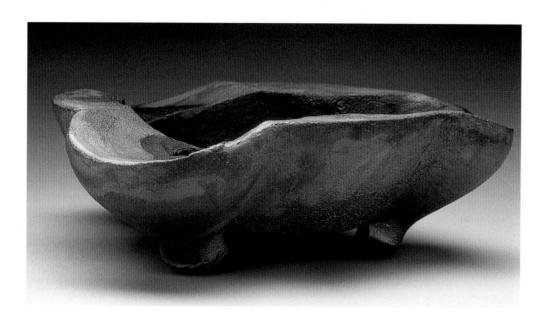

Above: Douglas E. Gray, *Aztec Ceremonial Vessel*

1996, 5" x 14" x 14" (13 x 36 x 36 cm). Wheel-thrown, altered, and assembled double wall form, with inset, textured, and expanded slabs on each leg and within the interior; inset slabs brushed with white slip and black iron oxide, then smoked; copper flashing, textured glaze on remaining surface; raku fired, approximately cone 06. Photo by Harrison Evans

My work is primarily concerned with space and the constructed barriers which not only divide the spaces of our existence, but divide us as well. So often, we are like vessels, sometimes revealing and at other times concealing the center landscape of our identities. It is the process of revealing and concealing space that intrigues me.

Right: Suze Lindsay, *Candelabra*

1997, 26" x 15" x 2" (66 x 38 x 5 cm). Handbuilt and wheel-thrown elements, stacked; slip decoration, paper resist, brushwork, and sgraffito; salt-fired stoneware, cone 10. Photo by Tom Mills

I really enjoy playing with form by throwing and altering pots. Some are made on the wheel without bottoms and ovalled while soft. Others are made in the round, then cut and darted to create angles that suggest stance or attitude. I hope to give my pots a personality that will invite you to use them, whether it be for your first cup of coffee in the morning or for a fancy dinner party.

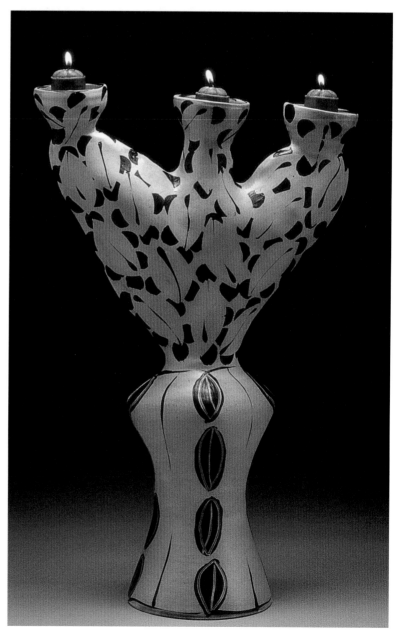

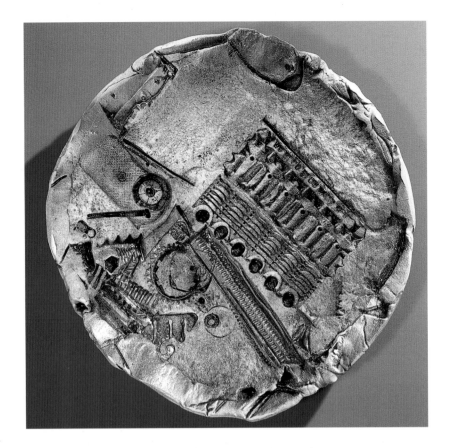

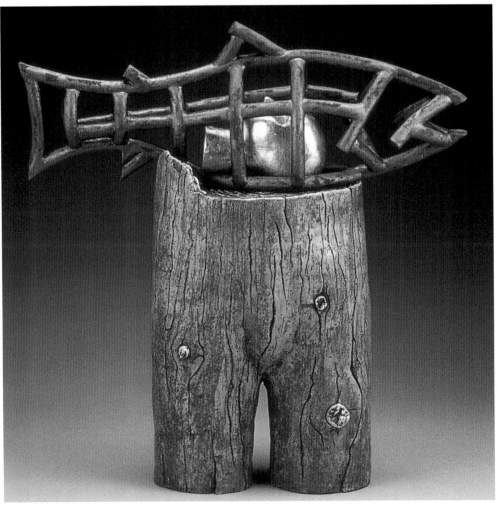

Top: **Sandra Blain,** *Elements #12*
1997, 22" x 22" x 4½" (56 x 56 x 11 cm). Slab and coil platter form, wheel-thrown tube base; clear glaze on greenware slab; sifted organic/inorganic matter pressed into surface; stamped, rolled, and brushed slips, underglazes, and oxides; bisque fired in electric kiln, cone 07; added colorants and clear glaze; glaze fired in electric kiln, cone 03. Photo by Tom Neff

The substance of clay functions on both a physical and a symbolic level. Elements—manmade or natural—affect our landscape and serve as metaphors for forms and surfaces of earthenware clay pieces. A recent series of platter forms constructed of handbuilt components alludes to the scarification of our environment, and in particular to the markings on elements in our forests, water, air, and land, or the effects of living creatures.

Left: **Ted Vogel,** *Fish Cage*
1997, height: 24" (61 cm). Earthenware; pinched, coiled, and carved stump figure; coiled fish; press-molded head; glaze, terra sigillatas, and gold leaf; fired in electric kiln, cone 04. Photo by Bill Bachhuber

My work explores landscape and relationships between nature and mankind.

Top: **Jim Koudelka, *Reservoir***

1997, 19" x 12" x 11" (48 x 30.5 x 28 cm). Wheel-thrown container and lid with slip-cast and press-molded additions; post-firing additions of steel rods and wire; high alumina glazes, crackle slips, salt slips, low-fire commercial glazes; salt fired, cone 10; additional cone 06 firings; sandblasted. Photo by Courtney Frisse

My sculptures recontextualize essential qualities of industrial, mechanical, and architectural structures. I incorporate this with figurative references, symbols, and text. These pieces function metaphysically as containers or devices. The patination of age is simulated through my interaction with ceramic materials and painting processes.

Right: **Richard Bonner, *Tumble***

1997, 24" x 47" x 24" (61 x 119 x 61 cm). Coiled and press-molded earthenware, and steel cable; glazes, including one "washed" with ferric chloride after firing; fired in gas kiln, cone 04; copper leaf

My thoughts in some way or another come around to motion. Sometimes it is the motion related to machines. Sometimes it is the motion related to internal and external body processes. Ideally, they are somehow combined.

Above: **Lori Mills,** *Tulip Holder with Two Caterpillars and a Worm*

1996, 13½" x 19" x 8½" (34 x 48 x 22 cm). Wheel-thrown and altered forms, handbuilt additions; colored slips, sgraffito, and colored and textured glazes; fired in electric kiln, cone 05-04

Left: **Jill Gross,** *Beastcake: a Covered Vessel*

1997, 17" x 11" x 11" (43 x 28 x 28 cm). Porcelain; wheel-thrown body, head, legs, and tail; textured slab wings; pinched claws, spikes, and teeth; painted underglazes, clear glaze; bisque fired in electric kiln, cone 08; glaze fired, cone 10. Photo by Arruda Studio, Wellesley, MA

My earliest connection with clay was as a child climbing the multicolored Gay Head cliffs, fashioning small creatures out of the clay, and watching the Wampanoag potters at the wheel. Continuing to work with clay over the years, I have drawn inspiration from Eastern and Middle Eastern art, mythological painting and sculpture, music, my students, and most of all from the natural world.

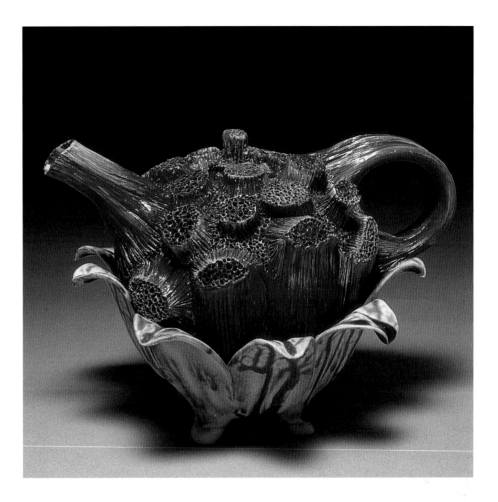

Right: **Bonnie Seeman,** *Hojala*

1997, 6" x 8½" x 4½" (15 x 22 x 11 cm). Wheel thrown, with handbuilt additions; oxidation fired, cone 10; china paints; fired, cone 018

Below: **Colleen Zufelt,** *Roses-n-Stripes Teapot*

1996, 12" x 20" x 10" (30.5 x 51 x 25 cm). Wheel-thrown, cut and draped slab, extruded and pulled portions; designs airbrushed over stencils and masking-tape resist, press-apply labels, underglaze pencil accents, clear glaze; bisque fired in electric kiln, cone 04; glaze fired, cone 06. Photo by Carson Zullinger

My recent work plays light airbrushed areas against hard graphics. I use a lot of bright colors with black accents or black-and-white patterns. I love contrast. It exists in my life, so my work reflects it. My vessels seem to have personalities—bodies, arms, feet, heads. They are becoming a celebration of the people around me—family, my kids, and children I teach.

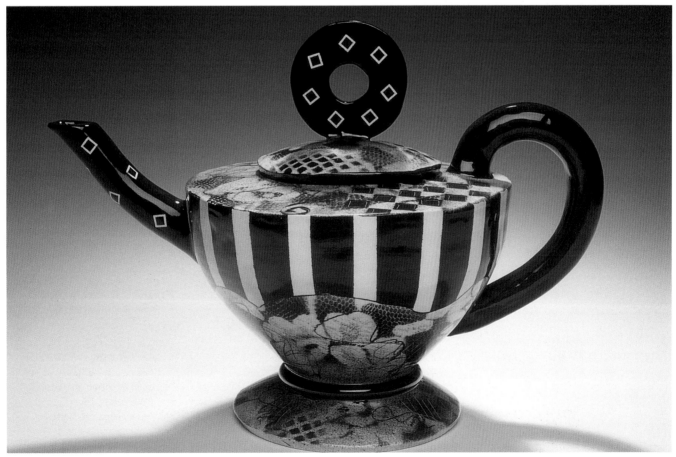

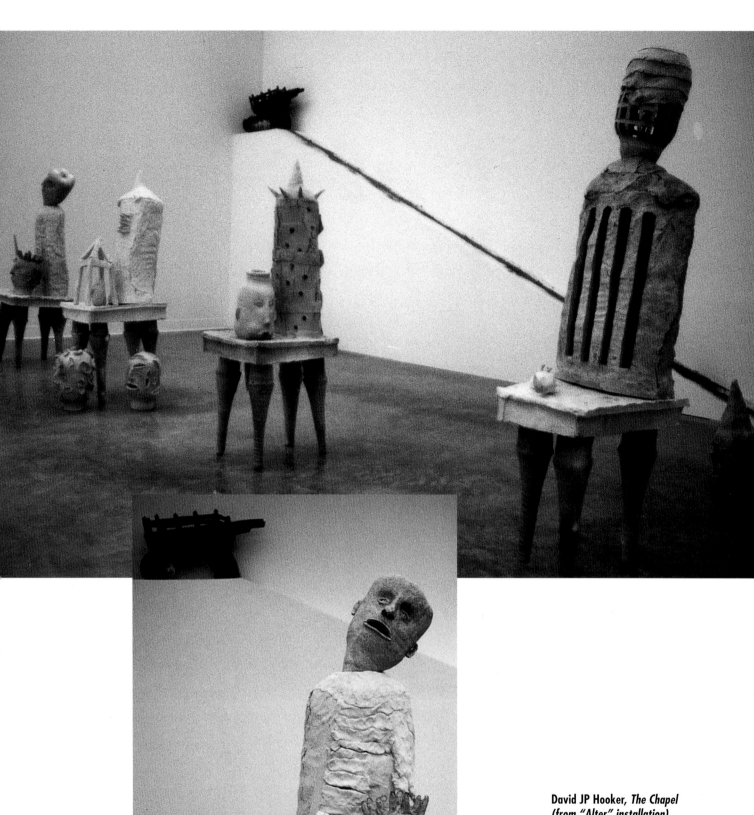

David JP Hooker, *The Chapel (from "Alter" installation)*

1996, figure/chair: 52" x 21" x 20" (132 x 53 x 51 cm). Wheel-thrown and altered heads; slab-built bodies with coiled highlights; wheel-thrown chair legs; figure/chairs: salt-fired stoneware, cone 1; death-cart: wood fired, cone 10

Right: **Shigeru Miyamoto,**
Poi Pounder

1996, 28½" x 18" x 17½" (72 x 46 x 44 cm). Coil constructed, with wheel-thrown disk attached to top portion; slips and oxide stains, with high-fire black satin glaze (used to symbolize the color of lava); fired in light reduction, cone 04 to cone 9, with ½-hour oxidation at the end. Photo by Shuzo Uemoto

Far right: **Victoria Shaw,**
Totemic Dreams

1997, 64" x 14" x 13½" (163 x 36 x 34 cm). Stacked clay forms (wheel thrown, and slab and coil constructed), slab also used in disk forms; surfaces combed, forms stacked on pipe, with wood and granite base; airbrushed barium glaze; oxidation fired, cone 6. Photo by Courtney Frisse

Below: **Julie B. Hawthorne,**
Plum Street

1997, 39" x 42" x 23½" (99 x 107 x 60 cm). Slab built and wheel thrown; black engobe, sprayed clear glaze; once-fired, cone 5

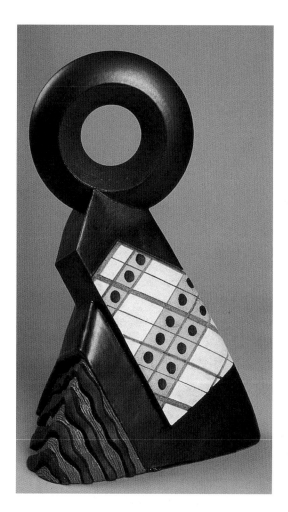

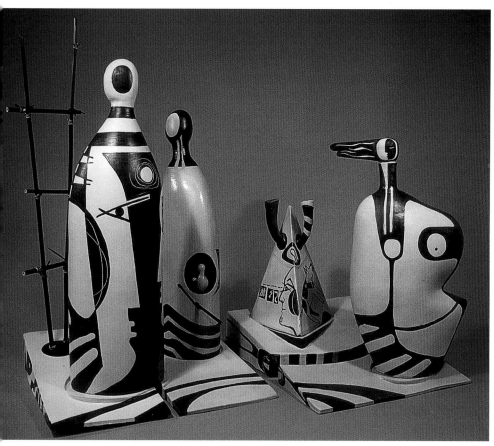

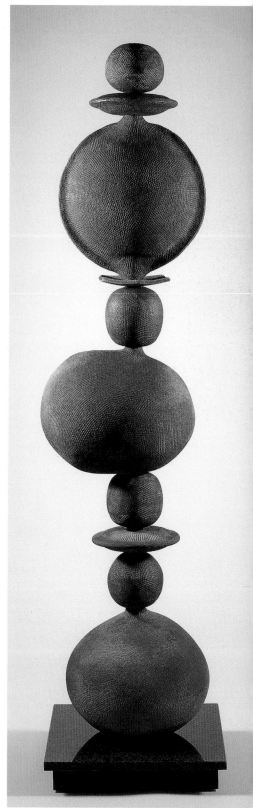

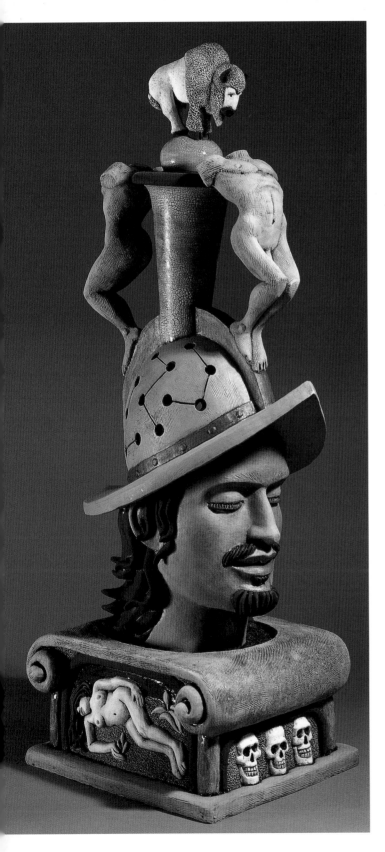

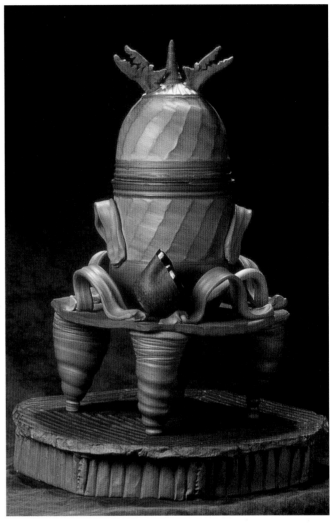

Above: **Kreg Richard Owens, *Howling Dog Soup Tureen with Trivet and Ladle***

1996, 32" x 24" x 24" (81 x 61 x 61 cm). Terra-cotta; handbuilt trivet with stamped and carved designs; wheel-thrown, stretched, and cut tureen stand; pulled handles; wheel-thrown and altered legs; wheel-thrown and faceted tureen; wheel-thrown finial; handbuilt howling dog hands; wheel-thrown ladle with pulled handle; glazed interior, terra sigillata on exterior; once-fired in electric kiln, cone 05

This work is firmly rooted in the functional tradition, with a heavy emphasis on ceremonial aesthetics and a light and sometimes whimsical approach to formal elements. The pieces are designed for use but also for decorative purposes.

Left: **Mark Messenger, *Empire***

1996, 34" x 14" x 12" (86 x 36 x 30.5 cm). Slab, wheel thrown, and hollowed. Photo by Ken Von Schlegel

My work represents a personal mythology based on a contemporary perspective. It includes a combination of drawing, painting, modeling, and pottery techniques which reference both folk art and fine art. Through these, I explore social, political, and psychological issues which I experience as a sense of place.

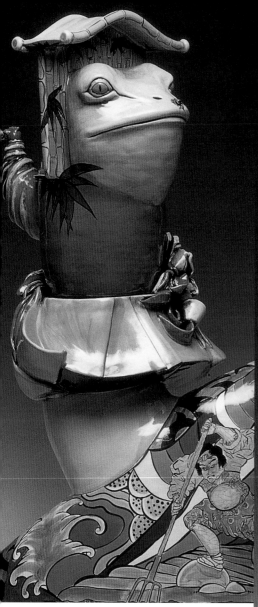

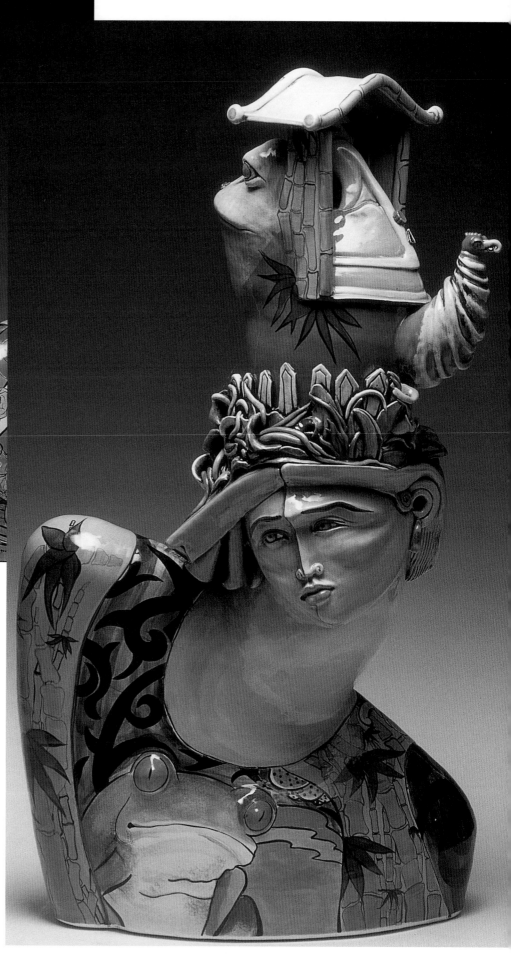

Jean Cappadonna-Nichols, *Crazed Weekend Warrior*

1997, 43" x 24½" x 15½" (109 x 62 x 39 cm). Slab built, coiled, wheel thrown, and altered; underglazes, glaze, and India ink; bisque fired in electric kiln, cone 04; glaze fired, cone 05. Photo by William C. Martin

Several years ago, I became interested in the aesthetic of the Japanese tattoo. The surface of this piece is influenced by that aesthetic. The images have been manipulated and transported from Eastern to Western culture to create a personal iconography and to address the lighter side of domesticity. While this piece has a strong case of "Asian flu," cultural icons from other countries also appear in my work. This cross-culturalization is directly due to the impact of television. Crazed Weekend Warrior *is one of 16 pieces in a series entitled "What's a Nice Girl Like You ..."*

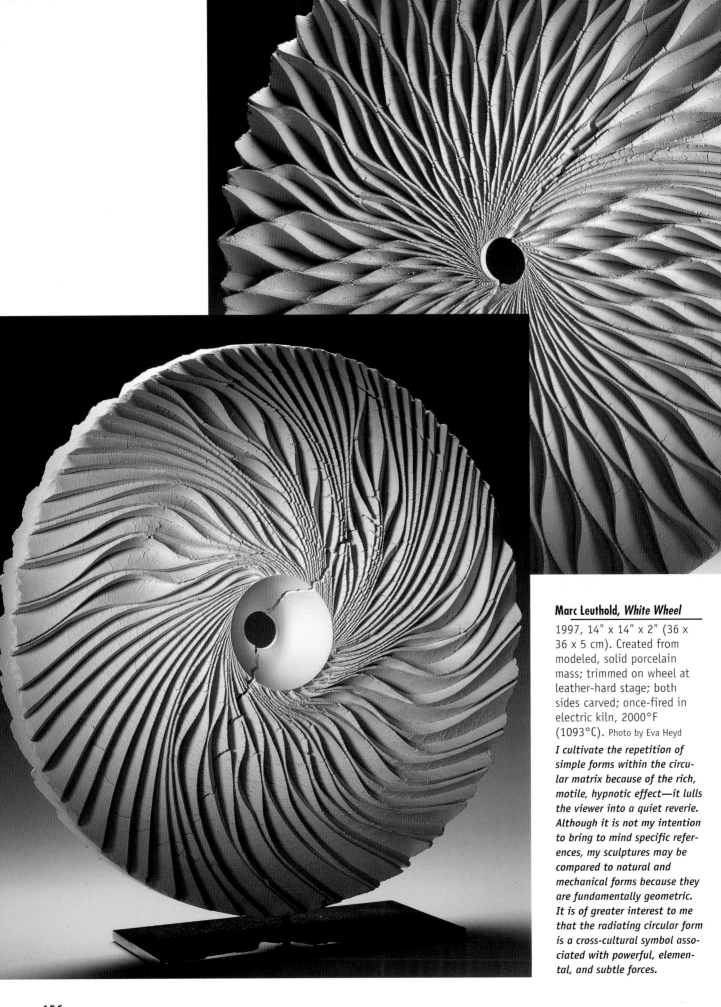

Marc Leuthold, *White Wheel*

1997, 14" x 14" x 2" (36 x 36 x 5 cm). Created from modeled, solid porcelain mass; trimmed on wheel at leather-hard stage; both sides carved; once-fired in electric kiln, 2000°F (1093°C). Photo by Eva Heyd

I cultivate the repetition of simple forms within the circular matrix because of the rich, motile, hypnotic effect—it lulls the viewer into a quiet reverie. Although it is not my intention to bring to mind specific references, my sculptures may be compared to natural and mechanical forms because they are fundamentally geometric. It is of greater interest to me that the radiating circular form is a cross-cultural symbol associated with powerful, elemental, and subtle forces.

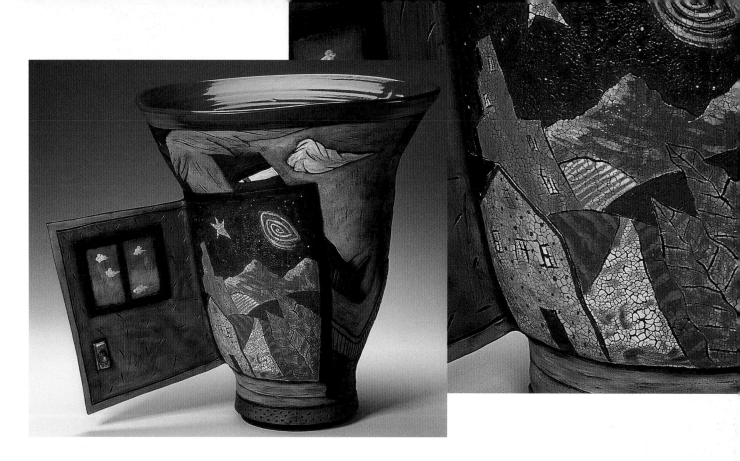

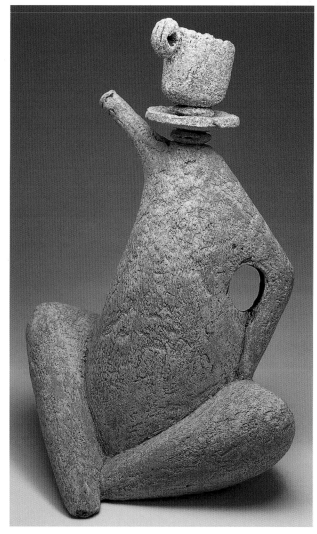

Above: David Stabley, *Vessel with Open Door*

1997, 22" x 18" x 13" (56 x 46 x 33 cm). Wheel-thrown and altered earthenware, with slab addition; drawn and carved; glazes and rubbed-on patina finish; fired in electric kiln, cone 05. Photo by Gorden Wenzel

This work stems from ideas about the house as a form and as a vessel. The door and interior symbolize ways that we can escape into another realm through our dreams. All of my ideas relate to fantasy and the fragmented ways that we remember our dreams. I have always drawn imagery from my imagination, combining forms into a visual narrative, using people, landscapes, houses, texture, shapes, and color.

Right: Howard Christian Koerth, *Seated Teapot: "Effigy" series*

1996, 17" x 12" x 9" (43 x 30.5 x 23 cm). Wheel-thrown, altered, and coil-built body and cup; handbuilt spout; hand-formed saucer; lithium glaze fired to just below fluxing temperature over gray slip and black underglaze; bisque fired in electric kiln, cone 06; glaze and body fired to cone 04; outer surface fired to cone 010. Photo by Stevie Scheidemantel

The "Effigy" series was the culmination of a previous series which explored vessel, ritual object, and the human nature of both. With this series, I wanted to push the structure of the teapot toward human gesture and develop a solid, continuous merging of figure, vessel, and form. I want in each individual piece an object that compels the viewer to visually respond not only to vessel, but also to its human content and qualities.

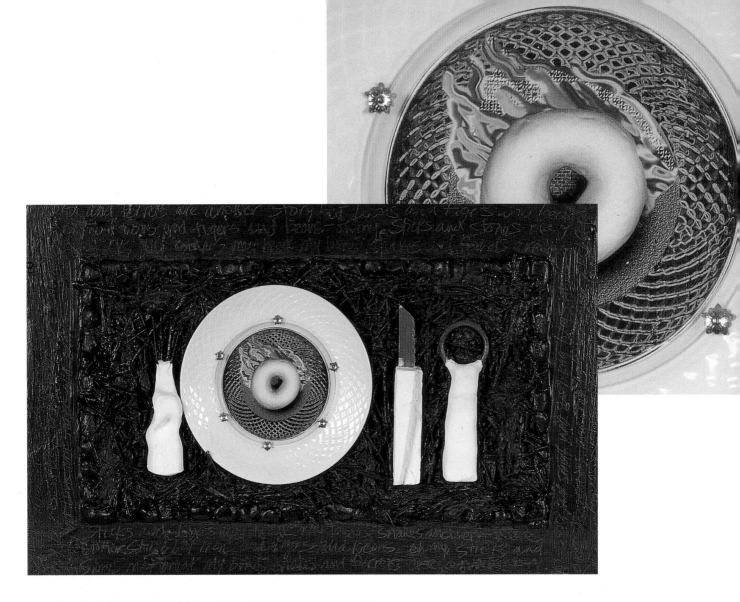

Above: Judith Cook, *Portrait of The Boys v.1.5*

1997, 19" x 30" x 2½" (48 x 76 x 6 cm). Commercial high-fire porcelain plate was first scanned; then digital image manipulated with computer software; new image printed onto another commercial high-fire porcelain plate with mixed media; pinched low-fire whiteware utensils with found metal parts; "place mat" consists of sticks, stones, and stabilized clay with paint on wood; ceramic whiteware parts oxidation fired, cone 06. Photo by Ethan Kaminsky

"Art is a lie that enables us to realize the truth." —Picasso

In my current work, I create or appropriate found ceramic parts, scan them, then combine them with other digital images and my original paintings. All of this is then combined, manipulated, and layered with the final image, and transferred to fired ceramic tile. Often, the resulting works then begin a new series of paintings.

Left: Michael Sheba, *"Synergy" Raku Platter*

1997, diameter: 18" (46 cm). Handbuilt, with wheel-thrown and attached foot ring; impressed, incised, and carved; airbrushed slips, underglazes, and glazes; multiple raku firings, with post-firing reduction, cone 06. Photo by artist

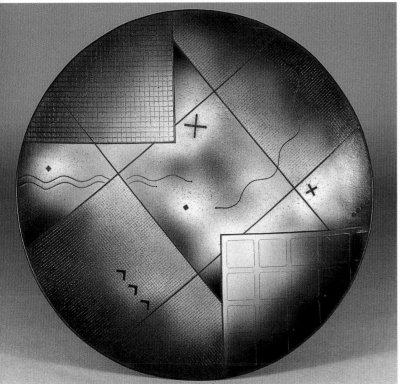

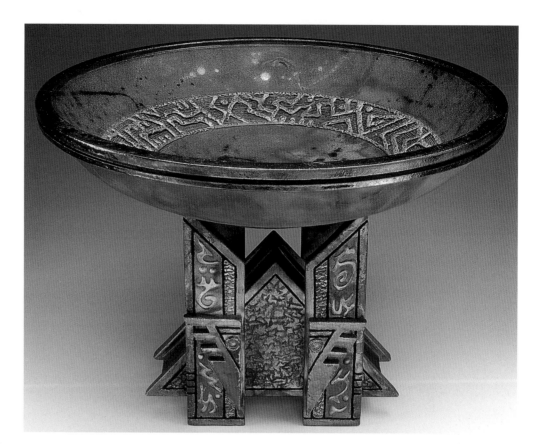

Top: Kendell Coniff, *Temple of the Sun People*

1997, bowl diameter: 14"
(36 cm). Stoneware; wheel-
thrown bowl, slab-built
stand; carved, impressed,
slip trailed, multiple raku
glazes; bisque fired in elec-
tric kiln, cone 06; raku fired
in gas kiln, cone 08-04. Photo
by John Bonath

*The art I create combines both
ancient and futuristic ele-
ments, influenced by science,
nature, machines, and history.
The pieces are meant to be
visually satisfying yet intrigu-
ing, combining line, form, tex-
ture, color, and imagery. They
entice the viewer to discover
the underlying inorganic visual
power and rich subtlety of the
vessels and evoke hidden feel-
ings of another time and place.*

Right: Allison Lowe, *Persian Tea*

1996, 15" x 10" x 4" (38 x
25 x 10 cm). Wheel-thrown,
handbuilt, and assembled
sections; carved and incised
decoration; oxidation fired,
cone 6

*I take inspiration from history
and cultures all over the world.
Also, a fascination with archi-
tecture is evident in my pieces.*

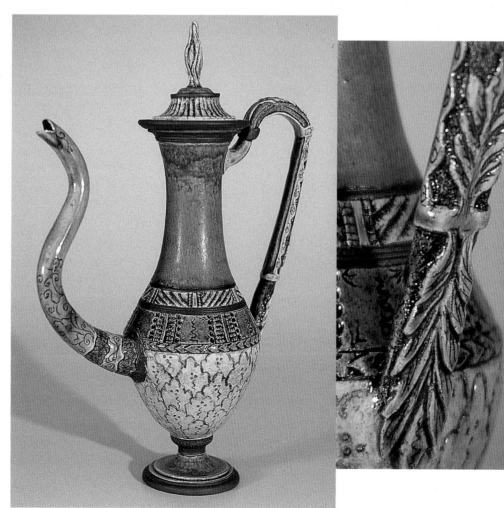

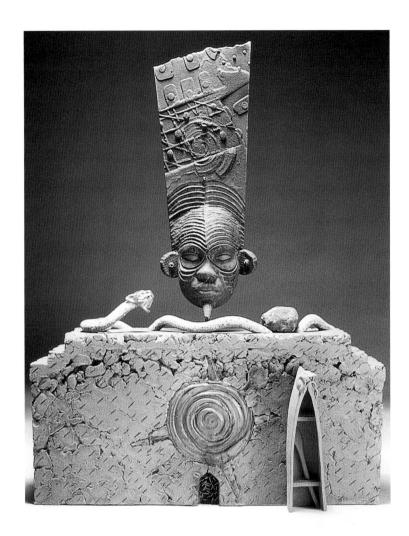

Above: **Patrick S. Crabb, *Lekana's Temple***

1997, 37" x 22" x 11" (94 x 56 x 28 cm). Press-molded base/face, slab-built canoe, extruded snake, inlaid "turtle" image above temple doorway, geodes affixed with epoxy; multiple firings in electric kiln, cone 06-02; gold luster mask on snake fired to cone 018. Photo by artist

My most current direction is the clay vessel in its architectural analogies, with cross-visual references from Mayan temples to African huts. These forms are an extension of my past vessel-making interests. In many ways, architecture is the most generic, fundamental form of a vessel. It holds not only the physical, but also the spiritual embodiment of mankind. Ritual and ceremony are major components of ancient architecture. Symbols abound with the use of undulating "masked" snakes, canoes, actual stones, offering vessels, and faces (masks) filled with ornamentations.

Left: **Gina Vigliarolo, *We Found Everything Just As It Had Been Left***

1997, height: 96" (244 cm). Wheel-thrown, stretched, draped, and molded porcelain slabs; brushed terra sigillata, underglazes, brush-painted words; fired in electric kiln, cone 1

The work illuminates a moment. The porcelain fragments act as pieces of paper. A record of my existence. The writing and symbols explore memory, thoughts, and influences contained in that moment. I am searching for an awareness of how we perceive reality. My intention is to engage the viewer in that moment.

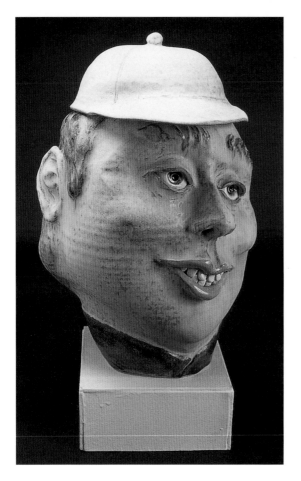

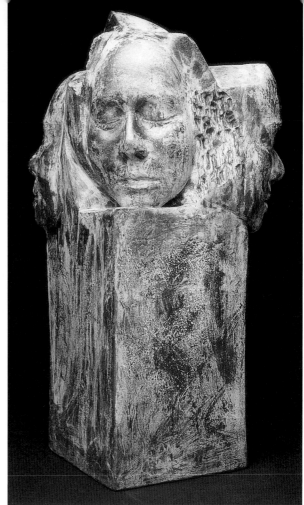

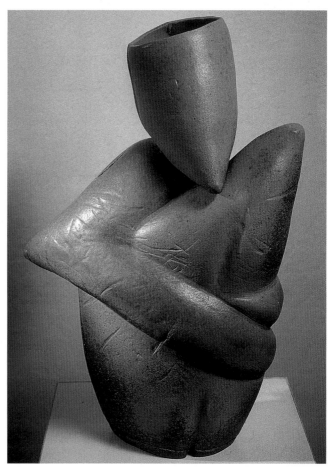

Above: **Alison McCauley,** *Man's Head with Cap*

1997, 14" x 10" x 10" (36 x 25 x 25 cm). Wheel-thrown stoneware; altered by pushing, adding coils and slabs, scraping; porcelain eyes and teeth; dipped and brushed glazes; fired in electric kiln, cone 10. Photo by John Dunn

My work is mostly wheel-thrown functional ware and the more sculptural, thrown heads. Inspiration for the heads comes from all the expressive faces around me.

Top right: **Tobias Weissman,** *Faces*

1997, 21" x 12" x 10" (53 x 30.5 x 25 cm). Slab form, molded faces with sculpted alterations; bisque fired, cone 06; copper patina. Photo by Robert Mathewson

The experience of creating pottery is my spiritual quest. It gives me a deep connection with the earth and its elements—a profound and symbolic reflection of life in its purest form. It is a place of unfolding, learning, and experimentation—a place of deep wonderment and respect for the paradox of life. I've come to realize and appreciate that the randomness of nature and the order of the universe are truly interchangeable.

Right: **Julie B. Hawthorne,** *Limbo*

1997, 30" x 19" x 9" (76 x 48 x 23 cm). Slab built and wheel thrown; black engobe, sprayed clear glaze; once-fired, cone 5

My work reflects contemporary images of the human form and body language. My pieces are completed while wet, sprayed primarily with a simple three- or four-part glaze, and once-fired.

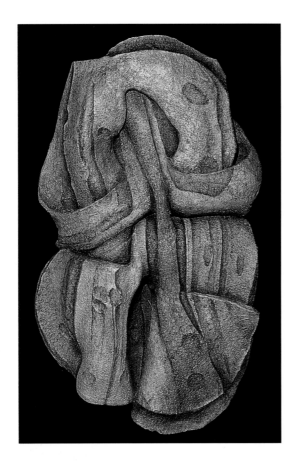

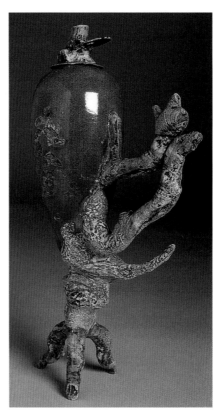

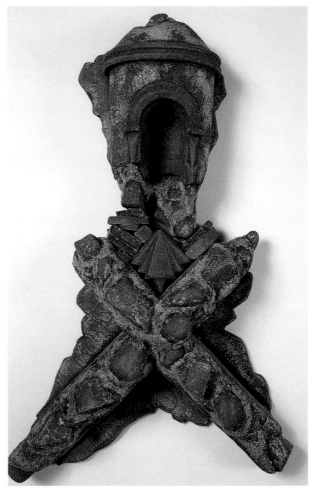

Top left: **Leslie Green,**
Venetian Knot

1996, 22" x 13" x 4" (56 x
33 x 10 cm). Tossed, tex-
tured slabs formed over
newspaper and joined; oxida-
tion fired, cone 5, either as a
single piece or in sections
and later joined in a small
gas kiln; wall piece mounted
on a board, gessoed, and
painted with multiple layers
of acrylic wash.
Photo by Gary G. Gibson

Top right: **Shane M. Keena,** ***Clear***
Cut Commodity

1997, 15" x 7½" x 8" (38 x
19 x 20 cm). Handbuilt,
wheel-thrown earthenware,
trimmed and joined sections,
"eroded" under running
water; commercial and cus-
tom glazes; bisque fired in
electric kiln, cone 04; multi-
ple glaze firings, cone 06;
luster fired, cone 018; stained
with commercial wood stains.
Photo by Kevin Koppers

Left: **Cameron Crawford,**
Safe Haven

1996, 30" x 19" x 6" (76 x
48 x 15 cm). Slab and coil
built, with one wheel-thrown
and altered section; slips and
underglazes; bisque fired,
cone 08; sandblasted,
stained, and glazed; glaze
fired, cone 04. Photo by
Chris Autio

Right: Karen Koblitz, *Gina's Journey: Tree of Life for My Daughter*

1996, 30¾" x 24¼" x 5¾" (78 x 62 x 14.5 cm). Modeled, coiled, and press-molded tree of life; slab-built shelf; press-molded tiles; underglaze, glaze, and gold luster; bisque fired, cone 04; glaze fired, cone 06; luster fired, cone 017. Photo by Susan Einstein

This piece is my gift to our beautiful daughter. We are an adoptive family, and the tree of life has our hopes and dreams for Gina. The tree sits on a shelf with symbols of her Latina biological roots.

Below: Makoto Hatori, *Confrontation*

1996, 20" x 38¼" x 9¾" (51 x 97 x 25 cm). Wheel-thrown joined ceramic forms, wire, and wood; wood fired for ten days (oxidation) in traditional Japanese "bank" kiln, 1300°C (2372°F).
Photo by artist

I work in the Bizen tradition but have developed a contemporary language in sculptural work that links my own lineage with life today. The starting point of my work is the goal of harmonizing ceramics with other materials.

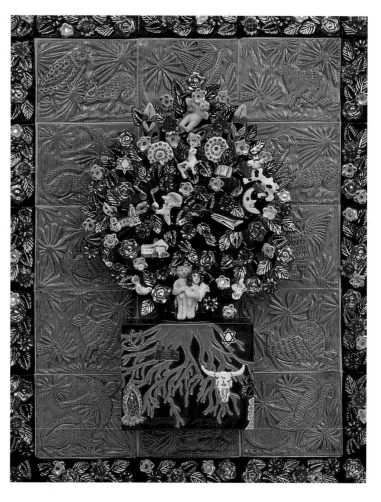

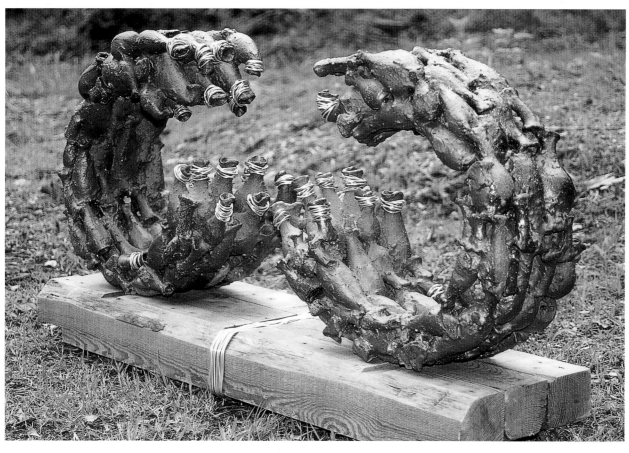

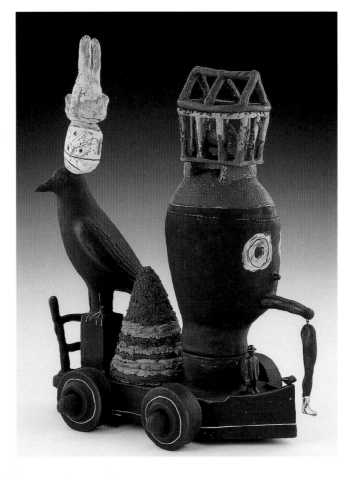

Left: **Bill Stewart,**
Charter Boat

1996, 27" x 14" x 22"
(69 x 36 x 56 cm)
Handbuilt terra-cotta,
with additional molded
shapes or forms; glaze,
slip, sand, etc.; multiple
firings, cone 06-04.
Photo by Bruce Miller

Below: **Lisa Marie Barber,**
The Cake

1996, 58" x 132" x 132"
(147 x 335 x 335 cm).
Pinched, coiled, slab
built, wheel thrown,
and cast; slips, engob-
es, stains, low-fire
glazes; multiple firings,
cone 05.

Photo by Richard Bonner

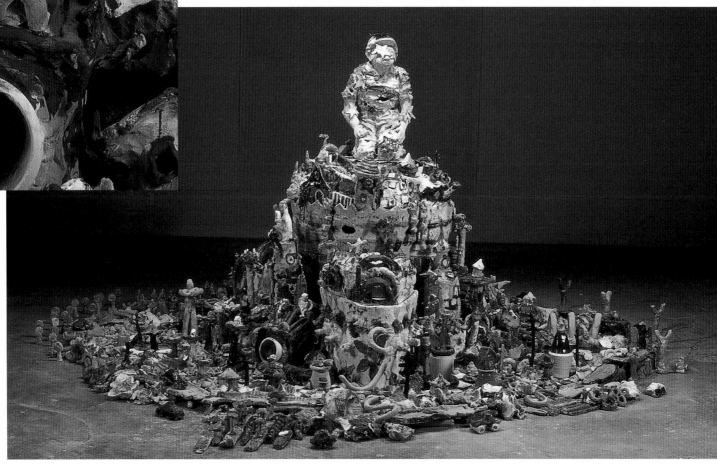

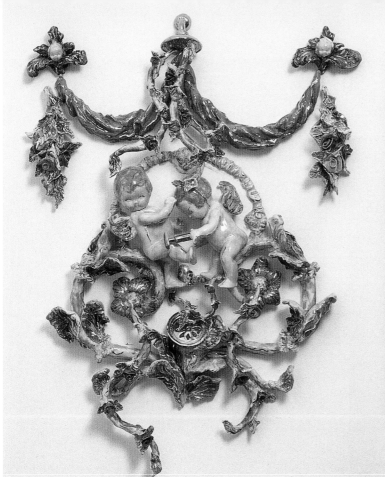

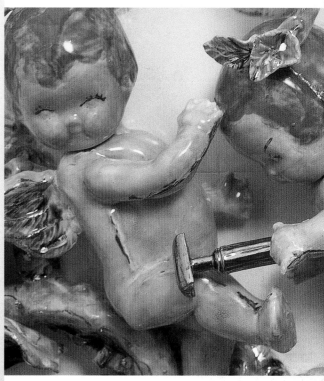

Above: **Beth Katleman, *Close***

1997, 30" x 26" x 6" (76 x 66 x 15 cm). Slip cast, press molded, altered, handbuilt, and carved; underglazes, translucent glazes, and lusters; fired in electric kiln, cone 05; luster fired, cone 017. Photo by James Dee

As a child, I often visited my Aunt Toby, a flamboyant woman with orange hair and long crimson fingernails. In her bathroom, she had a chandelier, two small gilt chairs, and a toilet that played the Star Spangled Banner when you sat on it. She is the muse for my exploration of opulence, excess, and artifice. I marvel at the curios we collect and the ways in which we decorate our homes and bodies. In my work, icons of popular culture collide with rococo motifs and sources of classical mythology. Rather than accentuating the manufactured slickness of the curios and consumer products in my pieces, I highlight the touch of my hand and the rhythm of my brush strokes. By celebrating and parodying our obsessions with good taste, status, and physical perfection, I hope to shed some light on the nature of beauty and pleasure in our time.

Right: **Keith Ekstam, *Temple of Opulent Praise***

1997, 30" x 24" x 12" (76 x 61 x 30.5 cm). Coil built, wheel thrown, and press molded; brushed slips and glaze, luster glaze on small top form; salt fired, cone 10; fired in electric kiln, cone 05

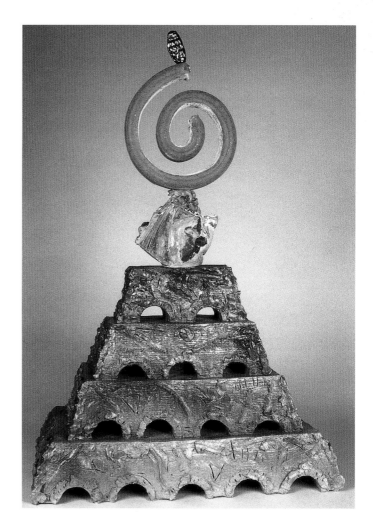

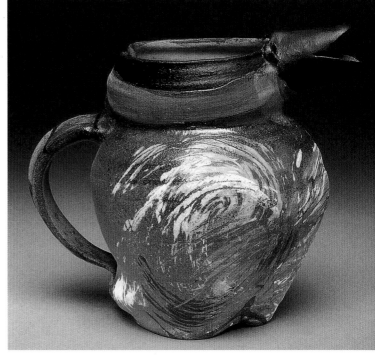

Above: **John Kantar,** *Bird Pitcher with Black Beak*

1997, 8½" x 9" x 6" (22 x 23 x 15 cm). Wheel thrown and altered, with slab-formed beak/spout and pulled handle; vitreous engobes, sgraffito, sodium; gas fired, cone 1. Photo by Peter Lee

Top left: **Linda Nannizzi,** *Vessel with Collared Lizard*

1997, 15" x 13¼" x 12" (38 x 33.5 x 30.5 cm). Wheel-thrown and altered stoneware, sculpted and added lizard, extruded rim and handles; brushed, thick slip surface formed with a pallet knife, airbrushed and painted pigmented engobes, hand-rubbed red iron oxide (some areas sponged clean), interior glazes; reduction fired, cone 10

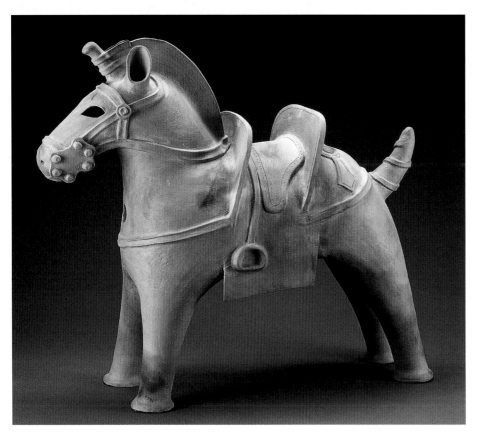

Left: **Matthew Lyon,** *Haniwa Horse*

1997, 34" x 40" x 14" (86 x 102 x 36 cm). Wheel-thrown legs; slab and coil body, saddle, and reins; slab neck and ears; sculpted and hollowed head and tail; reduction fired in gas kiln, cone 04; "smoke" patterns added after firing, using propane torch and newspaper. Photo by Bill Bachhuber

My work, including this horse, is inspired by the ceramics of prehistoric Japan. I'd thought I might try to just make a replica, but it was irresistible not to make my own version, with a personal and more contemporary design, while still maintaining strong visual references to the originals.

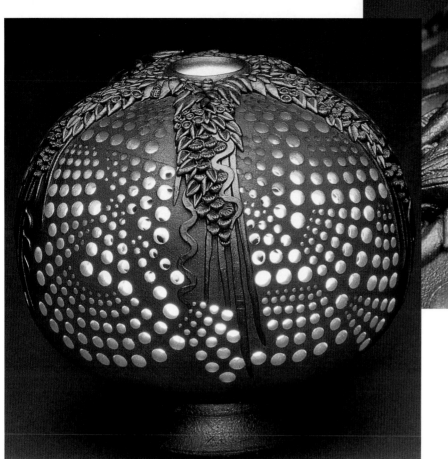

Above: Jerry Conrad, *Sphere with Bugs & Lizard Lantern*

1997, diameter: 11" (28 cm). Wheel thrown; main form thrown upside down so that thrown lip rests on the separately thrown base when lantern is finished; added coils, bugs, leaves, and lizard in different colored clay; brushed iron; sprayed iron, nepheline syenite, and flint; reduction fired in gas kiln, cone 9 or 10; light reduction to cone 8 down, short period of heavy reduction, short period of oxidation, then light reduction to cone 9 down.
Photo by Doug Yaples

This piece is a response to the glittering, dew-drop covered, huge spider webs you see in the early morning along the coastal areas of Washington.

Right: Marla Bollak, *Two Lizards Pot*

1997, 12¼" x 13" x 9½" (31 x 33 x 24 cm). Two joined, hand-formed spheres, added wheel-thrown and altered rings, added lizards; glaze; raku fired, cone 04. Photo by David Caras

Art has exerted a profoundly healing force in my life. I am deeply influenced by pre-Columbian art. I like lizards.

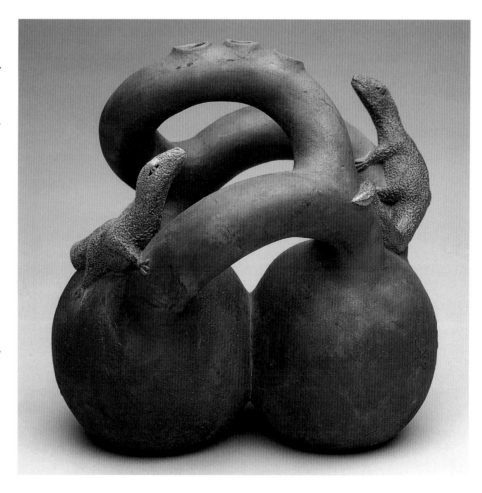

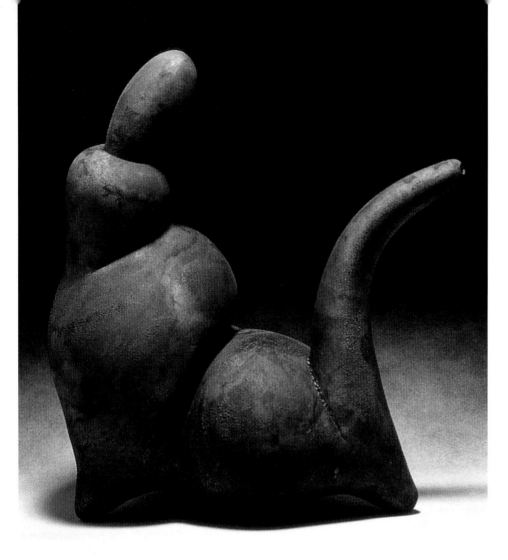

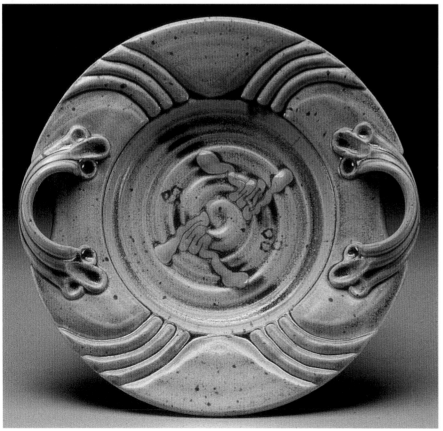

Dale Marhanka, *Ewer Form*

1997, 13" x 12" x 8" (33 x 30.5 x 20 cm). Wheel thrown and altered, with some coil building; sponged copper and iron raku glaze; raku fired, cone 06, reduced in pine needles and straw. Photo by artist

Figural dialogue in our everyday environment is a major influence in my work. These nonfunctional vessel forms are intimate gestural forms created in response to that stimulus, whether it is conscious or subconscious. My intent is to produce an analogy about the balance or tension between the feminine and masculine association. These sculptural vessel forms are products of the feelings, values, and sensitivity I have actualized through clay. The many years I have spent making pots has made me realize how fundamental touch and spirituality are to my work and life. I have chosen the teapot and ewer form as the vehicle I feel will best express this analogy and intimacy. By using the potter's wheel, then altering and handbuilding these forms, I have gained the ability to express myself intuitively in a very personal way.

Catherine "Cat" Jarosz, *Large Platter*

1997, 3¼" x 20" x 20" (8 x 51 x 51 cm). Wheel thrown and trimmed, with extruded handle; carved, dipped glaze, brushed copper, trailed glaze slip, sponge-stamped red iron oxide, copper overspray; reduction fired in gas kiln, cone 9-10. Photo by Tim Barnwell

I am first and foremost a functional potter. Everything I do revolves around this, whether it's the placement of a handle or a dripless spout, right down to the clay body and glazes used. I find great satisfaction creating art that can be used on a daily basis. My forms are difficult to achieve without a lot of sculpting and carving away. But I am a sculptor at heart, and the results, I hope, are appreciated and recognized by regular folks and not just trained craftsmen and artists.

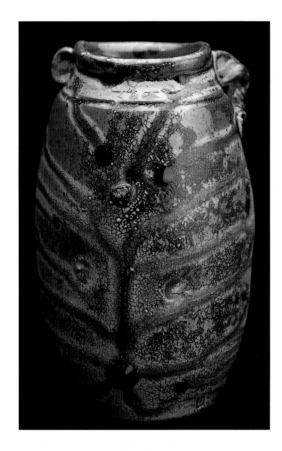

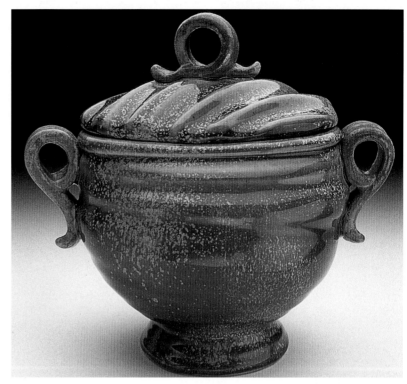

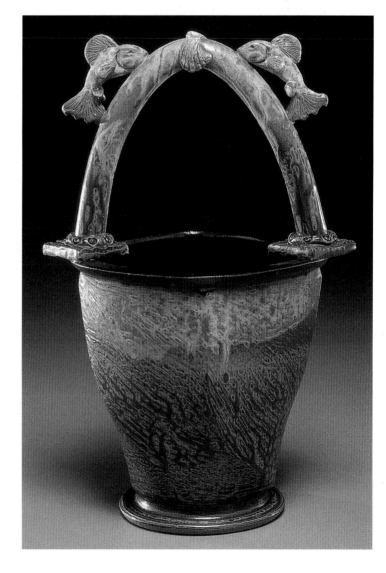

Above: **Dick Lehman,** *Sidefired Tiger Stripe*

1996, 9" x 5" x 3" (23 x 13 x 8 cm). Wheel thrown and altered; handles rolled, textured, twisted, and attached while pot was wet on the wheel; carbon trapping glaze applied, and wood ash, fluxes, and colorants sprinkled on one side of pot while glaze still wet; reduction fired on its side (sprinkled side up), on a one-time-use tripod, in a gas kiln, cone 10; as ash, fluxes, and colorants melt, they run to bottom, creating the "front" of the piece as you see it. Photo by artist

Not having an anagama (my studio and kilns are located in town), I decided to try to work within the limitations of my current setting to create pots which have the kind of movement, flow, and "juiciness" of the anagama pots I most admire.

Top right: **Shannon Nelson,** *Covered Jar*

1996, 8" x 8" x 5" (20 x 20 x 13 cm). Wheel-thrown and altered body; handbuilt, altered, textured slab lid attached to wheel-thrown flange; pulled handles; blue chun glaze; wood fired in anagama kiln, cone 10. Photo by artist

Right: **Larry Spears,** *Fish Basket*

1997, 14" x 6" x 6" (36 x 15 x 15 cm). Wheel-thrown and altered stoneware, with extruded handle and handbuilt appendages; matt glazed interior, ash glazed exterior; reduction fired in gas kiln, cone 10. Photo by Kevin Montique

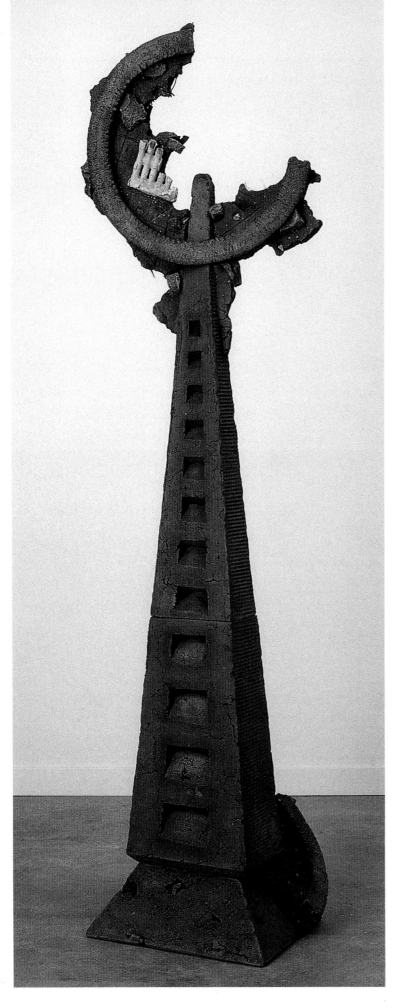

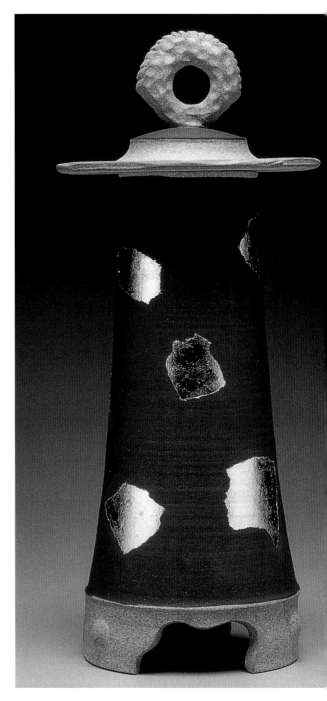

Above: **Don Davis, *Footed Canister***

1996, 20" x 7" x 7" (51 x 18 x 18 cm). Wheel thrown, with handbuilt knob; black engobe and gold leaf, interior glazed; fired to cone 7, light reduction. Photo by Tim Barnwell

Left: **Robert L. Wood, *Orbital***

1996, 72" x 22" x 18" (183 x 56 x 46 cm). Slab-built, press-molded, and extruded construction; embedded objects include cone packs, broken pottery shards, kiln elements, kiln posts, and glass; iron oxide and frit; fired in gas kiln, cone 3, light reduction

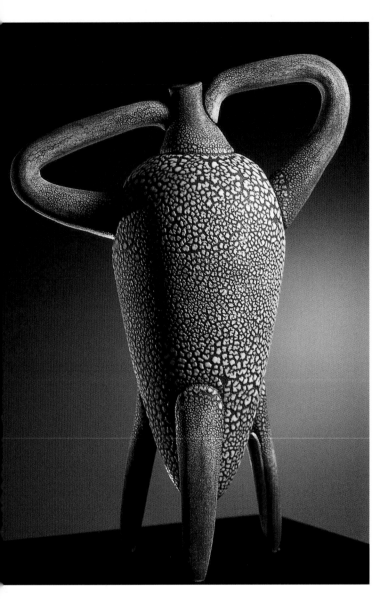

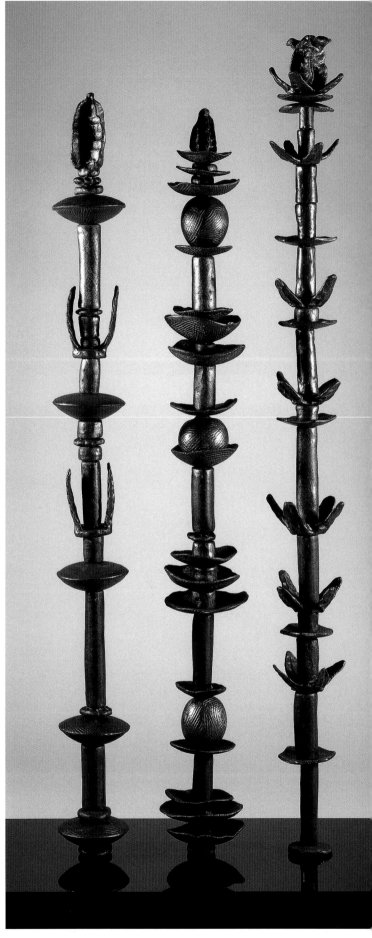

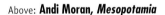

Above: **Andi Moran,** *Mesopotamia*

1997, 15" x 10" x 5" (38 x 25 x 13 cm). Low-fire white clay; slab-constructed body; extruded and altered side appendages and top form; carved; rubbed black glaze, sprayed white wood-ash engobe, stain; bisque fired in electric kiln, cone 06; glaze fired, cone 04. Photo by Tom Joynt

Right: **Victoria Shaw,** *Growth Totem*

1997, 54" x 20" x 5" (137 x 51 x 13 cm). Handbuilt and round wheel-thrown stoneware forms; surfaces combed, pinch marks on leaf design; pieces stacked on rods, with granite base; manganese dioxide wash; once-fired (oxidation), cone 6. Photo by Courtney Frisse

Growth Totem *is a playful piece inspired by nature and symbolic of the interior spiritual growth that is our legacy to explore on this earth. My clay work and my inner spirituality are interconnected. Clay is like a bridge and it brings me to a land within, and from that land I find myself.*

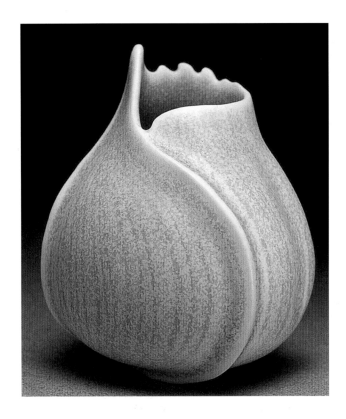

Above: **Ole Morten Rokvam, *Untitled Teapot***

1996, 12½" x 12" x 8" (32 x 30.5 x 20 cm). Handbuilt slabs, one wheel-thrown piece assembled; rubber hosing and metal attachments added; glazed and sandblasted; reduction fired, cone 10

Top left: **Sandra Byers, *Vernal Bloom***

1997, 3" x 2½" x 2½" (8 x 6 x 6 cm). Wheel-thrown and pinched porcelain, with extruded additions; carved, incised, microcrystalline matt copper glazes; oxidation fired, cone 9½. Photo by artist

The gentle spiral of a tightly furled calla lily leaf. The closely veined surface of a gladiolus corm. The sparkle of fresh, dry snow. They amaze, fascinate, and inspire me. Lines and shapes in nature flow gracefully while maintaining a feeling of tension. Forms and surfaces are unified. In porcelain, I am trying to catch the delicacy as well as the strength of nature's details. Like the walls of a shell or the petals of a flower, translucent porcelain forms come to life in the sunlight. I am not trying to recreate nature but only to capture a feeling, hoping to stimulate those who see my work to stop for a moment and observe the richness of the world around them.

Left: **Jim Koudelka, *Aid Container***

1996, 23" x 10" x 11" (58 x 25 x 28 cm). Wheel-thrown container and lid with press-molded additions; high alumina glazes, crackle slips, salt slips, low-fire commercial glazes; salt fired, cone 10; additional cone 06 firings; sandblasted. Photo by Courtney Frisse

ACKNOWLEDGMENTS

Lark Books is deeply indebted to renowned ceramic artist and teacher Val M. Cushing and to his wife, Elsie. Mr. Cushing not only wrote the superb introduction to this book, but also helped us with the very challenging processes of selecting visuals and keeping the ceramic editor's anxiety at a manageable level. Mrs. Cushing lent her support at every step.

Mr. Cushing, whose work is exhibited internationally, has had a long and distinguished career. He has held teaching positions at a number of educational institutions, including the SUNY College of Ceramics at Alfred University, New York; the National School of Art & Design in Oslo, Norway; the University of Illinois School of Art in Champaign/Urbana, Illinois; and Penland School of Arts & Crafts, Penland, North Carolina. Mr. Cushing has been elected as a Fellow of the National Council on Education in the Ceramic Arts (he has also served as President) and as a Fellow of the American Craft Council. Among his honors and awards are a Fulbright Award for teaching abroad; an individual artist's grant from the National Endowment for the Arts (NEA); the Ceramic Artist of the Year Award, given jointly by the American Ceramic Society and the NCECA; the Chancellor's Award for Excellence in Teaching, given by the Chancellor of the State University of New York; and the Kruson Award for Distinguished Teaching from Alfred University.

We're extremely grateful to Kathy Triplett and Brian McCarthy for their help selecting the photos in this book. Kathy—a fine ceramic artist and the author of *Handbuilt Ceramics* (Lark Books, 1997)—is a resident of Weaverville, NC. Brian—the owner of Highwater Clays in Asheville, NC—is a long-term friend of Lark. Their expert skills and astute eye for fine ceramic art proved invaluable.

Without the artists listed in the following pages, we could never have compiled this gallery of contemporary work. We thank them all—for having shared their work, their enthusiasm, and their convictions so generously.

CONTRIBUTING ARTISTS

Sue Abbrescia
Abbrescia Fine Art & Pottery Studio
Kalispell, Montana, USA
Page 54

Elaine F. Alt
Marblehead, Massachusetts, USA
Page 43

Donna Anderegg
Denver, Colorado, USA
Page 32

Wesley Anderegg
Denver, Colorado, USA
Page 87

Marilyn Andrews
Plainfield, Massachusetts, USA
Page 104

Susie Stamm Andrews
The Garden Gallery
Carlisle, Pennsylvania, USA
Page 78

Linda Arbuckle
University of Florida
Micanopy, Florida, USA
Page 82

Jane A. Archambeau
Toledo, Ohio, USA
Page 133

Linda Arndt
Albany, Indiana, USA
Page 32

Posey Bacopoulos
New York, New York, USA
Pages 41 and 49

Carl Baker
Carl Baker, Potter
Santa Cruz, California, USA
Page 50

Allen Bales
Earth, Fire, Water Studio
Lakewood, Colorado, USA
Page 144

Bruce C. Bangert
Half Moon Bay, California, USA
Page 39

Lisa Marie Barber
Fresno, California, USA
Page 164

Laura Barov
Palatine, Illinois, USA
Page 73

Tom Bartel
Meadville, Pennsylvania, USA
Page 59

Bennett Bean
Blairstown, New Jersey, USA
Page 17

Jennie Bireline
Bireline Studios
Raleigh, North Carolina, USA
Page 103

Ravit Birenboim
Forest Hills, New York, USA
Page 136

Garry Bish
Epsom, Victoria, Australia
Page 120

Sandra Blain
Knoxville, Tennessee, USA
Page 148

Marla Bollak
Away With Clay
Black Mountain, North Carolina USA
Page 167

Richard Bonner
Austin, Texas, USA
Page 149

Lynn Smiser Bowers
Kansas City, Missouri, USA
Page 23

Robert Bowman
Minneapolis, Minnesota, USA
Pages 15 and 51

Carol Bradley
Kitchener, Ontario, Canada
Page 68

Karen Branch
Earthfire Branch
Huntsville, Arkansas, USA
Page 113

Sara E. Bressem
East Longmeadow
Massachusetts, USA
Page 143

John Britt
Dys-Functional Pottery
Dallas, Texas, USA
Page 35

Joseph Bruhin
Fox, Arkansas, USA
Page 42

Francesc Burgos
Salt Lake City, Utah, USA
Page 117

Vincent Burke
Ohio University
Athens, Ohio, USA
Pages 55 and 115

Janet Buskirk
Portland, Oregon, USA
Page 116

Sandra Byers
Rock Springs, Wisconsin, USA
Pages 146 and 172

Winthrop Byers
Rock Springs, Wisconsin, USA
Pages 6 and 25

Robin Campo
Chamblee, Georgia, USA
Page 135

Jean Cappadonna-Nichols
Tupelo, Mississippi, USA
Pages 64 and 155

Barbara Chadwick
Houston, Texas, USA
Pages 24 and 106

Debra Belcher Chako
Virginia Beach, Virginia, USA
Page 95

Robert Bede Clarke
Columbia, Missouri, USA
Page 20

Sam Clarkson
Carrollton, Texas, USA
Pages 6 and 13

Alan E. Cober
Pleasantville, New York, USA
Page 97

Judith N. Condon
Knoxville, Tennessee, USA
Page 110

Kendell Coniff
Denver, Colorado, USA
Page 159

Jim Connell
Rock Hill, South Carolina, USA
Page 68

Jerry Conrad
Conrad Pottery
Seattle, Washington, USA
Page 167

Ginny Conrow
Conrow Porcelain
Seattle, Washington, USA
Pages 82 and 121

Judith Cook
Desert Hot Springs, California, USA
Page 158

Patrick S. Crabb
Tustin, California, USA
Page 160

Cameron Crawford
Chico, California, USA
Page 162

Beverly Crist
Dallas, Texas, USA
Page 106

Angi Curreri
Fort Lauderdale, Florida, USA
Pages 59 and 90

Val M. Cushing
VC Pottery
Alfred, New York, USA
Pages 8 and 9

Norris Dalton
Fayetteville, Arkansas, USA
Page 34

Jacqueline Davidson
Mendocino, California, USA
Page 104

Don Davis
Davis Studio Pottery
Asheville, North Carolina, USA
Page 170

William Davis
Charlotte, North Carolina, USA
Page 110

Dave and Boni Deal
Raku by Dave and Boni Deal
Camas, Washington, USA
Page 19

Dorothée Deschamps
Montreal, Quebec, Canada
Page 107

Joseph Detwiler
Fredericksburg, Virginia, USA
Page 122

Gary Dinnen
Sacramento, California, USA
Page 87

Barb Doll
Atlanta, Georgia, USA
Pages 66 and 96

Sang Roberson
Nyoka
Ormond Beach, Florida, USA
Page 120

Inge Roberts
San Francisco, California, USA
Page 116

Ole Morten Rokvam
Dallaz, Texas, USA
Pages 131 and 172

Laurie Rolland
Laurie Rolland, Potter
Sechelt, British Columbia, Canada
Pages 125 and 126

Allan Rosenbaum
Richmond, Virginia, USA
Page 113

Betsy A. Rosenmiller
Tempe, Arizona, USA
Pages 101 and 144

Kathi Roussel
Buffalo, New York, USA
Page 133

Paul Rozman
Calgary, Alberta, Canada
Pages 45 and 130

Peter Saenger
Saenger Porcelain
Newark, Delaware, USA
Page 119

Richard Sager
Sager Scott Studio
San Diego, California, USA
Page 94

Amedeo Salamoni
Oxford, Pennsylvania, USA
Page 113

Robert Sanderson
Crieff, Perthshire, Scotland
Page 30

Elyse Saperstein
Elkins Park, Pennsylvania, USA
Page 66

Anne Schiesel-Harris
West Park, New York, USA
Page 92

Tom Schiller
Kansas City, Missouri, USA
Pages 56 and 61

Catherine Schmid-Maybach
Sebastopol, California, USA
Page 86

Brad Schwieger
Athens, Ohio, USA
Page 14

Virginia Scotchie
University of South Carolina
Columbia, South Carolina, USA
Page 62

Doug Scott
Sager Scott Studio
San Diego, California, USA
Page 94

Bonnie Seeman
Plantation, Florida, USA
Page 151

Ljubov Seidl
Oyster Bay, New South Wales
Australia
Pages 21 and 52

Kate Shakeshaft
Round Earth Studio
Gainesville, Florida, USA
Page 14

Ellen Shankin
Floyd, Virginia, USA
Pages 3, 18, and 46

Andy Shaw
Alfred, New York, USA
Page 39

Victoria Shaw
V. Shaw Ceramics
Portland, Oregon, USA
Pages 153 and 171

Michael Sheba
Toronto, Ontario, Canada
Pages 18 and 158

Kristin Sherlaw
Snowmass Village, Colorado, USA
Page 119

Dale Shuffler
Spring City, Pennsylvania, USA
Pages 70 and 106

Shari Sikora
Havertown, Pennsylvania, USA
Page 47

Chris Simoncelli
Atlanta, Georgia, USA
Page 37

Amy L. Smith
Lincoln, Nebraska, USA
Page 46

Larry Spears
Nashville, Tennessee, USA
Page 169

Betty Spindler
Ridgecrest, California, USA
Page 64

David A. Stabley
Danville, Pennsylvania, USA
Page 157

Chris Staley
State College, Pennsylvania USA
Page 51

Laura Stamper
Original Wearable Art
New Hope, Minnesota, USA
Page 65

Bill Stewart
Hamlin, New York, USA
Page 164

Alfred Stolken
Herrmann-Stolken Porcelain
Santa Barbara, California, USA
Page 48

James Stonebraker
Red Fish Blue Fish Designs
Hoboken, New Jersey, USA
Page 54

Renée Stonebraker
Red Fish Blue Fish Designs
Hoboken, New Jersey, USA
Page 54

Diane L. Sullivan
Colorado Springs, Colorado, USA
Page 129

Laurie Sylwester
Raku by Laurie Sylwester
Tuolumne, California, USA
Pages 16 and 28

Cheryl Tall
Stuart, Florida, USA
Page 57

John A. Taylor
Taylor Tile & Pottery
Renton, Washington, USA
Page 97

Charles Tefft
Atlanta, Georgia, USA
Page 39

Sandra K. Tesar
Gurley, Alabama, USA
Page 84

Lisa Tevia-Clark
Brasstown, North Carolina, USA
Pages 31 and 116

Adriana Pazmany Thomas
Watertown, Massachusetts, USA
Pages 15 and 40

Skeff Thomas
Bridgeton, New Jersey, USA
Page 20

Jacqueline Thompson
Jacqueline Thompson Ceramics
San Francisco, California, USA
Page 131

V. Thompson-Hess
Muncy, Pennsylvania, USA
Page 95

John Tilton
Alachua, Florida, USA
Page 15

Michael Torre
Northwestern Michigan College
Traverse City, Michigan, USA
Page 75

Carol Townsend
Snyder, New York, USA
Page 76

Jennifer Townsend
Mountain Park, Georgia, USA
Pages 121 and 141

Kathy Triplett
Weaverville, North Carolina, USA
Page 67

Penny Truitt
Santa Fe, New Mexico
(and) Rosedale, Virginia, USA
Page 99

Brad Tucker
Brad Tucker Pottery
Creedmoor, North Carolina, USA
Page 51

Mia Tyson
Rock Hill, South Carolina, USA
Page 90

Andrew Van Assche
Plainfield, Massachusetts, USA
Page 75

Michael Vatalaro
Central, South Carolina, USA
Page 21

Gina Vigliarolo
Nesconset, New York, USA
Page 160

Ted Vogel
Portland, Oregon, USA
Page 148

Mary Walyer
Stone Circle Studio
Portland, Oregon, USA
Page 138

Marianne Weinberg-Benson
Atlanta, Georgia, USA
Page 44

Tobias Weissman
Leonia, New Jersey, USA
Page 161

Helen Weisz
Architectural Ceramics
Southampton, Pennsylvania, USA
Page 74

Jim Whalen
Paradox Pottery
Horse Shoe, North Carolina, USA
Page 17

Susan Whalen
Paradox Pottery
Horse Shoe, North Carolina, USA
Page 17

Geoffrey Wheeler
Minneapolis, Minnesota, USA
Page 130

Lisa Wolkow
Madison, Connecticut, USA
Page 57

Eileen Wong
Dover, New Hampshire, USA
Page 23

Robert L. Wood
Kenmore, New York, USA
Page 170

Matthew A. Yanchuk
Matthew A. Yanchuk Ceramics
New York, New York, USA
Page 118

Zak Zaikine
Sebastopol, California, USA
Page 36

Colleen Zufelt
Zufelt Design
Wilmington, Delaware, USA
Pages 142 and 151

**Artists may be contacted
directly or through Lark Books
(*The Ceramic Design Book*),
50 College Street,
Asheville, NC 28801**